ul Guilliatt

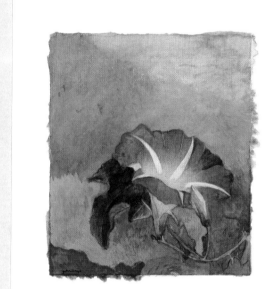

From the Library of

American Impressionism

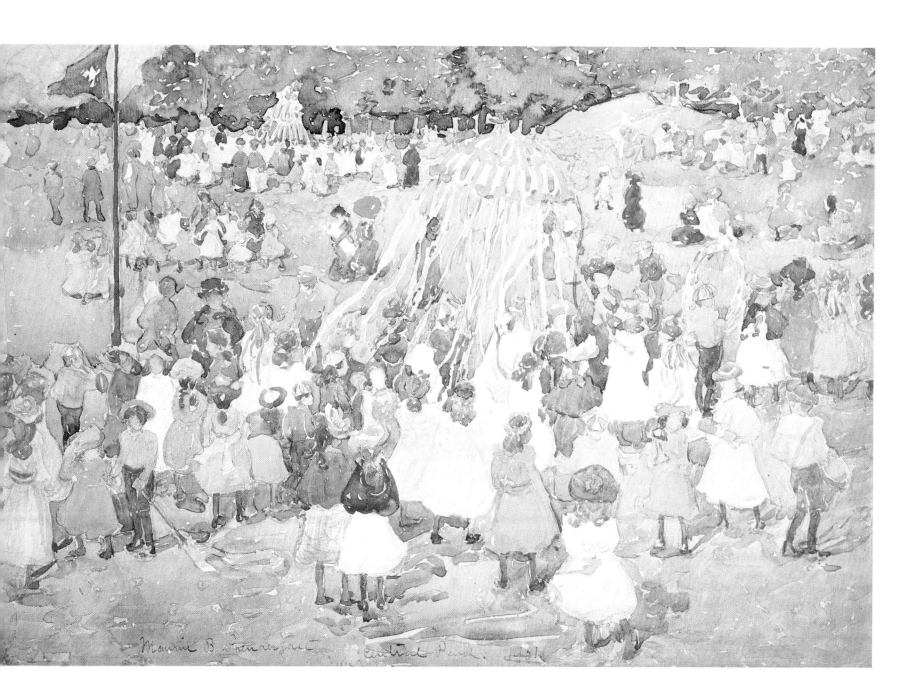

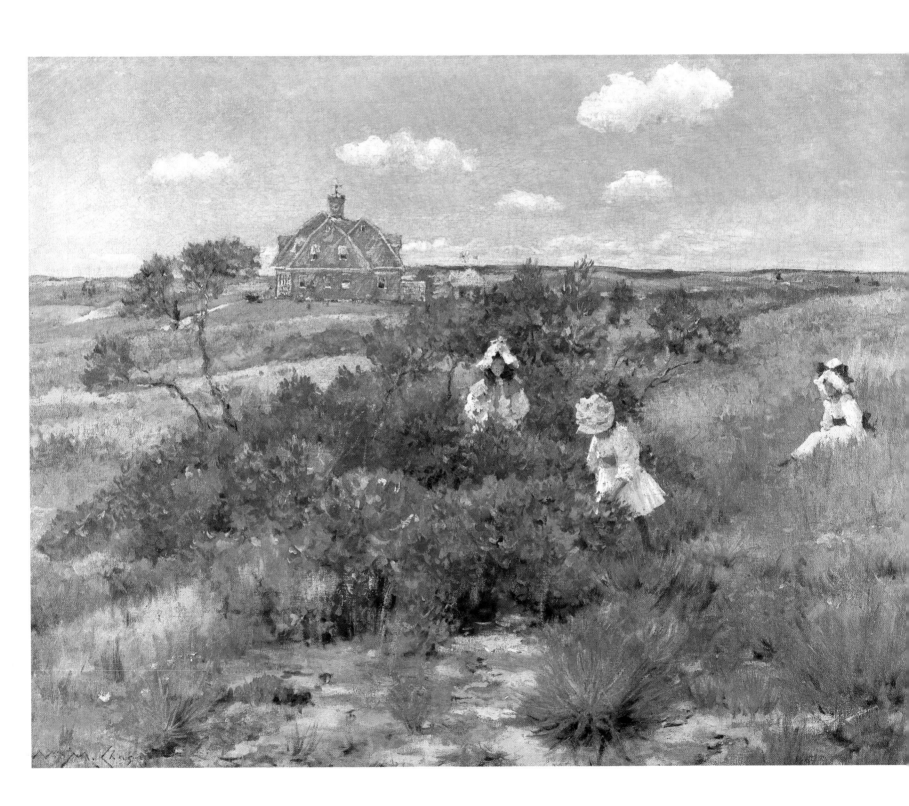

American Impressionism

Richard J. Boyle

New York Graphic Society, Boston, Massachusetts

For Eric

in memory of Daniella

ACKNOWLEDGMENTS

In the writing of this book, from the initial conception to the final draft, many people have contributed their knowledge, their ideas, practical assistance and moral support. The following people have been particularly helpful in many ways: Philip R. Adams, former Director of the Cincinnati Art Museum, who not only wrote the foreword but has been equally generous throughout in his support and encouragement; Alice Hook, Librarian, Cincinnati Art Museum, and her assistant Grace Keam, who patiently helped with my research; my former secretary, Adrienne Tripp, who carried out the arduous task of typing the whole manuscript and organized a myriad of details, both large and small; Louise Schutz, of the Pennsylvania Academy of the Fine Arts, whose organizational ability is astounding. I gratefully acknowledge the help of Dr. Edgar P. Richardson; Vivian and Meyer P. Potamkin, Philadelphia; William B. Truettner, Associate Curator, The National Collection of Fine Art, and Cynthia Perlis, also of the NCFA; Ralph Mayer, New York, for his valuable technical advice, and Dr. Rosamond D. Harley of Winsor & Newton, Ltd., for her technical advice and generous use of her research material; Henry La Farge; Norman Hirschl and Stuart Feld of Hirschl and Adler Galleries, Inc., New York; Karen V. Wright of the Museum of Fine Arts, Boston; Nancy Moure of the Los Angeles County Museum of Art; Natalie Spasskey, American Department, The Metropolitan Museum of Art, New York; Jeffery Brown, former Curator of Collections, Indianapolis Art Museum; William Campbell, Curator of American Painting and Sculpture, The National Gallery of Art, Washington, D.C.; Mahonri Sharp Young, Director, Columbus Gallery of Fine Arts, Ohio; Ira Spanierman, New York; Lawrence Fleischman and Dr. Irving Levitt, Kennedy Galleries, New York; Christine Huber and Elizabeth Bailey, Registrars, Pennsylvania Academy of the Fine Arts; Robert Chapellier, Chapellier Gallery, New York; Robert C. Vose, Jr., Vose Galleries, Boston; Denys Sutton, London; Dr. Phyllis Kaplan, the University of Cincinnati; Dr. Carol Macht, Curator of Decorative Arts, Cincinnati Art Museum; Sheila Hogan and Brucette Greiser, formerly Cincinnati Art Museum; Burton Closson, Cincinnati, Ohio; Mrs. Joseph Calloway, Selma, Alabama; Linda Landis, New York Graphic Society; and especially Donelson Hoopes, Curator of American Painting, Los Angeles County Museum of Art.

And finally my thanks to my wife Pat, my daughters Cheri and Barbara, and my sons Rick and Eric, who patiently put up with the whole project.

Philadelphia RICHARD J. BOYLE

page 1
MAURICE PRENDERGAST
May Day, Central Park (1901)
Watercolor. 13⅞ x 19¾ inches
*The Cleveland Museum of Art
Gift of J. H. Wade*

page 2
WILLIAM MERRITT CHASE
Shinnecock Hill (circa 1895)
25½ x 32 inches
Parrish Art Museum, Southampton

International Standard Book Number 0-8212-0597-8
Library of Congress Catalog Card Number 73-89951

First published 1974 by New York Graphic Society, Ltd.
11 Beacon Street, Boston, Mass. 02108
First printing 1974

Designed by M. B. Glick

Manufactured in Italy by Mondadori, Verona

Foreword

This is a timely book. 1974 will be the centennial of the first impressionist exhibition to be celebrated properly by all who take simple pleasure from fine painting, or who find their vision enlarged in the process. 1976 will be the bicentennial of the American Republic. So a double problem of definition is posed: what is it to be an American, and what exactly is impressionism?

France gave many princely gifts to the art of modern times, but the Gallic compulsion to categorize has been a mixed blessing. "Isms" flourished like weeds in the congenial soil of Paris and have spread to the rest of the world. They were always of much greater interest to critics and apologists than they were to the painters who could quietly and nonverbally answer to the demands of the changing times and to their own inner needs. Definition is, however, a first step on the road to knowledge and those who want to find a path through the profusion of late nineteenth-century styles must start the journey. They may need a guide.

Mr. Boyle is a very good one. He is a painter as well as an art historian, and so can bring dual insight to this complicated task. And it is complicated; how, for example, to sort out the vast technological changes of the century as they affected —profoundly affected—the art of painting? Mr. Boyle is not dismayed. He cites the chemists' new colors and color theories, the Industrial Revolution's reordering of the landscape here and abroad, the equally revolutionary impact of photography on the visual artist, even the humble invention of the collapsible metal tube to hold painters' pigments. He weighs these factors carefully, finding that change is neither good nor bad, but simply different, a discovery so elementary that it has eluded some of the subtlest minds.

He examines the European background of impressionism; the moral implications of mid-nineteenth-century American landscape; the singularity of Whistler and Sargent. Then he assembles a good-sized company of those painters, many of them recently discovered, who more precisely fit his definitions. They will not be, could not be, everyone's selection, but they are all fascinating artists, too often neglected, and Mr. Boyle has a painter's feel for the canvases emerging from museum reserves and the attics of crumbling mansions.

Centennial celebrations are probably good things; they fix a point from which to untangle the skein of the past, to look at it freshly, and to wonder how it may thread through the present. It is indeed time for this book.

PHILLIP R. ADAMS
Director Emeritus, Cincinnati Art Museum

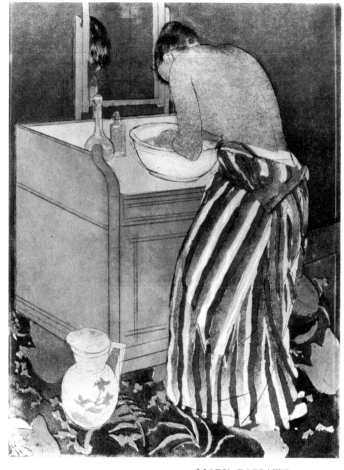

MARY CASSATT
La Toilette (1891) Drypoint and aquatint,
14⅜ x 10⁹⁄₁₆ inches
The Cincinnati Art Museum,
Gift of Herbert Greer French

Contents and List of Illustrations

In captions, height precedes width in dimensions; works are in oil unless otherwise specified.

◇ Diamond indicates color plate.

6

Contents and List of Illustrations

Contents and List of Illustrations

Contents and List of Illustrations

Contents and List of Illustrations

This book has three main purposes. First, to present a general survey of the impressionist style as practiced by American artists in the last quarter of the nineteenth century, and through these works to trace the development of the style in the United States. Second, to trace the influence, native and foreign, aesthetic and technological, that gave rise to the movement in general and its American variation in particular. Third, to try to isolate those characteristics or tendencies in American impressionism that make it specifically American. For example, was the home-grown variant of the style just that—a variation on a French theme? Was it simply Greenwich and Gloucester and Shinnecock as seen through French eyes? Or was it a natural use of an international style, a form and a way of seeing that was modified by American traditions and American experience?

Before these questions are dealt with, however, it would be best to set forth the *limits* of this book as well as its purposes, and to indicate the time-span within which I feel American impressionism was most alive and the style best expressed by its most able practitioners. The French evolved what is now known as impressionism in the 1860s, and although there were some parallels in the work of John La Farge and Winslow Homer about the same time, the new painting did not take hold in America until the 1880s. Then from the late '80s to the turn of the century, the vitality of American impressionism reached its highest pitch. In 1894, the novelist and critic Hamlin Garland could enthusiastically devote a chapter to the style in his book *Crumbling Idols*. Writing about the art section of the Chicago World's Fair of 1893, he noted that "every competent observer who passed through the art palace of the Exposition was probably made aware of the immense growth of impressionistic or open-air painting." While devoted to the impressionists' use of "frank" color, and delighted with their "buoyant and cheerful" painting, Garland nevertheless predicted the eventual demise of the movement; toward the end of his essay, he wrote: "The impressionist will try to submit gracefully" in giving over to the younger generation with different ideas and a different style. The generation of Robert Henri, for instance. Henri and his followers would rebel against the excesses of impressionism; Henri himself was trained in an impressionist manner, but eventually banished "buoyant and cheerful" color from his palette altogether. And by the time the famous Armory Show had opened its doors in 1913, impressionism had run its course. Its conventions had hardened and its formulas were taught in art schools.

But the chapter has been reopened by the quickening interest on the part of historians and collectors of nineteenth-century painting and particularly American nineteenth-century painting. Along with this, American

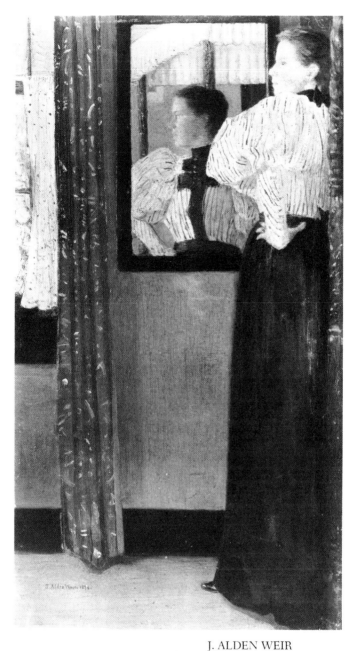

J. ALDEN WEIR
Reflections (1896) 24¼ x 13⅝ inches
Museum of Art
Rhode Island School of Design, Providence

impressionism is receiving its own full share of popularity and interest. Yet it appears that every painter who ever swung a loaded brush at a canvas, or used a bit of broken color, has been called an impressionist. So for my own purposes as well as for the purposes of this book, I feel that an approach toward a definition of the style is called for. Taking as a starting point the work of Manet, Monet, and Pissarro, the work of those whom Borgmeyer called "The Master Impressionists," what was the general style they used? Actually there was no encompassing impressionist manner, but a number of related styles practiced by artists who shared a common ground in a number of areas. Basically impressionism was a perceptual mode of painting, of which the late work of Monet is the outstanding example. As Cézanne remarked, "Monet is only an eye, but what an eye!" However, not all the artists in the group were as devoted to the perceptual approach as he. Degas, for example, in his concern for drawing and the formal elements of composition is at the other extreme from Monet; Degas was more conceptual, as was Renoir in his later work. Yet as the movement is known today, they are both considered impressionists. There were other contributing factors as well; the use of photographs and the discovery of the Japanese print in the early 1860s. There was a concern for the representation of light, air, atmosphere; the expression of what Monet called the *enveloppe*. And the primary tool for this representation was color. A brighter palette was the technical ground on which they all met. The dark hues of the Salon paintings and of most Barbizon School works were eliminated from the canvas, and tonal values for modeling were replaced by hues to give an "all over" effect. The impressionists used new colors in a new way.

This is the "common ground" as I see it, a concept that has determined the direction and form of the book, the limits under which the artists were included or not included. It eliminates Frank Duveneck, for example, who used *tonal values* (commonly known as light and shade) to model three-dimensional form. It would also eliminate—because they were tonalists rather than colorists—such artists as J. Francis Murphy, William Keith, and Robert Henri; but not James McNeill Whistler. Whistler is included although he is an exception to the criterion (in fact Whistler was *always* an exception). He used either an all-dark palette, or an all-light palette, but he did not model three-dimensional form; and although he was associated with the French impressionists in the early years of the movement, and although his beautiful Nocturnes are so evocative of the atmosphere of evening that he has been called a "twilight impressionist," his aims were quite different. Yet because of his ideas, his personal, spare, and abstract style, his experiments in pastel and etching, and his independent stand, he had a pervasive influence on the course of American impressionism.

In an attempt to chart this course, I have divided the book into sections. There are brief summaries of the European and American backgrounds; a

section devoted to artists who I feel are "pre-impressionists," those artists who form a kind of link between the older forms of American landscape painting and the new impressionist style; a main section devoted to the American impressionists, both major and minor, leading to a climax in the organization of The Ten American Painters in 1897; and last, a section devoted to the demise of the movement.

Many of the artists discussed are not well known and the information on them is either scanty or scattered. Therefore it is my hope that this book will provide the framework and impetus for further study in what I feel is one of the most interesting and rewarding areas in American art history.

WILLIAM MERRITT CHASE
The Fairy Tale (1892) 16½ x 24½ inches
Collection of Mr. and Mrs. Raymond J. Horowitz

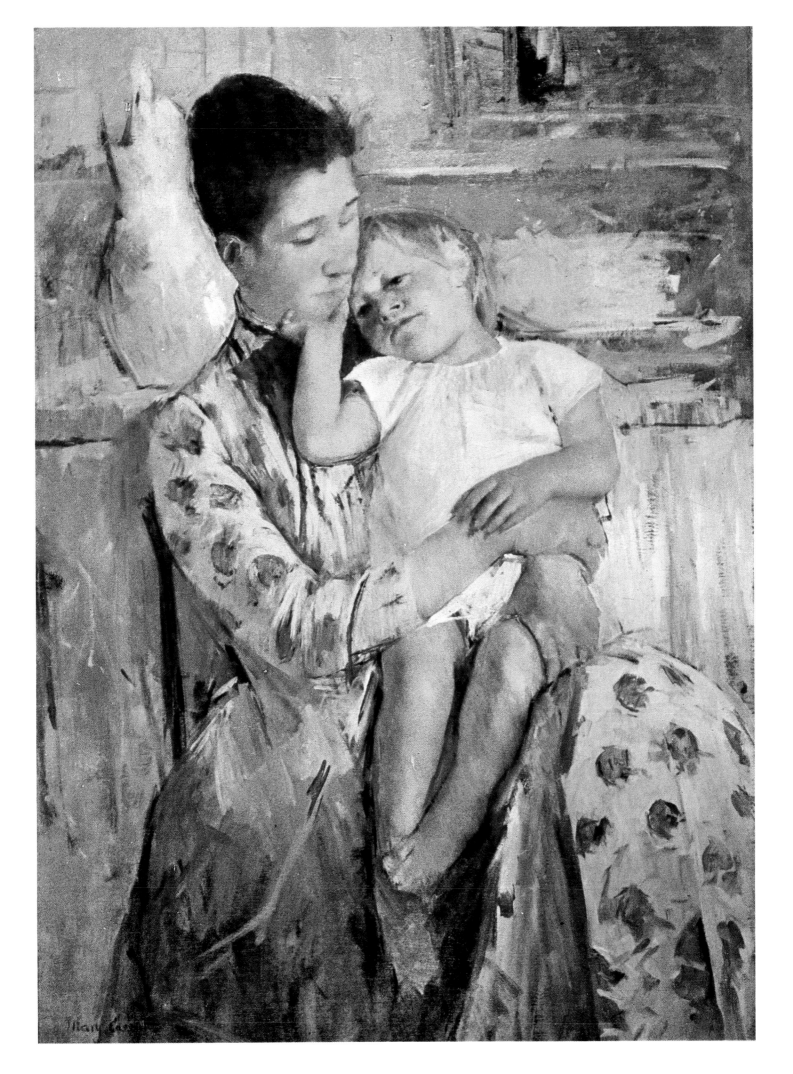

14

The European Background

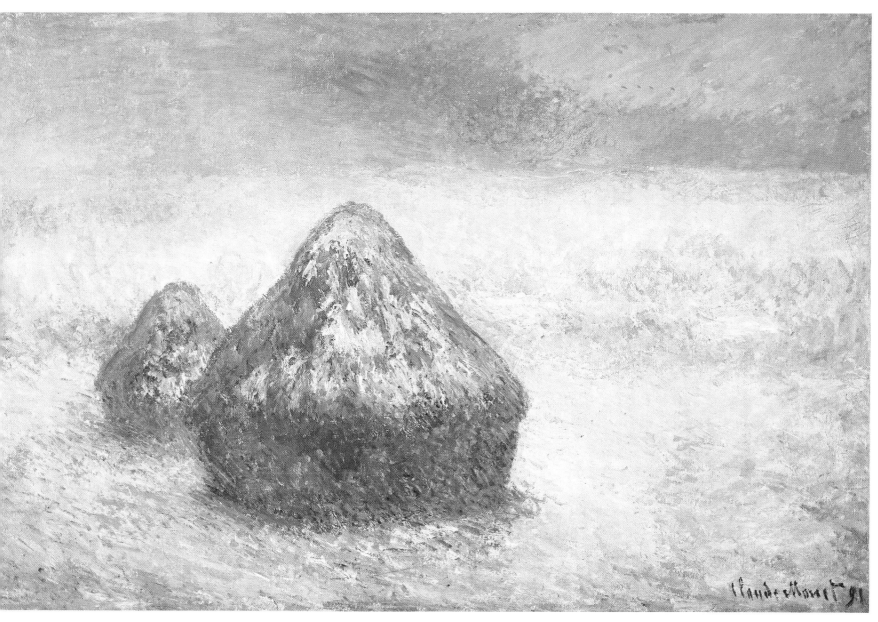

CLAUDE MONET
Haystacks, Setting Sun (1891) 25½ x 39½ inches
The Art Institute of Chicago
The Potter Palmer Collection

facing page:
MARY CASSATT
Emmie and Her Child (1889) 35⅜ x 25⅜ inches
Wichita Art Museum
Ronald P. Murdock Collection

CHAPTER I

"Light is therefore color." J. M. W. TURNER

"These so-called artists style themselves In-transigeants, Impressionists. . . . They throw a few colors on to the canvas at random, and then they sign the lot." ALBERT WOLFF

IN the beginning there were Claude Monet, Auguste Renoir, Alfred Sisley, Frédéric Bazille, and Camille Pissarro. Then they were joined by Edouard Manet; and after him Paul Cézanne and Edgar Degas. These men formed the nucleus of what later came to be known as impressionism, the term coined—as is often related—in 1874 by a mocking critic, Louis Leroy, when he saw Monet's *Impression: Sunrise* shown in the group's first exhibition in the Paris studio of the photographer Nadar. The term was derisive, of course, but endured, and between their first exhibition in 1874 and their last in 1886, the impressionists were probably reviled and maligned more than any other artistic movement before or since. They were considered rebels, degenerates, and a menace to society by a hostile press and a jeering, disbelieving public. A comment like that of Albert Wolff was the rule, and Emile Zola, then a reporter on *L'Evènement,* not only had his favorable criticisms torn and thrown in his face on the street, but actually lost his job because he dared to defend them.

In fact, the early impressionists did not consider themselves rebels. When they organized their first exhibition they were all already mature artists who had been working for fifteen years or more. In the early 1860s, when they were evolving their personal styles, they were linked together by their dissatisfaction with the official art world and would meet at the Café Guerbois in Paris to discuss their common problems and to share ideas. Dissatisfied they might have been, but they did not consider that they were as yet beyond the pale. Manet, in fact, still endeavored to show in the Salon, and was bitterly disappointed when he was rejected. The impressionists sat there in the Café Guerbois, top-hatted and frock-coated, looking, as Cézanne once remarked, "like a bunch of lawyers!" Nevertheless, they quietly fashioned a new way of painting and made impressionism as a movement unique in the history of art up to its time.

The impressionist procedure can be said to derive from the painting of Corot and the Barbizon masters, with their attachment to working in the open air; from the sensitive seascapes of Boudin and the gentle landscapes of Jongkind; and, of course, from the earthy realism of Gustave Courbet. Manet's influence would later be joined to these first sources. Degas, who inherited the classic draftsmanship of Ingres and Raphael, stood somewhat apart from the group, but through his seemingly spontaneous compositions, derived from Japanese prints and photography, compositions which

facing page:

JAMES McNEILL WHISTLER
Southend Pier. Watercolor, 10⅛ x 7⅛ inches
Freer Gallery of Art, Smithsonian Institution
Washington, D.C.

17

had a great influence on Mary Cassatt, he added his own contribution to the impressionist conception.

It is the work of Monet, Renoir, Sisley, and Pissarro (Bazille was killed in the Franco-Prussian War) that is most thoroughly identified in the public mind as examples of true impressionism. These were the men who consistently started with, and evolved away from, the Barbizon masters; and their evolution was accomplished gradually and deliberately. Although Monet, Renoir, and Sisley had a common teacher—they first met in 1862 as pupils of Albert Gleyre at the *Ecole des Beaux-Arts*—the summers they spent painting in the forest of Fontainebleau were more crucial than the shared

AUGUSTE RENOIR
The Seine at Argenteuil (1873) 19¾ x 25¾ inches
Portland Art Museum, Portland, Oregon
Bequest of Winslow B. Ayer

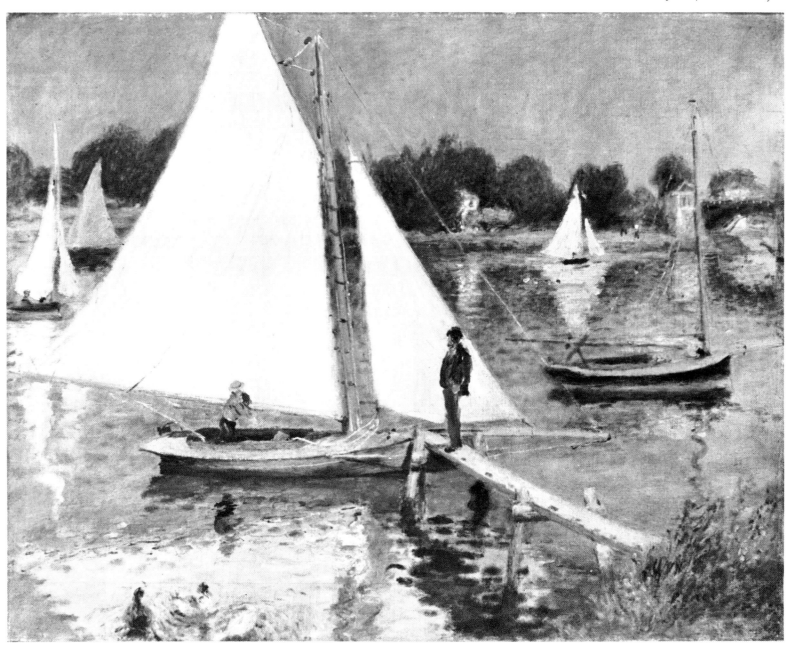

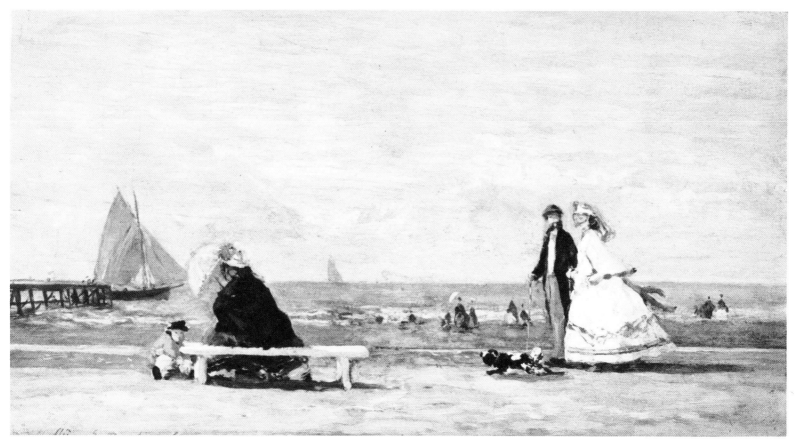

EUGENE LOUIS BOUDIN
Beach at Trouville (circa 1863) 7 x 13¾ inches
The Phillips Collection, Washington, D.C.

instruction to the evolution of their style. Pissarro talked of Corot; and in addition to the influence of the latter, and of Courbet, the future impressionists had a chance to benefit from Diaz, Daubigny, and Millet, the remaining members of the Barbizon group. However, even before the visits to Fountainebleau, these men had been interested in working in the open air, whether in the country or on the streets of Paris. Renoir loved the life of the Parisian boulevards, the parks and the boating places on the river Seine; Pissarro had painted some landscapes of his native West Indies and had been an informal pupil of Corot; and Monet had been initiated into the painting profession by Boudin, whom Corot had called "the king of the skies." Boudin influenced Monet as a painter, and Monet never forgot it. Boudin was interested in light, space, and the changing elements; he delighted in the varieties of cloud and sky, noting atmospheric changes on his canvases, including the time they were painted and the direction of the wind.

The French artists were also influenced by the work of the British painters Constable and Turner, who were among the first painters to see light in terms of a pervasive veil of atmosphere. When Constable, who was also knowledgeable about meteorology, exhibited his *Haywain* at the Salon of 1824, its loose technique and atmospheric effects caused a sensation in Paris.

(*see page* 20)

19

The paintings of Turner, who was one of the first artists to make color diagrams, were seen by Monet and Pissarro when they were in London during the Franco-Prussian War.

(*see page* 23)

In 1863, Manet's *Le déjeuner sur l'herbe,* rejected from the official Salon, held the center stage in the famous *Salon des Refusés* instituted by Napoleon III. Manet's picture was an object of scorn or laughter to everyone who saw it—everyone except Monet and his friends. They were impressed by the audacity of the subject and the boldness of the handling; it was fresh, startling, and they had never seen anything like it. It was the spark they needed. Soon Manet's influence began to tell, and Manet himself became the star attraction during their meetings at the Café Guerbois. In return, Monet's circle exercised a strong influence on Manet, and his color became purer and more brilliant. In fact from about 1865, this increased brilliancy

JOHN CONSTABLE
The Haywain (1821) 51¼ x 73 inches
National Gallery, London

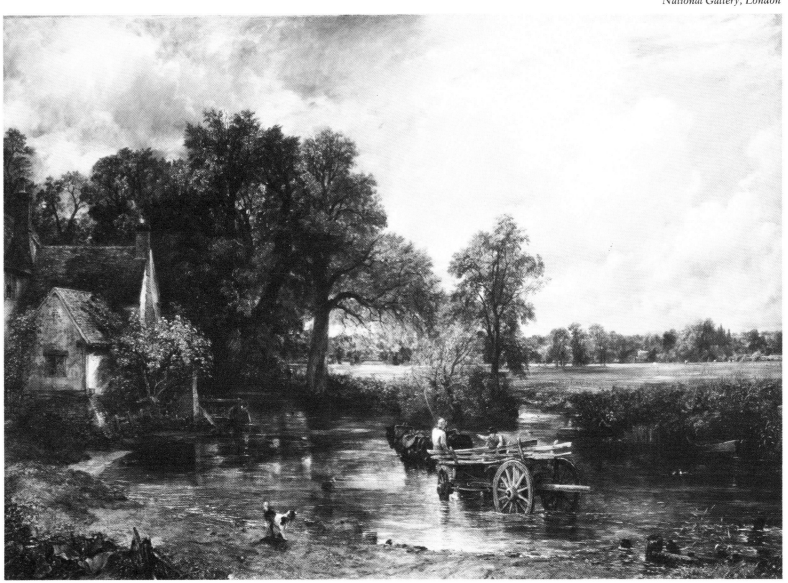

of color was characteristic of all this group as they became more and more absorbed in the analysis of atmosphere and light.

Discoveries of science and technology were important in the evolution of the treatment of light and atmosphere, an evolution that culminated in the impressionist manner of representing light through color. The increasing curiosity of scientists about the nature of luminosity and of color perception and the physical properties of pigments discovered by the new chemical industry all had their effect on artists. In many cases, the researches of scientists paralleled those of the painters of the time. In the seventeenth century, Christiaan Huygens in Holland and Isaac Newton in England laid the groundwork for the study of light. Goethe's theories of color and color physiology were published in English in 1840. In 1802, the English scientist Thomas Young proposed that the eye was capable of receiving three primary sensations of color: red, green, and violet. Since then physicists have disagreed about the exact nature of the three primaries, but they agree that these would fall into the red, yellow, blue areas of the spectrum.

In the area of technology, the development of photography would be important for the impressionists. In 1839, Daguerre and Niepce invented the daguerreotype. This process, the ancestor of photography, was the permanent recording of light waves on a sensitized surface. In the same year, Eugène Chevreul published his theory on the contrast of colors. Chevreul's theories would have the most telling influence on the nineteenth century and would provide the most pertinent material for artists. He was widely recognized as one of the most distinguished scientists of his era, and one of the century's most important scientists. And he was versatile. His researches on animal fats and the nature of soap in 1823 are classics of their kind. In 1824, he became director of the Gobelins Tapestry Works, where he carried out his studies of color intensity in wool, which led in turn to his studies on color contrast. Chevreul was best known to artists for his monumental work on color: *De la Loi du Contraste Simultané des Couleurs,* published in 1839 and appearing in English in 1872 as *Principles of Harmony and Contrast of Colors.* He discovered that the intensity of a given color often depended upon the color adjacent to it. This led to the formulation of his law of simultaneous contrast and his principles of harmony, for which he established a workable set of terms. He also diagramed the chromatic circle, a formulation he thought would be useful to artists because it represented every possible color modification as well as its complement. Although Chevreul was primarily concerned with the problems of color in regard to the making of tapestries, he also considered in his book the application of his law to color in all the arts, including architecture and painting.

There was also relevant research in optics being carried out. In 1857, the prominent French scientist Jules Jamin published an article on light in *La Revue des Deux-Mondes* entitled "Optics and Painting." It was addressed

to landscape painters, encouraging them to make use of the latest discoveries in optics. In 1867, Hermann von Helmholtz summarized the knowledge on light perception in his *Handbook of Optical Physiology*. And from 1855 to 1872, the precocious British physicist James Clerk Maxwell published a series of experiments on color perception and color blindness in which he demonstrated, by using a machine with rotating discs, the mixture of light beams that corresponded to the three primaries; by so doing, he anticipated three-color photography.

But all this concerns experiments with actual light and not the mixture of pigments on the painter's palette. The difference between the mixture of colored lights, which is additive, and the mixture of pigments, which is subtractive, was first pointed out by Helmholtz in his celebrated handbook. A subtractive mixture is a combination of pigments themselves, either on a palette or directly on the surface of the canvas. The primary colors are red, yellow, and blue; in the mixture of red and yellow, elements of each are subtracted to produce orange. The same happens with yellow and blue to produce green, and with blue and red to produce violet. In an additive mixture, superimposed beams of light are projected through rotating discs of varying colors at high speeds. Red, green, and blue-violet are considered the additive primaries, and the results of their mixtures would be quite different from a mixture of pigments. However, there is theoretically another way to mix color additively which has been directly related to painting, and some have claimed this method was part of impressionist practice. This is the technique of mixing numerous small equal-sized spots of two colors on a flat surface. If the observer steps back, the two colors fuse visually and produce a third or reflected color, a result that scientists call "optical fusion." However, contrary to what has been thought for many years, the impressionists did not use this technique. In their analysis of light they may have *appeared* to be scientific, but their approach was essentially an intuitive one.

Nevertheless, the impressionists were probably well aware of the theories of color that were current at the time. The painting of Delacroix had interested the impressionists greatly, so that the publication of his notes on color in 1865 was probably not without its effect. Like Chevreul and Helmholtz, Delacroix insisted on the validity of the three primary colors; that shadows cast upon the ground tend toward blue or violet; and that the color of flesh is closer to the truth when observed in the open air—all of which sounds like a description of a painting by Monet or Pissarro. Helmholtz published his handbook in 1867, and in that same year the critic and art historian Charles Blanc published *The Grammar of the Arts of Design* in which he summarizes Delacroix's views on color and gives a résumé of the theories of Eugène Chevreul. In 1879, the American physicist Ogden N. Rood published his *Modern Chromatics* which was re-issued and translated into French in 1881 as *Théorie Scientifique des Couleurs*. Although French

impressionism was already mature by that time, it is highly possible that Rood's book had some influence on American impressionism.

Thus there were a number of handbooks on color theory and various treatises by physicists containing a body of knowledge on optics dating back to the seventeenth century to which the impressionists could have turned during and after their formative years. There is no concrete proof that artists delved deeply into optical theory; theories of light are relatively abstract and not too practical for the painter. Handbooks on color, such as Chevreul's, were useful, of course; but it was not the physicist who had the greatest impact on the technique of the painter, particularly on the impressionist painter—it was the chemist. Of more direct and practical use were the products of the newly developed chemical industry. The invention and discovery of new pigments by the chemical industry from the beginning of the century on transformed the artist's palette so emphatically that painting has not been the same since.

JOSEPH M. W. TURNER
The Dogana and Santa Maria Della Salute, Venice
(circa 1843) 24⅜ x 36⅝ inches
National Gallery of Art, Washington, D.C.

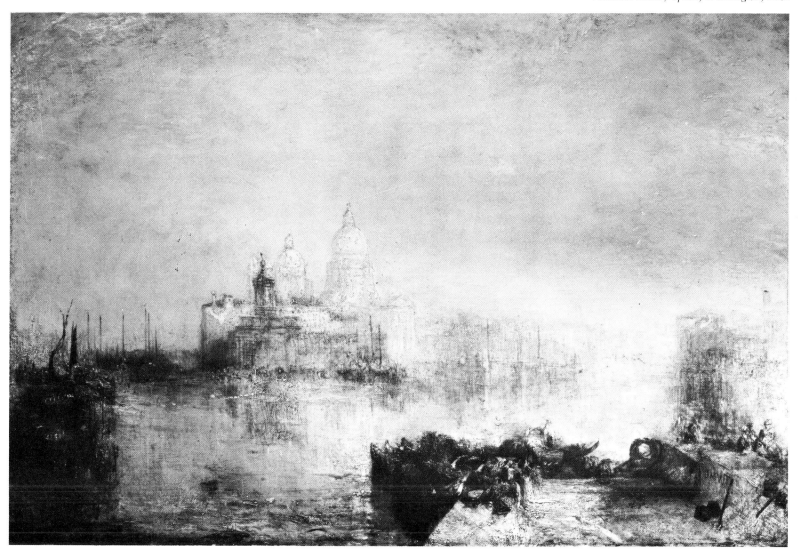

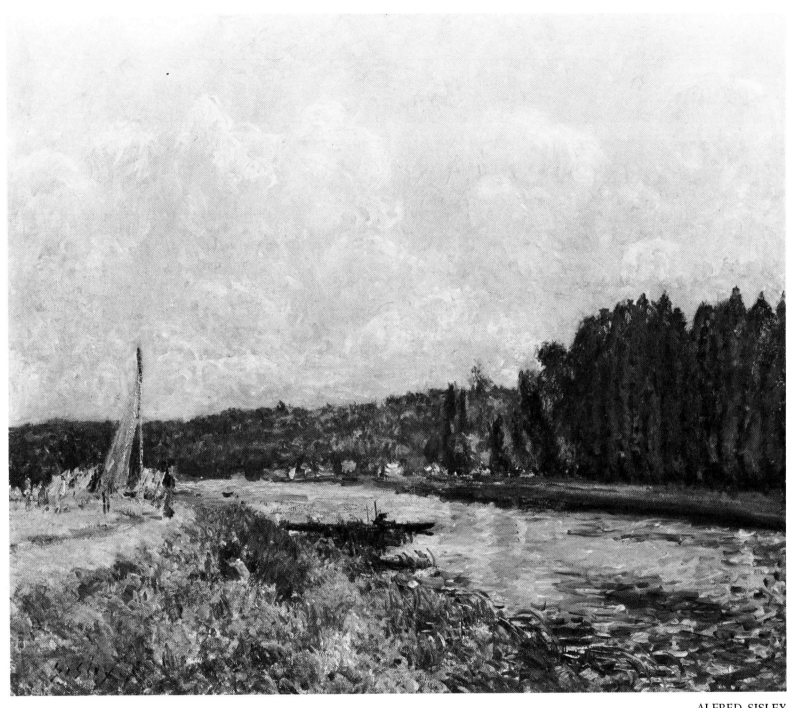

ALFRED SISLEY
The Banks of the Oise (circa 1878–80) 21⅜ x 25½ inches
National Gallery of Art, Washington, D.C.
Chester Dale Collection

24

CHAPTER II

OF the many technological innovations during the nineteenth century, three have had a decisive influence on painters: the invention of the daguerreotype; the discovery of the collapsible tin tube as a container for oil colors; and most important of all, the use of new colors from the beginning of the century onward.

The importance of technical matters as a contribution to the development of new styles is often overlooked or simply ignored by art historians and is neglected in most of the writing on the development of painting in the last quarter of the nineteenth century, developments in impressionist painting especially; even in John Rewald's celebrated work, *The History of Impressionism,* this aspect has received no attention at all. Yet if it were not for the discovery of new colors by the chemical industry, impressionism as it is known today would not have existed. Take, for example, Claude Monet's palette. In a letter of June 3, 1905, to his dealer Durand-Ruel, the artist indicated that the colors he used were cobalt blue, cadmium yellow, vermilion, deep madder, emerald green, and white; and with the exception of vermilion and white, all the colors that he mentions were introduced to artists in the nineteenth century. Cobalt blue went into production in 1807; cadmium yellow in the late 1840s, and was definitely in use by 1851. Emerald green was introduced about 1822; and madder, although used for about two thousand years as a dye derived from the madder plant, was introduced as an artist's pigment in the early nineteenth century with the finer grades dating from about 1826. Vermilion has been manufactured in Europe for use by artists since the early middle ages, and the vermilion made in China was considered to be the finest quality obtainable. An extremely brilliant orange-red, it has the effect of eclipsing other reds, and certainly most other colors as well. As to the white Monet mentions, it could have been lead white (called flake white since the seventeenth century) or possibly zinc white. Both were in use before the nineteenth century, although there seems to have been more of a preference for flake white.

Until the beginning of the nineteenth century, painters still retained, for the most part, their use of traditional techniques and traditional pigments. Although there had been new colors introduced, such as prussian blue, in the seventeenth and eighteenth centuries, the technological pace was slow and nothing at all like the explosion of knowledge and process that took place in the chemical industry in the nineteenth century. Since the arts, then as now, were in a secondary position economically, new pigments were often byproducts of industries unconnected with painting. Prussian blue, introduced to artists circa 1710, and probably the first of the artificial pigments with a known history of development, was used as a dye in the textile

industry before it came into general use as an artist's color. Opaque oxide of chromium or chromium oxide green found acceptance in the ceramics industry before it was made available to artists. It is listed in Winsor & Newton catalogues in the 1840s. New colors came on the market as a result of technical advances in the textile industry, although many of them were fugitive or not resistant to light.

The growth of the textile industry was a direct result of the rapid development of both pure and applied chemistry which affected all areas of commerce. The explosion of color began with the discovery, by Wilhelm von Hofmann in 1845, that coal-tar was a treasure for the organic chemist. From coal-tar came aniline; and after experimenting with aniline, Sir William Henry Perkin, a student of Hofmann's, discovered a purplish-colored solution from which purple crystals could be obtained. He found that this solution would not only dye silk, but that it was not removed by washing and it did not readily fade. That was in 1856, and in 1857, Perkin himself went into business to produce his violet. The French loved it and called it "mauve." Queen Victoria wore a mauve dress at the Exposition of 1862, and postage stamps were printed in that color. Thus the "Mauve Decade" was born. The success of Perkin's violet led other chemists to the investigation of aniline, and more dye stuffs were soon forthcoming. Some of the colors, such as magenta (1859) and alizarin (1868), to name two that have lasted, were made into artists' pigments. Because the materials for making pigments had important applications in other industries, more new colors became available for the use of artists.

In a letter to the author, Ralph Mayer, an expert on artists' materials and techniques, pointed out that "a number of our most brilliant inorganic colors of absolute permanence were developed during the middle and late nineteenth century, but these were the continuation of the constant pigment research to find new and better colors that has gone on since ancient times." Comparing the pigments used earlier, Mayer suggests that the following colors may have influenced painters of the last quarter of the nineteenth century. Artificial ultramarine replaced the pigment made from the costly mineral lapis lazuli and was one of the most important events in the history of artists' materials. This long-awaited substitute for natural ultramarine, the blue of Vermeer, was first manufactured in France in 1826, and has been called French ultramarine ever since. Barium (lemon yellow) was introduced before 1825, but not widely available until circa 1845; cobalt yellow (aureolin) was available in Paris in 1852 and sold in England and America in 1861; a form of viridian (bluish-green) was made in France in the early nineteenth century, but not generally available elsewhere until about 1862. Cobalt violet was introduced circa 1860, cerulean blue in 1870; and manganese violet was made in England in 1890, but not sold in America before the 1930s. Other important pigments introduced at the time were chrome yellow, discovered about 1810

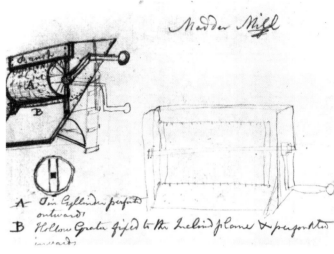

George Field's madder mill, with which he ground up the tough pieces of root. The sketch is an extract from one of his five notebooks, all of which have now been deposited with the Courtauld Institute of Art, by Winsor and Newton Ltd.

by Vauquelin, Chevreul's teacher; and the Mars colors, yellows and reds, which were made from iron oxides and manufactured in France in the late eighteenth and early nineteenth centuries. These marvelous colors are still very much in use.

However, as Mayer indicates, it was not only the invention of new colors that was significant, but "the establishment of new standards of consistency for oil colors was strongly involved. It resulted from the preferences of painters who innovated or followed new movements; the invention of improved pigment-grinding machinery and methods, and the invention of the collapsible tube which not only made possible the indefinite preservation of oil colors, but also the use of a portable paint box which was first used at the time of the Barbizon painters."

Until the early nineteenth century, skin bladders were the customary containers for oil colors; when the paint was put in, the bladder was tied tightly at the top in order to make it air-proof. When color was needed, the painter would puncture the bladder with a tack; the puncture would be plugged up with the same tack or a piece of ivory or bone. Bladders, however, had some obvious disadvantages. They were awkward to handle, and the colors had a tendency to deteriorate and oxidize once the container was punctured. There were many attempts to improve the bladders themselves; there were brass syringes and glass syringes, the latter patented in 1840 by William Winsor who had established his color business eight years earlier.

But the most significant invention, the one to have the greatest impact, was made public in the following year. In March 1841, John G. Rand (1801–1873), an American portrait painter, was granted a British patent for "Improvements in Preserving Paints and other Fluids." He had invented "metallic collapsible tubes for oil colours" which are still used today. Rand was living in London at the time, but he was born in Bedford, New Hampshire. Although he was trained for cabinetmaking, he became a painter, primarily self-taught. He had some help from Samuel Morse and Chester Harding, and mild success as a portraitist in Boston and Charleston, South Carolina. He moved to New York in 1833, and from there to London a few years later, where he continued as a portrait painter of the nobility. The circumstances surrounding his development of the collapsible tin tube are unknown, but it was instantly recognized as the solution to the problem of containers for oil colors, and Rand became a rich man. John Rand was one of very few artists to develop an idea that had an immediate and direct benefit to his own profession, and although collapsible metal tubes had a wide effect on the packaging of many commodities, the very first were made specifically for artists; they were made of tin, an inert metal that would not react chemically with any of the pigments used. Collapsible tubes made outdoor painting much easier, and their use was an especially important

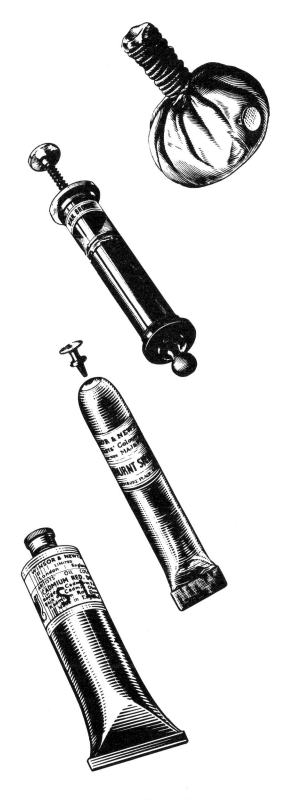

Pigskin bladder; glass syringe;
early collapsible metal tube;
type of tube in use since 1940
(*photographs courtesy of Winsor and Newton, Ltd.*)

27

development for the impressionists, who worked from start to finish on a landscape painting entirely out-of-doors, and did not, as was the custom of the Barbizon School, bring the picture back to the studio for "finishing."

In any case, the definition of the word "finish" as applied to a painting was undergoing a radical change in the latter half of the nineteenth century. The idea of a "finished" look was alien to the impressionist painter; the polished and gleaming surfaces so dear to the academicians and to the public of the time were not for him. To the impressionist, the work was finished, no matter how casual the execution, when the idea was completely realized on the canvas. For the most part, this development came about as a result of his working methods; and in part as a result of the invention of photography.

Photography burst into the artist's studio with the invention of the daguerreotype by the realist painter Louis Daguerre in 1839, coincidentally the same year in which Eugène Chevreul published his famous book on color theory. From the beginning, artists recognized both the value as well as the threat of the new invention. It was felt that the precise and realistic images that the camera produced would be invaluable for study; no artist could ever reproduce that kind of detail. Samuel Morse subscribed to this point of view, and so did Delacroix. Certain of Corot's landscapes were affected by the photographic vision. Of course, photography hurt the portrait painter's trade. Renoir once remarked that it "freed painting from a lot of tiresome chores, starting with family portraits." It also released the painter from the need to paint naturalistically, and gave added impetus to the direction of a free and more broadly brushed type of execution, a direction, however, in which many artists were going anyway. The effect of spontaneity, and immediacy, the catching of a fleeting moment in time, that peculiar "slice of life" imagery of the photograph was of great interest to the impressionists. They used photographs as source material more than is generally thought. The painting of Degas is the obvious example. His figures were often caught in awkward positions and sometimes cut off by the edge of the picture, compositional devices similar to the casual attitudes of the subjects caught by the camera's eye. By breaking away from the older concepts of placing figures in idealized poses or arrangements, Degas charged his images with the flavor of actuality; he not only enhanced the feeling of life, but he created a feeling of continuous action which the classical unity of academic painting did not do. The American impressionist Theodore Robinson depended a great deal on photographs to provide him with important elements of his compositions, reasoning that "the camera helps to retain the picture in your mind"; and one of his own photographs was used as the basis for painting *Two in a Boat*. In the painting he eliminated one of the boats and the tree branch, both in the upper right of the photograph.

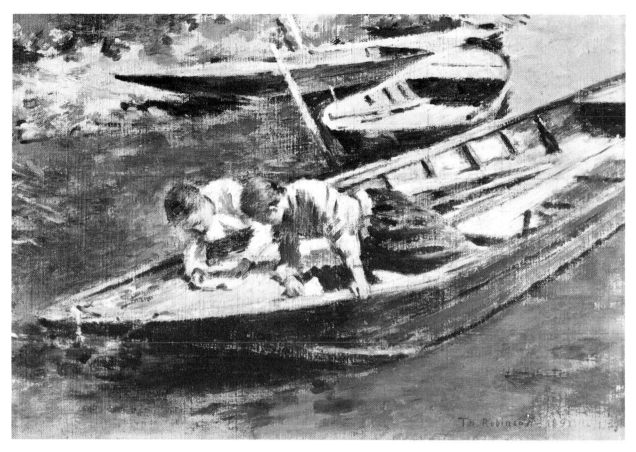

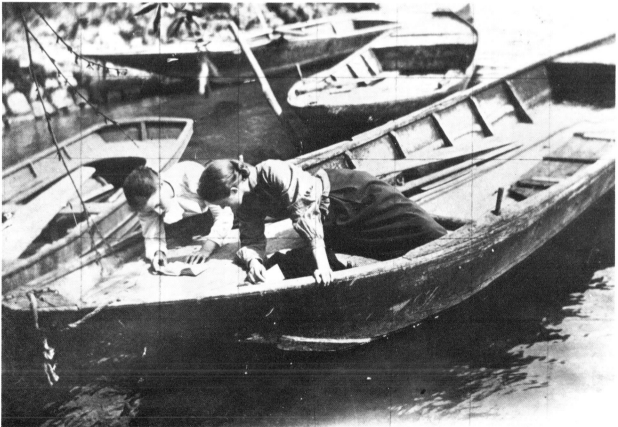

Thus technology was woven into the very fabric of the impressionist style, and technology injects an aspect of dynamism, a feeling of speed and change which Arnold Hauser, in *The Social History of Art,* contends is expressed in impressionism, signifying one of the most important turning points in the history of European art. He stresses the dominion of the moment; that reality is not a constant, but constantly in a state of becoming. In other words, a Darwinian concept of evolution, of change, began to replace the notion of a fixed and orderly universe.

Toward the middle of the nineteenth century, however, there appeared to be a dual emphasis in the painting of both European and American landscape. On one hand there was a feeling for the forces of nature and an increasing concern for light and atmosphere as part of this feeling. On the other hand, the form of their work seemed also to indicate an emphasis on permanence, stability, and order as expressed in the use of the fixed and monumental elements of nature, such as mountains, rocks, huge old trees. These elements were combined in such a way as to give weight, stability, and balance to their compositions, which remained classically ordered units in time and space. They were painted tonally, based upon the values of greens, browns, and grays, and the forms were modeled in light and shade to produce an illusion of depth. Impressionism replaced the fixed elements of Barbizon painting with those representing change and movement, as expressed in the use of clouds, wind, the shifting atmosphere, and of course,

WINSLOW HOMER
In the Mountains (1877) 24 x 37^{15}⁄$_{16}$ inches
The Brooklyn Museum

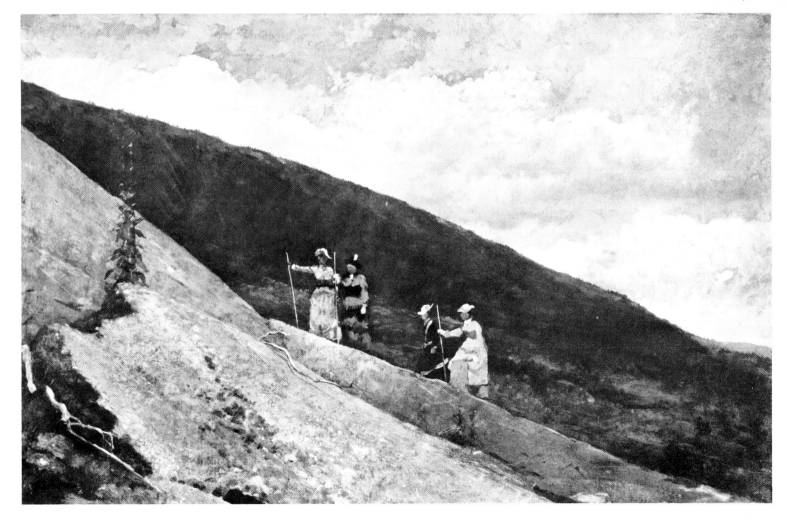

the vibrancy of light. Impressionism deals with a pictorial rendering of these elements through the medium of atmosphere filled with an overall light. The impressionist uses a quick, nervous brush stroke, creating a fabric of broken color that forms a unity of object, light, and atmosphere, and a greater cohesion and emphasis on the picture plane. There was a reduction of tonal gradations which led to a reduction of modeling; hue replaced tone in expressive importance. In this the impressionist also drew inspiration from Japanese woodcut prints which found their way to Paris in the early 1860s.

But the most important technical difference between the impressionist and the Barbizon school (and needless to say, the Salon painting of the time) was a chromatic one. The impressionists reveled in freedom of color, a new use of new colors. They replaced theoretical knowledge by optical experience, thereby implying an expansion of sensual perception, a new sharpening of sensibility. Gone were the murky shadows, the "brown sauce," and in their place vibrant color shone from the canvas. Shadows were blue or violet; and sunlight was chrome or cadmium, and it was everywhere. This was a new way of painting that required a new way of seeing.

They rejected the popular anecdotal or story-telling painting, the contrived subject-picture, and instead painted the everyday life around them. It was optimistic painting. And it was pleasant and charming, this world of light and atmosphere. They painted the "smiling aspects" of life in what seems the golden age of the nineteenth century in which Paris was the unquestioned center of artistic life. Little by little, French impressionism prospered. By the 1880s, it was somewhat more acceptable, and by the '90s it was almost fashionable. In the meantime, the style had spread on the Continent and to the United States. In Italy, there were Mancini and Segantini; in Spain, there was Sorolla; and in Belgium, there was Alfred Stevens who was to be an influence on William Merritt Chase. In England, George Clousen and Wilson Steer were practitioners of the new painting; as was Walter Sickert, a pupil of Whistler and friend of Degas. In Germany, Max Liebermann and Lovis Corinth pursued "the fleeting loveliness of an instant." In the United States, John La Farge (as early as the '60s) and Winslow Homer studied the effects of light and atmosphere; and among the Americans in Europe there was Mary Cassatt. Mary Cassatt sat at the feet of Degas and exhibited in impressionist exhibitions from the '70s. In the late '80s, Theodore Robinson lived in Giverny, and was an informal pupil of Monet's.

This then was the background, and the basis of the style that the Americans brought back from Paris in the '80s. However, there was a certain amount of groundwork done by earlier American painters working in a native tradition; by exhibitions of French impressionism in America; and by American collectors who were among the first anywhere to appreciate and buy French impressionist paintings.

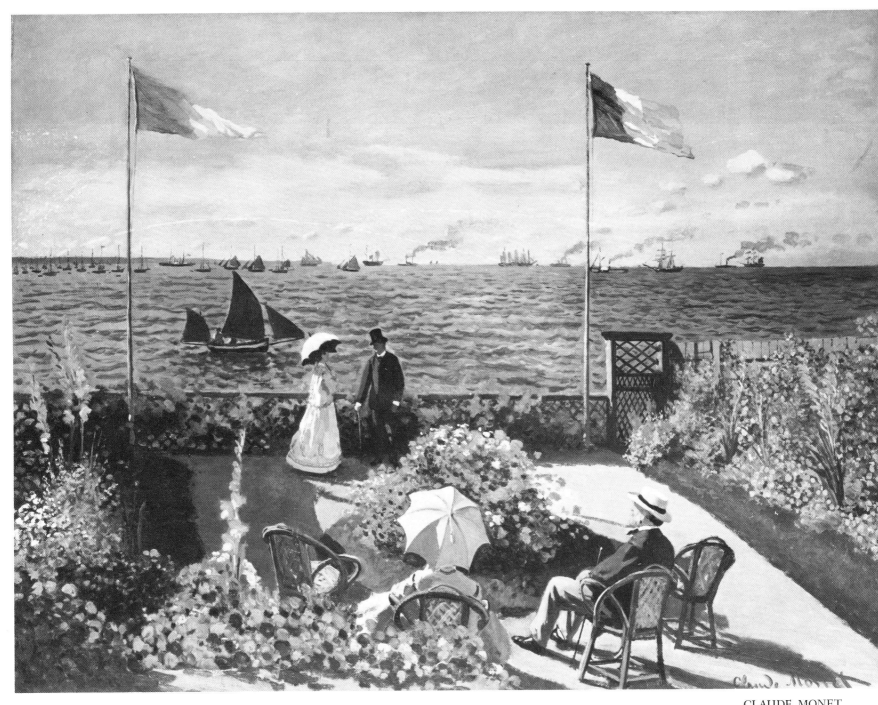

CLAUDE MONET
Terrace at Sainte Adresse
38½ x 51 inches
The Metropolitan Museum of Art

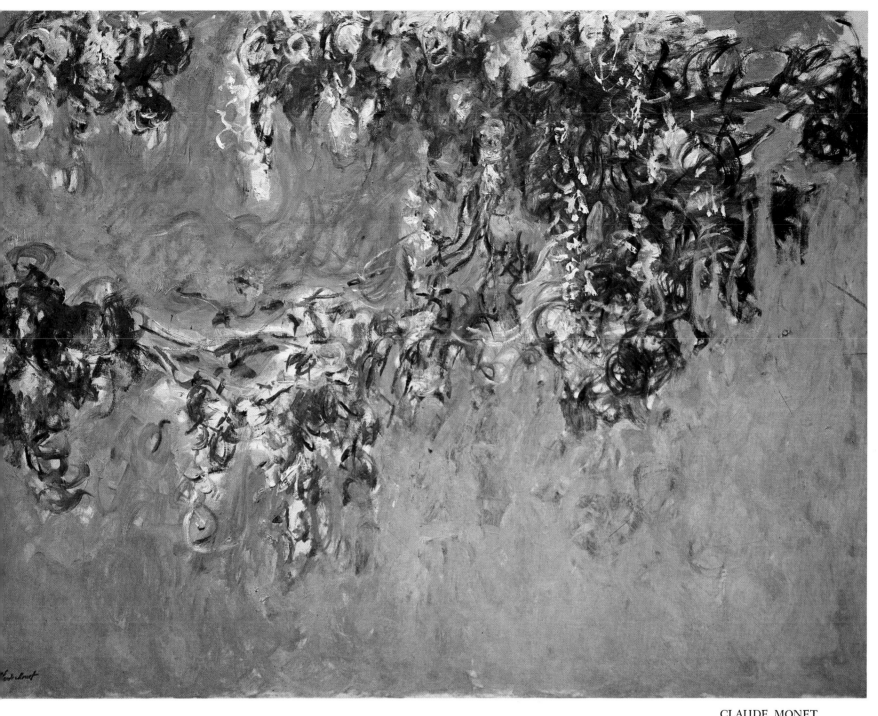

CLAUDE MONET
Wisteria (circa 1918–1920) 59⅛ x 78⅞ inches
Allen Memorial Art Museum
Oberlin College, Oberlin, Ohio

33

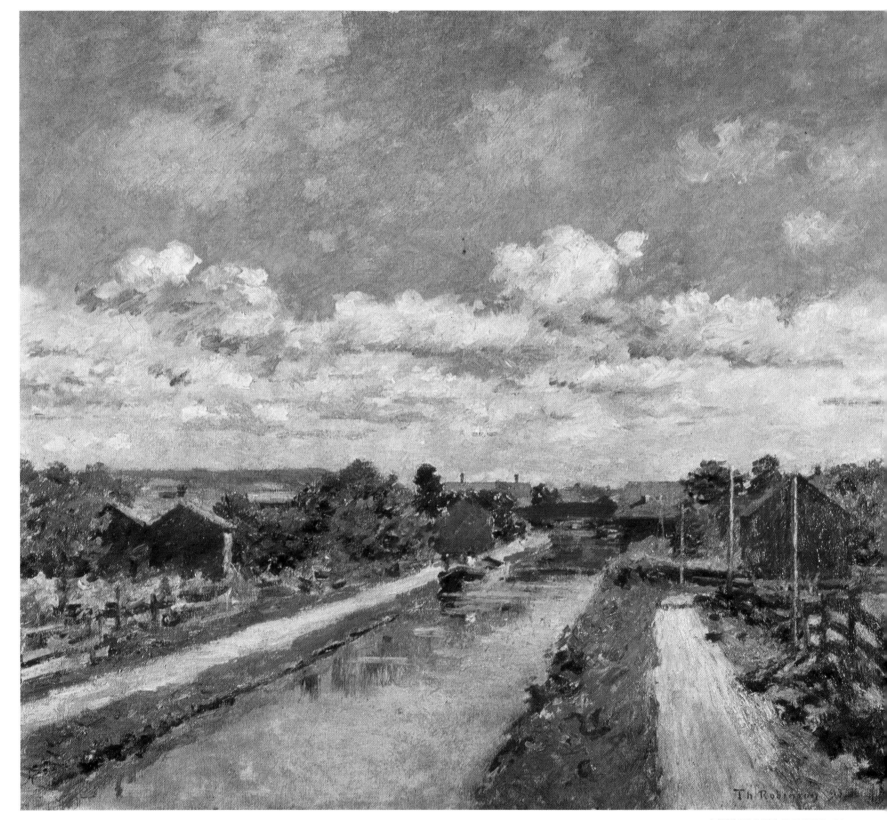

THEODORE ROBINSON
Port Ben, Delaware and Hudson Canal (1893)
30½ x 34¾ inches
Pennsylvania Academy of the Fine Arts, Philadelphia

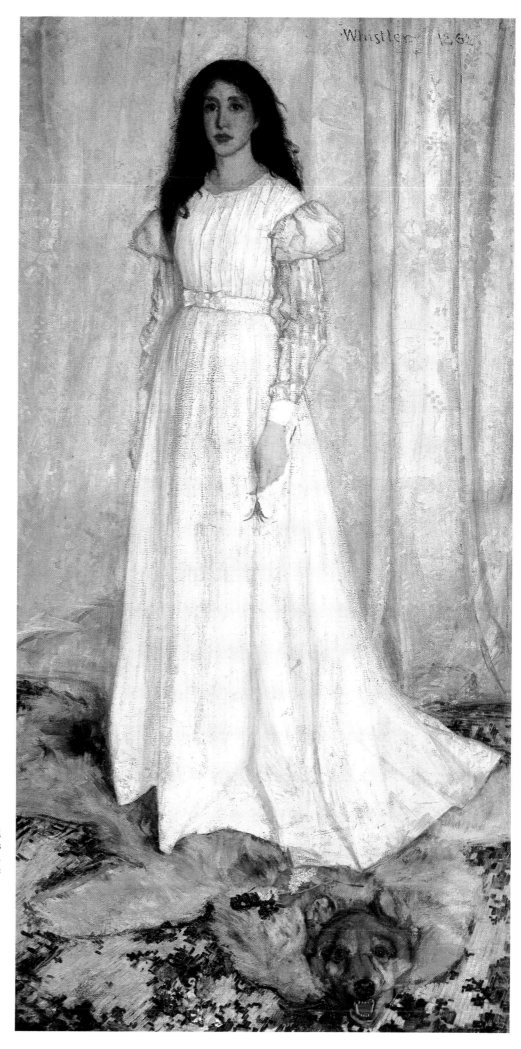

JAMES McNEILL WHISTLER
White Girl (1892) 84½ x 42½ inches
National Gallery of Art, Washington, D.C.
Harris Whittemore Collection

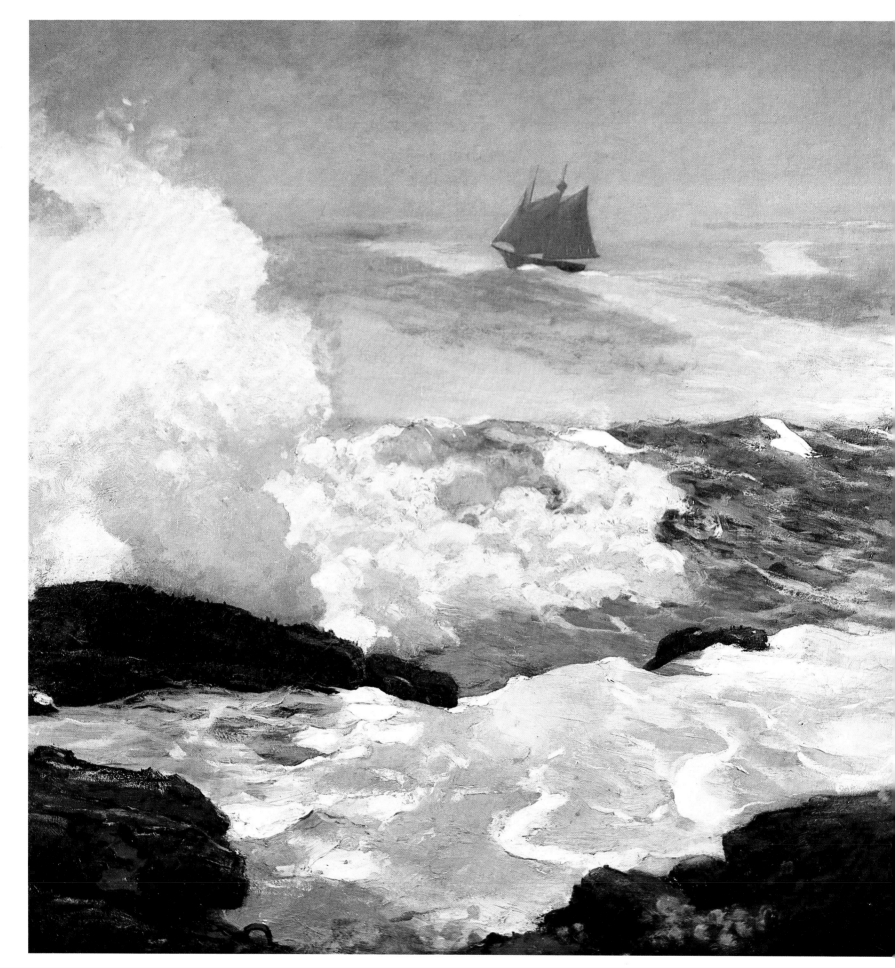

WINSLOW HOMER
On a Lee Shore (circa 1900) 39 x 39 inches
Museum of Art
Rhode Island School of Design, Providence

facing page:
JOHN LA FARGE
Bishop Berkeley's Rock, Newport (186
30¼ x 25¼ inc
The Metropolitan Museum of Art, New Yo
Gift of Frank Jewett Matthew, Jr., 19

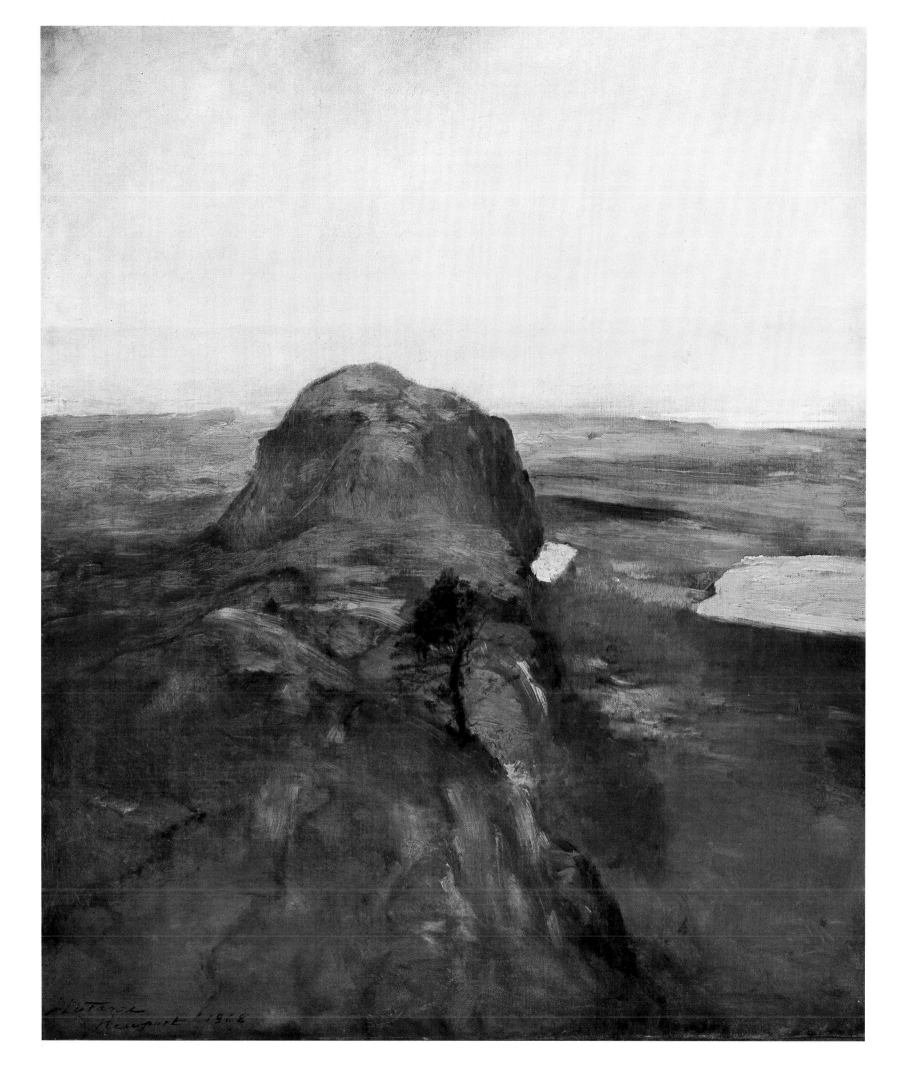

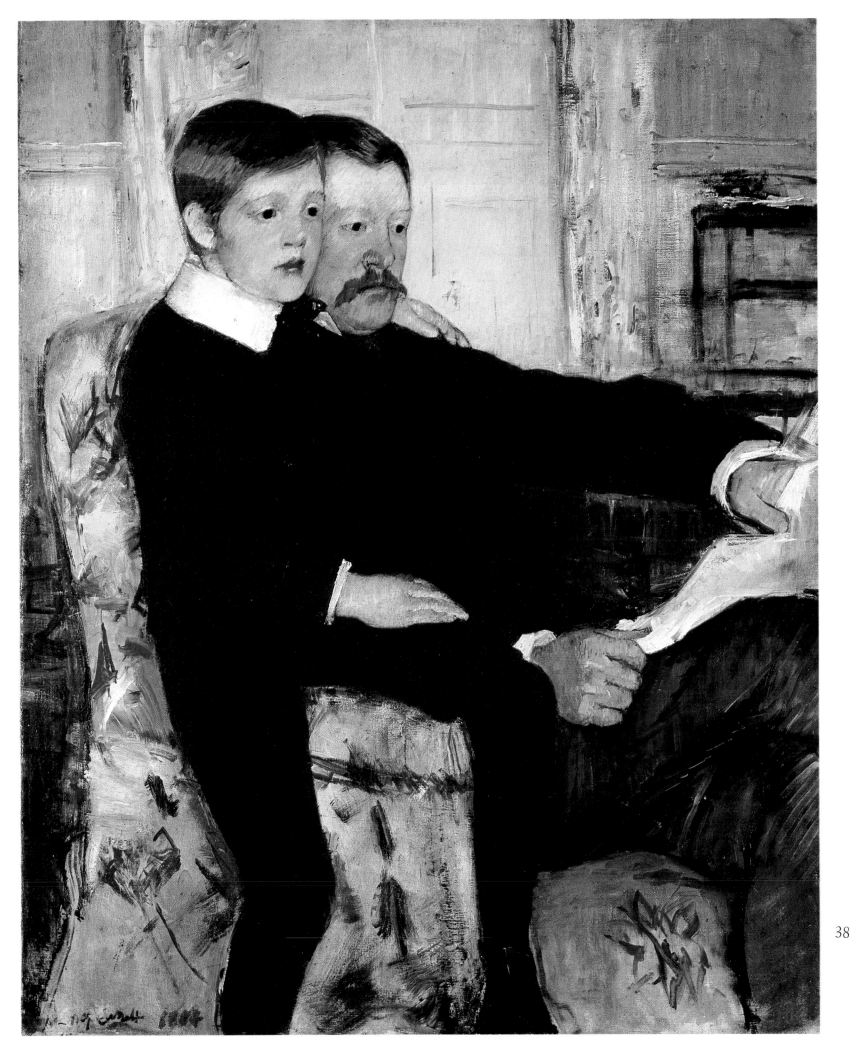

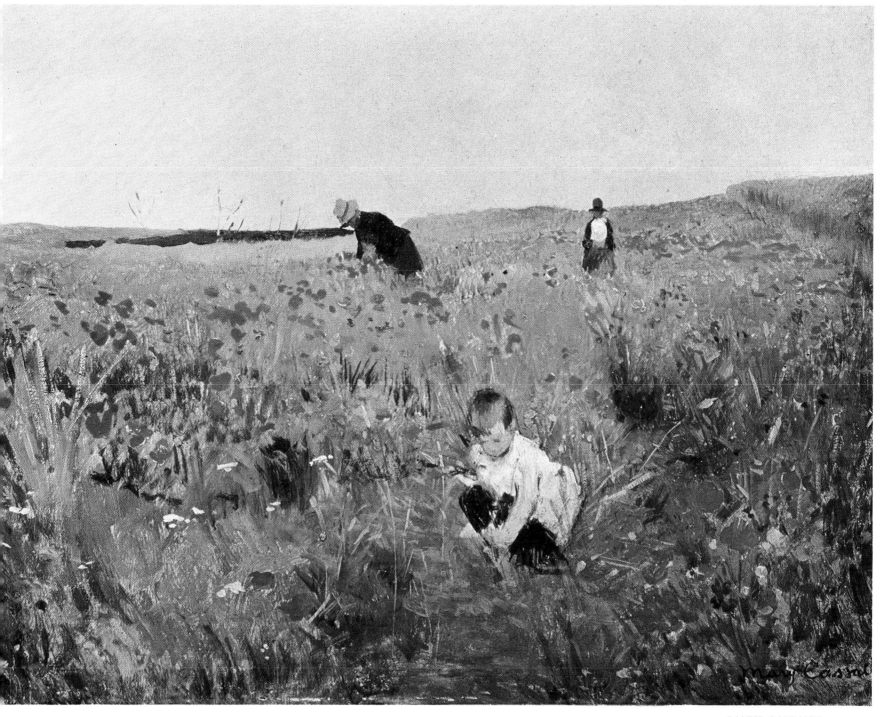

MARY CASSATT
Picking Flowers in a Field (circa 1875) 10½ x 13⅝ inches
Collection of Mrs. William Coxe Wright, St. Davids, Pa.

facing page:

MARY CASSATT
Portrait of Mr. Alexander Cassatt and Son Robert Kelso
(1884) 39½ x 32 inches
Philadelphia Museum of Art
Gift of Mr. and Mrs. William Coxe Wright

39

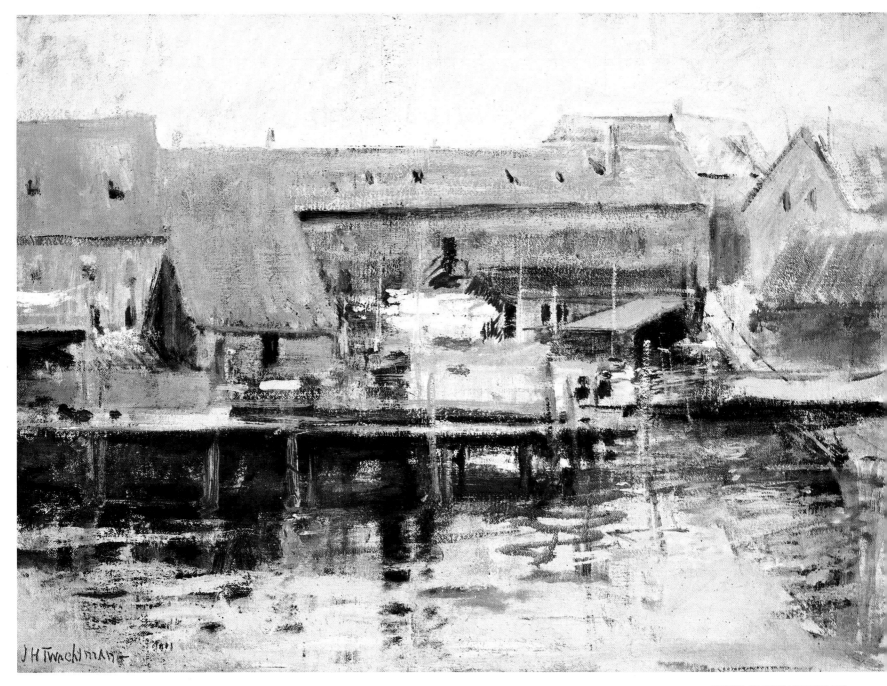

JOHN H. TWACHTMAN
Fishing Boats at Gloucester. 25 x 30 inches
National Collection of Fine Arts
Smithsonian Institution, Washington, D.C.

PART TWO

The American Background

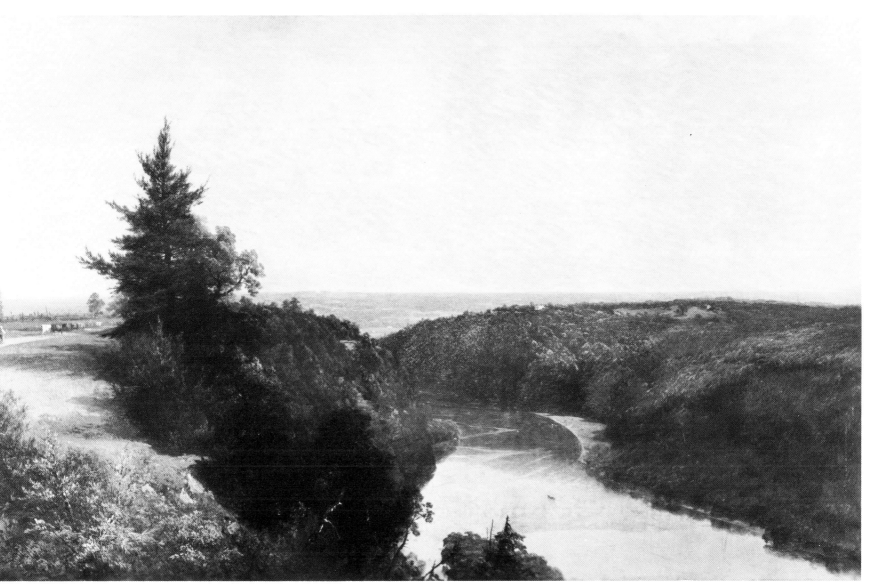

JOHN F. KENSETT
High Bank, Genesee River (1857) 30½ x 49¼ inches
The Corcoran Gallery of Art, Washington, D.C.

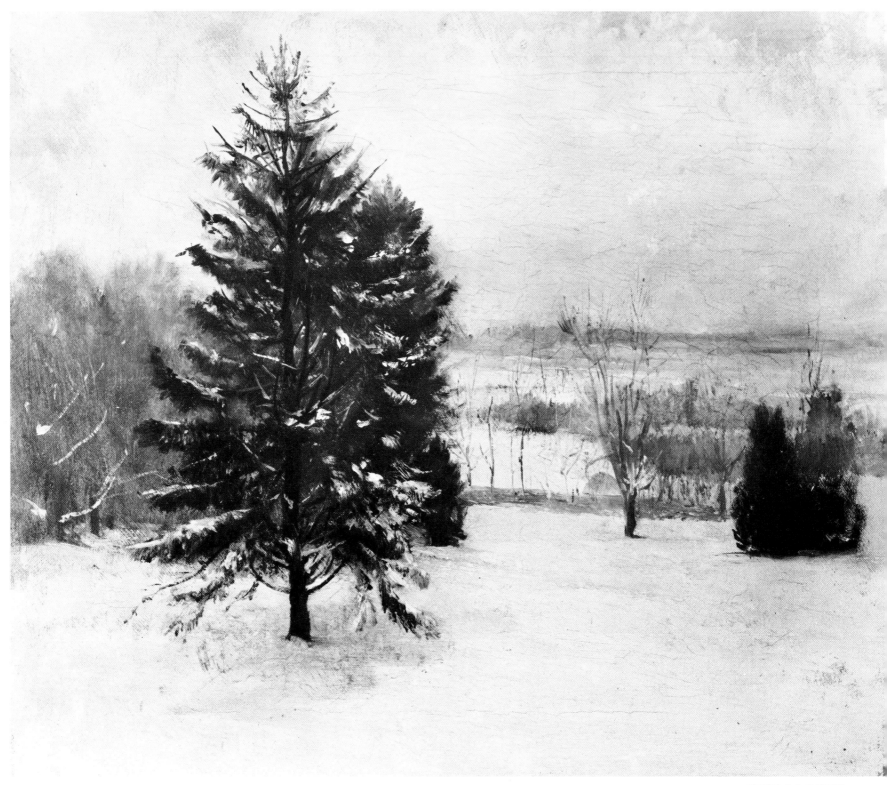

JOHN LA FARGE
Winter Landscape (circa 1867) 11½ x 13½ inches
Kennedy Galleries, Inc., New York

CHAPTER III

"The history of American art should perhaps be written not only in terms of style and personalities, but with a recognition of the immense changes that have been occasioned by political, social and economic factors."

DENYS SUTTON

There is no doubt that impressionism was a French innovation; and the final realization of the style was the result of a tradition and an evolution in French painting dating back, perhaps, to the seventeenth century. When it was exported in the 1880s and became international in scope, impressionist practice was, in a sense, grafted on to whatever mode of painting was prevalent in the country of its adoption; and modified, of course, according to the local artistic, philosophical, and social background. Although American art is obviously part of the western European artistic tradition, there exists in it an attitude of ambivalence toward the culture of Europe, ranging from the cultural colonialism of the Eastern Seaboard in the eighteenth century, to the optimistic chauvinism of the young nation in the mid-nineteenth century; from the total embrace of things European after the American Civil War, and particularly after the famous Philadelphia Centennial of 1876, to the isolationism of the 1930s with its emphasis on a "true" national style as interpreted by the painters of the American scene. Of the colonies, and later the young Republic, James Jackson Jarves wrote in *The Art Idea* of 1864, there were "no state collections to guide a growing taste; no caste of persons of whom fashion demands encouragement to art growth; no ancestral homes, replete with storied portraiture of the past; no legendary lore more dignified than forest or savage life." There was no legendary or allegorical painting of course, and painting of historical events had no real place in early America; in addition, the prevailing Puritan attitude opposed everything except portrait painting.

From the beginning, as America developed from colony to nation, it evolved into an open society, and industry soon made it the first modern one. However, the same forces leading to the industrial revolution served to work against the establishment of an artistic tradition as it was known and practiced in Europe. Americans, engaged necessarily in more pressing matters, did not have the time to support anything so unprofitable as the fine arts. The American artist had to absorb, for the most part, the major stylistic changes in the history of art by himself. What he absorbed was modified by a confrontation with his environment, which, from the first, was a vast, unknown, and untamed wilderness, that "Wilder Image." Yet the landscape could not be treated for its own sake, it had to be justified on moral or religious grounds. In the early nineteenth century, this justification was found in the theory that the unspoiled American landscape was a special gift

43

from God to the new American Adam. Paintings of the wilderness were considered to be reproductions of God's handiwork; and to contemplate them was morally "uplifting" and spiritually ennobling. Landscape painting in America became the dominant form of visual expression in the nineteenth century, and the major outlet for the romantic sensibility. It also became the vehicle for resolving the contradiction and conflict between the prevailing moral or idealistic mood and the demand for a quiet observation of fact. This resolution is one of the major characteristics of American landscape painting from its origins in the work of Thomas Cole and the Hudson River School in the early 1820s, to John Twachtman and the American impressionists in the last quarter of the nineteenth century. A certain amount of idealism was always a part of American painting; but at the end of the century, idealism would turn into decoration, and the means of factual observation would be made to serve sentimental ends. But that was yet to come. Meanwhile, back in Eden, American artists reproduced God's handiwork and painted the unsullied and virginal forests; and the American public, wanting to believe, perhaps, in the chaste image of a green and agrarian republic, bought their pictures. The 1840s and '50s seem to have been an ideal time, a time when there was no apparent gulf between the painter and his public—American patrons were proud to buy American art.

The vision of America as the new Eden originated perhaps in the sixteenth and seventeenth centuries. Leo Marx, in *The Machine in the Garden*, makes a good case for the fact that the pastoral ideal, a yearning for a simple and unspoiled garden of peace and plenty, has been a part of the national imagination since the discovery of America and the early days of its colonization. Although dealing primarily with literature, some of his assumptions can be applied, to a certain extent, to the visual arts. There was the problem, for example, of how to rationalize industrial progress with the prevailing older image of a country of independent farmers. For the most part, the painters did not really try. They ignored the intrusion of the machine and concentrated on the isolated, lonely, often nostalgic, and always romantic aspects of nature. With some exceptions, the machine was not referred to, and again with exceptions, such as some of the urban scenes of Childe Hassam and A. C. Goodwin, the city itself was rarely used as subject matter until after 1900 with the advent of Robert Henri and William Glackens. The question of why American nineteenth-century artists did not consider industry or the city as proper subjects would make an interesting study in itself, and is outside the scope of this book. But from the beginning Americans have always felt an animosity toward the city. Nevertheless, with the growth of the population, the fulfillment of its needs, and the accumulation of worldly goods, the land was raped; Americans had their Eden, but needed to use it.

The serenity that characterized landscape painting was not to last very long, as the country was torn by the violence of the Civil War. The conflict

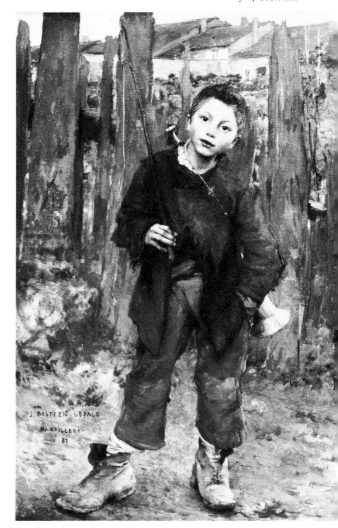

JULES BASTIEN-LEPAGE
PAS MÊCHE (Nothing Doing) (1881) 52 x 35 inches
National Gallery of Scotland

between the North and South was the first modern war, and the thrust of industrialism and economic change during and after the hostilities turned the United States into the first modern industrial state. By 1890, it had become one of the world's great manufacturing powers. The coming age of technology was revealed in the famous Philadelphia Centennial of 1876, symbolized by the immense Corliss engine which supplied the power for the whole exposition. As the public gazed in awe and wonder at the pistons of this remarkable engine, and as they watched the machines it supplied

with power make everything from carpets to shoes, they were watching the demise of the handicrafts industry, and, in fact, a way of life which at the very least would become deeply divided and rapidly transformed. The machine was in the garden then, or at least in Fairmont Park, Philadelphia.

The Centennial Exposition also symbolized a return to a cultural dependence on Europe. Exhibited in the main building were the products of thirty-six nations; and although the Japanese and the French had the biggest impact on the decorative arts in America, particularly on the Women's Art Movement which was organized in 1872, the general feeling was that since the United States had become a power in the world, she must exhibit the trappings of that power. The symbols of such status were to be found in Europe, and soon mock European palaces, topped with turrets, battlements, or the mansard roof, sprouted up on city streets and crawled on suburban lawns. Inside they were furnished with paintings and *objets d'art* ransacked from the galleries and estates of Europe in order to provide a gratifying aristocratic image for the new captains of commerce who had become rich quickly as a result of the terrific industrial expansion. Paintings were a badge of position rather than a means of enjoyment or "spiritual uplift." The public, therefore, came to think that works of art belonged in the houses of the rich or in the new museums being formed in the 1870s and '80s. Art was something removed from their lives—a way of thinking that still persists. A gulf was created between "official culture" and popular culture, and the American artist was caught in between. He had to fight for acceptance in a society that valued conspicuous wealth and ostentatious display. He was ignored because of an attitude favoring European chic, an attitude that began to take hold shortly before the Philadelphia Centennial of 1876 and endured through the World Columbian Exposition at Chicago in 1893. The old Emersonian self-reliance was gone, and Americans became increasingly confused and apologetic about their culture, causing Charles Eliot Norton to remark, "In America even the shadows are vulgar." No artist, whether painter, sculptor, writer, or philosopher, could entirely ignore the changed atmosphere around him. And in *The Education of Henry Adams,* Henry Adams calls attention to the transformation of life by "the mechanical development of power," to technology, impersonal and largely uncontrolled, acting upon human events. Some artists fled the "vulgar shadows" and took up a more leisurely residence in Europe.

However, many painters went abroad, not necessarily to escape from the crude materialism here, but to learn their trade and to absorb the new artistic movements. In 1864, James Jackson Jarves wrote, "We buy, borrow, adopt and adapt. For some time to come, Europe must do for us all what we are in too much of a hurry to do ourselves. It remains, then, for us to be as eclectic in our art as in the rest of our civilizations." American artists had always gone to Europe of course, but they did accelerate this travel in the 1870s

and '80s. To this younger generation who so eagerly flocked across the Atlantic to study, current painting of the American landscape must have seemed a dull and wornout form, and the picturesque chauvinism exhibited in the cineramic masterpieces of Bierstadt and Church was not for them. Yet there was a group of artists in America, in the years 1850 to about 1875, that was preoccupied with the study of light and atmosphere. These artists continued the American tradition of the serene and arcadian landscape, seeing in the study of light and its effects another source of wonder in the natural scheme of things. Although they were primarily tonal painters, their particular emphasis on light, and their personal, almost mystical rendering of its ambiance has given rise to the term *luminism* as a description of their style of painting. And they were influential. The luminists left their imprint upon painters as diverse as Inness, Eakins, Homer; and the style can be considered as a forerunner of American impressionism, a prelude to the full symphony of color that emerged in the late 1880s.

GEORGE INNESS
The Lackawanna Valley (1855) 33⅞ x 50¼ inches
National Gallery of Art, Washington, D.C.
Gift of Mrs. Huttleston Rogers, 1945

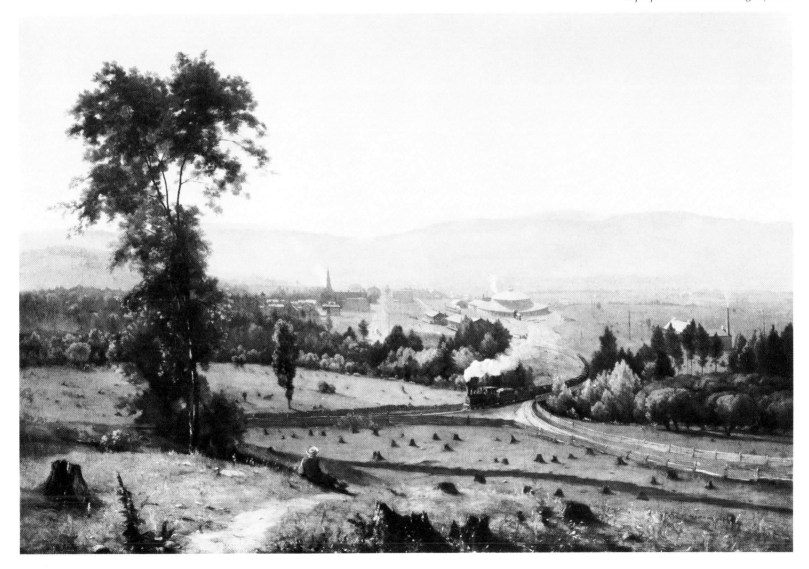

Luminism was an off-shoot of both the Hudson River School and the search to find a style that expressed the growing interest in the phenomenon of light, a phenomenon that was fascinating to painters all over the western world in the years after 1850. The luminist's approach—the lyrical expression of landscape under specific conditions of light and atmosphere—was similar to that of the French impressionists a decade or so later. The luminists, however, were not interested in broken brushwork or the disintegration of form. Within their general format of parallel bands of sky and water, dominated by a dramatic and visible source of light, they pushed the representation of light and atmosphere as far as the limits of their smoothly finished style allowed; and one of the limits of the style was an insistence on the integrity of objects, on the "quiet observation of fact." The origins of luminism lie in the landscapes of Thomas Cole and Asher B. Durand in the mid-1840s, as well as in some of the paintings of Mount and Bingham of the same period; but the artists most closely identified with the style are John Kensett (1816–1972) and Sanford Gifford (1823–1880), Fitz Hugh Lane (1804-1865) and Martin J. Heade (1819-1904).

(*see pages* 41, 50, 45)

Fitz Hugh Lane, whom Barbara Novak has called "a paradigm of Luminism," was a marine painter—and a good one. His draftsmanship was superb, his sense of tonal values, uncanny; and he understood the intricacies of naval architecture. Lane's art, however, is obviously more than ship portraiture. His best work is characterized by a feeling of solitude and calm, an eloquent silence that reaches beyond the limitations of subject matter and evokes the paintings of Jan Vermeer. In her book *American Painting of the Nineteenth Century,* Barbara Novak writes that Lane's art "is perhaps the closest parallel to Emerson's Transcendentalism that America produced."

Emerson's thinking seems to have permeated, in varying degrees of intensity, most mid-century American landscape painting. It affected Martin J. Heade, for instance, who produced a series of studies using haystacks as subject matter, studies in which the subject was seen each time in a different light, climate, atmosphere, and time of day. Heade's studies, painted in the 1860s, bear interesting comparisons with the same subject painted by Monet in the 1890s—comparisons that illuminate not only a difference in generations, but between two major styles of painting, both concerned with the representation of light.

This approach certainly had something in common with impressionism, and in particular Monet's treatment of the same theme in the '90s; but Monet's *Two Haystacks, Sunset* has a sense of immediacy, an emphasis on the surface of the canvas, and a freedom of color and handling which is absent in, for example, Heade's *Summer Showers.* Heade's picture is approached from a diametrically opposite point of view. The glowing sun dramatically illuminates his haystacks which are carefully placed in order to bring the eye *into* the picture, thereby creating the illusion of great distance.

(*see page* 15)

There is a concern for *lighting* in a theatrical sense, rather than a concern with color perceptions, or the unity of object, light, and atmosphere. The luminist technique evident in Heade's paintings—classical format of ordered formal relationships, the restrained handling and smoothness of surface—endows these pictures with an anonymous quality, a feeling that the presence of the artist's hand should not detract from the representation of one of nature's moods.

It is these qualities of anonymity and of mysticism in the presence of nature that appear to be the common denominator of all the luminist artists. Concurrent with that attitude was the rare appearance of man in their work; and when a figure is present, it is there to give a sense of scale and space to the landscape. And not only is man often absent, but his works as well. There is no hint, in any luminist painting, of the vast changes taking place in American society; no sign of the clamor and clang of industrial expansion, of the materialism of nineteenth-century America. The machine does not intrude into these landscapes, and as far as the luminists were concerned, it did not, in fact, even exist.

Luminism was an American style in subject and in attitude; and aspects of the style—the concern for light and atmosphere, for clarity of form, and a certain reticence of handling—became part of American impressionist prac-

MARTIN J. HEADE
Summer Showers (circa 1862–63) 13¼ x 26⅜ inches
The Brooklyn Museum
Dick S. Ramsey Fund

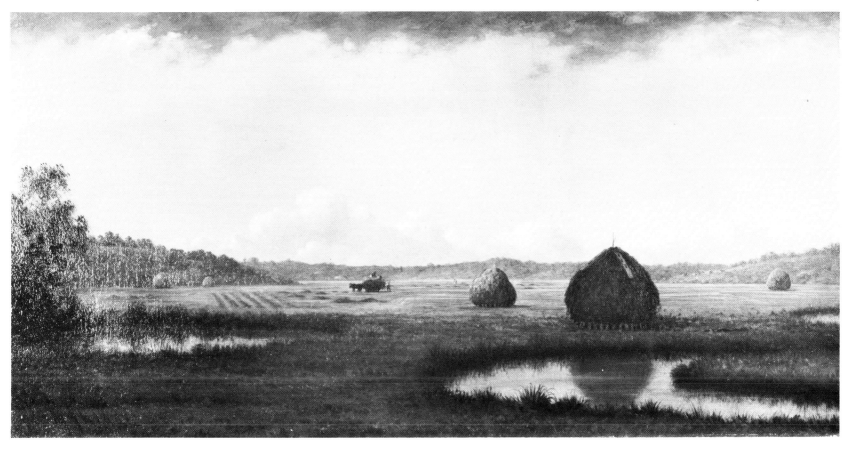

tice. In other respects, there was no smooth transition, no indigenous evolution from luminism to impressionism in America; in fact, there appears to be a sharp break in style in the 1870s and '80s as the younger generation returned from abroad, trained in European techniques and methods. Back they came, first brandishing the loaded brush of the Munich School, and finally bearing adaptations of impressionism itself. Yet when the new style reached these shores in the '80s, it received a better reception than anyone dared hope for, primarily because of the exhibitions of French impressionism in the United States, the collectors who bought examples of the new painting, and the dealers—or rather the *one* dealer who was responsible for promoting it here as well as in France: Paul Durand-Ruel.

SANFORD R. GIFFORD
Lake Nemi (1856–57) 40 x 60 inches
The Toledo Museum of Art
Gift of Florence Scott Libbey, 1957

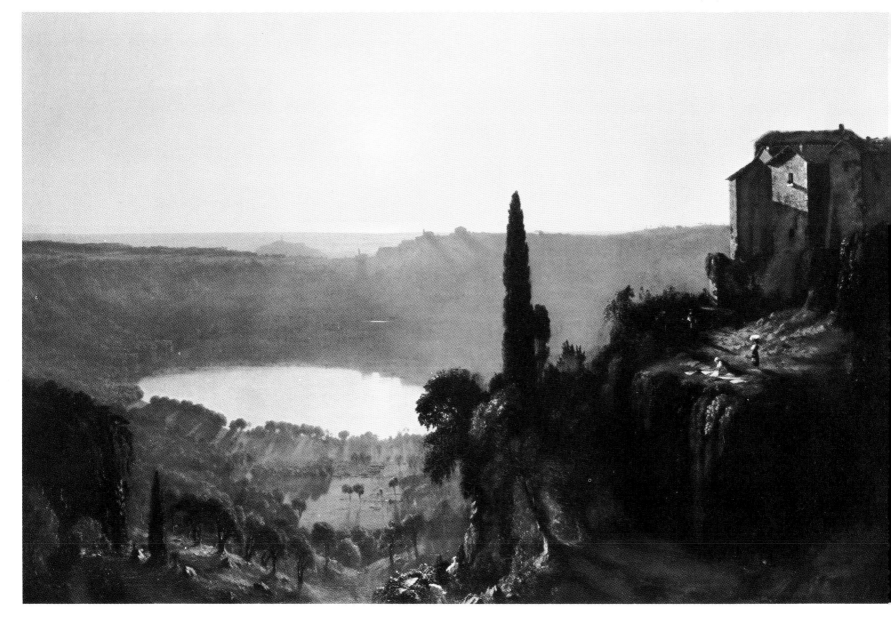

"Miss Cassatt was ever ready to recommend, Mr. Havemeyer to buy, and I to find a place for the pictures in our gallery."

LOUISINE W. HAVEMEYER

IN 1885, James F. Sutton, a former executive of Macy's and one of the founders of the American Art Association, asked Durand-Ruel (1831-1922) to put together an exhibition of French painting in New York. It was a momentous decision, and it came at exactly the right time for the noted art dealer whose fortunes were at their lowest ebb. In his memoirs, Durand-Ruel describes his difficulties, and the events that led to the organization of his impressionist exhibition in the United States: "Art which is in fashion always sells more easily than works by really great painters who are least understood by the public, in just the degree in which their art is more personal and original. I had unhappy experiences of this myself when I was struggling to launch my two important campaigns: the goal of the first was to establish the true value of works by the marvelous Barbizon School, while the second, on behalf of those artists known as the impressionists, cost me dearer still, in terms of terrible anguish and enormous financial losses." Durand-Ruel faced myriad difficulties and no way of overcoming them "without the happy circumstances which, late in 1885, put me in touch with the American Art Association of New York." Sutton together with Thomas Kirby, a former auctioneer, founded the association in 1877 in order to help younger artists. They started competitions and the prizes were underwritten by business friends in New York, Boston, Louisville, Chicago, and St. Louis. "One of the principals of this organization, brought to see me by a friend, was impressed by the importance and interest of my collections, which he felt would create a sensation in America. Thus we agreed that I would send to New York three hundred of my most beautiful paintings of the Impressionist School, to represent it in all its brilliance." The American Art Association paid all the expenses in connection with the exhibition in return for a simple sales commission which was a boon to Durand-Ruel. ". . . It would have been impossible for me to make the huge investment necessary for such a project."

Yet even with the agreement with the Art Association, it was a daring project for Durand-Ruel. It was a tremendous risk to take, particularly in the light of his experience with the impressionists in France; and as he sailed for New York in March of 1886 to arrange the exhibition in the Association's famous galleries, the suspense must have been awful. There was the frenzied activity usually associated with important exhibitions: details of transportation had to be arranged, a catalogue had to be prepared, and finally, the works had to be installed in time for the opening itself. Durand-Ruel must have been more than acutely sensitive to the demands of exhibition pro-

cedure, and certainly worried about the outcome of this particular venture; he was not only risking his own reputation, but his artists' as well.

Works in oil and pastel by the Impressionists of Paris opened on April 10th, 1886, a few days after Durand-Ruel's arrival in New York. It was a stunning exhibition. Of the three hundred pictures there were forty-eight by Monet, twenty-three by Degas, and seventeen by Manet; there were forty-two Pissarros, thirty-eight Renoirs, fifteen Sisleys, and three Seurats. In addition there were a number of canvases by Boudin, Caillebotte, Mary Cassatt, Forain, Guillaumin, and Berthe Morisot. The exhibition was a triumph, and New York had never seen anything like it. The press was generally favorable, and the attitude of the public was quite different from that of Europe. Luther Hamilton, in *Cosmopolitan,* called it, "one of the most important artistic events that ever took place in this country"; *The Home Journal,* the New York *Tribune, The Critic,* and *Art Age* all gave serious and thoughtful coverage to the show. Not everyone was enthusiastic of course, but as a whole, the reaction was surprisingly good. "The exhibition," Durand-Ruel wrote, "was an immense success, for reasons of curiosity, but, as opposed to what happened in Paris, it provoked neither uproar, nor abusive comment, arousing no protest whatsoever. The general public, as well as every amateur came, not to laugh, but to learn about these notorious paintings which had caused such a stir in Paris. Since I was almost as well known in the United States as in France as one of the first defenders of The Barbizon School, people flocked without reservation, to carefully examine works by my new friends." As the Art Association galleries had been reserved only for one month, the exhibition was moved to the vast galleries of the National Academy on 23rd Street and shown there for another month. Twenty-one pictures were added for the second half of the show; thirteen of these were loans from the avant-garde collectors of the time: Mary Cassatt's brother, A. J. Cassatt, Irwin Davis, and H. O. Havemeyer, to name just a few. In 1888, Durand-Ruel opened a gallery in New York, and in the following decades he helped form the American collections of French impressionist painting that eventually came to museums all over the country.

The man who was responsible for the success of impressionism in America was born in Paris on October 31, 1831. His father owned a stationery shop which also handled a complete line of artist's supplies, and like *père* Tanguy later on, he arranged with painters to take their work in lieu of payment for materials. In this way, Jean-Marie-Fortune Durand-Ruel began to collect works by Delacroix, Daumier, Géricault; and he was among the first to do so. However as the sale of works of this sort brought in little income, Paul Durand-Ruel's father existed on the proceeds from the rental of works of art, a practice, surprisingly, fairly common at the time. Paul Durand-Ruel was married in 1862, and a few years later his father died, leaving Paul in sole charge of the business. In 1870, war broke out, and Durand-Ruel shipped

his paintings to England just before the train lines were cut. He himself just managed to get out of France before the blockade of Paris.

It was while continuing his business in London that Durand-Ruel first met Monet in 1871. Daubigny introduced the two men, and Monet in turn introduced Durand-Ruel to Pissarro. So in 1871, he began buying the work of Pissarro and Monet, and in doing so, he unwittingly laid the groundwork for the turning point of his career, his New York triumph fifteen years later. When he returned to Paris after the war, he met Renoir, Sisley, and Degas; he first saw Manet's work in Alfred Stevens's studio, and subsequently, on one occasion, he bought twenty-three paintings by Manet. In 1876, two years after the first impressionist exhibition, Durand-Ruel held an exhibition of their work at his gallery in the rue Le Peletier. It was this exhibition which occasioned the abusive remarks by the critic Albert Wolff quoted earlier. "The rue Le Peletier has its troubles," he wrote. Indeed it did. Durand-Ruel sold not a single impressionist painting, and he began to lose some of his best clients as well. The financial crisis of 1873 did not help either, and the stock market crash of 1882 brought him to the verge of bankruptcy. Mary Cassatt tried to help, even lending him some money; but it was not until he was approached by the American Art Association with their offer to mount an exhibition of his artists, and the subsequent success of that exhibition in New York, that he was "able gradually to emerge from the financial uncertainty against which I had struggled for so long."

Up to the time of Durand-Ruel's impressive exhibition in 1886, there were very few opportunities in this country to see the new kind of painting. Mary Cassatt had exhibited three paintings in a show at the Department of Fine Arts of the Massachusetts Charitable Mechanics Association in 1878, and she received flattering notices; however, the first showing of a French impressionist picture in the United States came about under rather bizarre circumstances. In November 1879, a French singer, Madame Ambré, came to Boston for a singing engagement, and brought with her Manet's *Execution of the Emperor Maximilian*. Supposedly she was a friend of the artist, but as the painting had been banned by the Paris police as being politically inflammatory, Madame Ambré was obviously using that fact as a publicity gambit to promote herself. The picture was first exhibited in New York at the Clarendon Hotel, and in Boston at the Studio Building Gallery. Although the members of the press were wined, dined, and generally entertained, and although the New York correspondent of the Boston *Transcript* was fascinated by the painting, calling it "singularly powerful and striking in its originality," the picture had a poor reception. The press in general was not entirely unfavorable, but the whole affair was self-seeking, rather shoddy, and not calculated to foster appreciation of Manet.

The artist fared no better when, in 1833, two of his paintings, along with three Monets, three Renoirs, and six Pissarros, were sent by Durand-Ruel to

the "Foreign Exhibition" held at the Mechanics Building in Boston in September. The "Foreign Exhibition" was part of an international exhibition for art and industry, and although this would have been the first real chance for impressionism to have been seen in this country, their paintings were not even discussed. However, a much better opportunity for Americans to see impressionism came along shortly after the Boston show. In the fall of 1883, the Statue of Liberty was given to the United States by the French Government; and since a building was needed to function as a pedestal, a special benefit exhibition, held at the National Academy of Design, was organized to raise the necessary funds. The exhibition was officially opened by General Grant in December 1883, and was the most sensational event of the New York season. William Merritt Chase and Carroll Beckwith were responsible for its organization. They selected the artists well; ignoring the popular salon picture-makers of the day, they chose all the Barbizon painters, as well as a good selection of paintings by Géricault, Corot, and Courbet—and they chose works by the French impressionists. Chase made Manet and Degas the stars, building the whole show around Manet's *Boy with Sword* and *Lady with a Parrot,* two other Manets and Degas's *Little Ballet Girls in Pink.* It was a daring and brilliant conception, and only Chase could have managed it so successfully. Painter, teacher, tastemaker, bon vivant, and brilliant Bohemian, William Merritt Chase was well liked and his judgment respected. Chase succeeded, but not without a struggle of course. There were protests from members of the conservative camp, such as academicians, yet interest in the new style was created. The ground was prepared for the bigger, more important exhibition of impressionist painting three years later.

William Merritt Chase was not the only artist who influenced progressive collectors in this country. John Singer Sargent helped and so did J. Alden Weir. Sargent actively supported Claude Monet in his campaign to buy Manet's *Olympia* for the Louvre, and during the 1890s he went out of his way to introduce Monet to the English public. It was Weir who induced Irwin Davis, the New York collector, to buy Manet's *Boy with Sword* and *Lady with a Parrot,* two paintings Davis bequeathed to the Metropolitan Museum in 1889. However, it was "The Lady from Philadelphia" who exerted the most influence, who was the most tireless worker on behalf of her colleagues. Mary Cassatt not only bought paintings for herself and her family—she also tried, with a great deal of success, to interest her friends in the work of the impressionists. In 1873, one year before the first exhibition of impressionist painting, one of Degas's pastels was bought by Miss Louisine Waldron Elder, probably on the advice of Mary Cassatt. Louisine Waldron Elder was to become Mrs. H. O. Havemeyer, and the Havemeyers, with the guidance of Miss Cassatt, were to be highly influential on American collecting. The pages of Mrs. Havemeyer's *Memoirs,* which reveal the developing judgment and courage of one of the earliest American collectors of impres-

sionism, are filled with laudatory references to the taste and expertise of Mary Cassatt: "As the French say, Miss Cassatt had the 'flair' of an old hunter, and her experience had made her as patient as Job and as wise as Solomon in art matters."

Mary Cassatt introduced the Havemeyers to the work of the avant-garde artists of the day and often to the artists themselves. She interested the Havemeyers in the work of Courbet for instance, whose talent was not "revealed" to them until 1881—even at that late date the French themselves were still ignoring his work. The H. O. Havemeyers soon had over thirty Courbets in their collection. They collected the work of Degas from the start, but Manet's work took more time for them to appreciate. As a result, the Havemeyers lost *Boy with Sword* to Irwin Davis, but they made up for it by the rapidity with which they collected "many of his greatest works" including Manet's marvelous portrait of Clemenceau, still unfinished after forty sittings, which they bought from the statesman himself.

There were other collectors who had the courage to amass quite important collections of impressionist painting, and some of these also benefited from the advice and friendship of Mary Cassatt. In Boston, there were Mrs. J. Montgomery Sears and Thomas S. Perry and his wife Lilla who was herself a painter. Mrs. Sears, both a *grande dame* and a spiritualist, bought good examples of the new painting with the help of Mary Cassatt. The Perrys, on the other hand, went straight to the artists. Thomas Sergeant Perry, a direct descendant of Thomas Jefferson, was an intimate friend of the James family and of William Dean Howells. A writer, he received books for the *Atlantic* and other periodicals, and in 1877, he wrote a "slim volume" called *The Evolution of a Snob*. In the '80s and '90s, he published books on German and English eighteenth-century literature, and one on Greek literature. Then he stopped writing altogether. He became a dilettante (in the eighteenth-century meaning of that word) and an "appreciator." This outlook, along with that of his wife, whose own impressionist painting will be considered later, led him to Monet with whom they would form a lasting friendship. In 1889, the Perrys approached Monet directly in his Giverny studio. It was obvious that Claude Monet was the impressionist most popular and sought after by American collectors; his output was prolific, his personality was strong and commanding, and he was able to communicate a sense of excitement about the new painting. Mrs. Perry wrote years later in her *Reminiscences of Claude Monet,* "I had been greatly impressed by this (to me) new painter whose work had a clearness of vision and a fidelity to nature . . . I had never seen before. The man himself, with his rugged honesty, his disarming frankness, his warm and sensitive nature, was as impressive as his pictures."

Lilla Cabot Perry lost no time in proclaiming her "discovery" to her friends. "He was not then appreciated as he deserved to be, in fact that first summer I wrote to several friends and relatives in America to tell them that

here was a very great artist. . . . Only one person responded, and for him I bought a picture of *Etretat*. When I brought it home that autumn of 1889 (I think it was the first Monet ever seen in Boston), to my great astonishment hardly anyone liked it, the one exception being John La Farge." That John La Farge would have been sympathetic is no great surprise, for he had been working with many of the same painting ideas twenty years earlier and, of course, was still dealing with color and light in his stained-glass windows. And it does emphasize the fact that, despite a generally favorable press for Durand-Ruel's New York exhibit of 1886, public acceptance of impressionist painting was not as widespread as it was to become at the turn of the century.

Desmond Fitzgerald, a Bostonian by adoption, was another dedicated collector of works by the impressionists. He wrote a preface about the work of Monet for an exhibition of Monet, Pissarro, and Sisley held in Durand-Ruel's New York gallery in 1891. An unusual man, Fitzgerald was born in the Bahamas, the son of a British army officer. His mother was connected with the Browns of Rhode Island where he spent his early years. When he was twelve, he spent a year in Paris studying to be a sculptor, but that career was never realized. Later he became private secretary to General Burnside, then governor of Rhode Island; and still later he was chief engineer for the Boston and Albany Railroad, becoming in due course one of the leading engineers in the country. He soon made a fortune and started to collect modern French and American painting as well as oriental pottery.

Other influential collectors were Frank Thompson, James S. Inglis, who later became president of Cottier and Company, the well-known New York dealers, Cyrus J. Lawrence, and William H. Fuller, who arranged a one-man show of Monet's work at the New York Union League Club in 1891. A. W. Kingman collected Monets, as did James F. Sutton, president of the American Art Association, who, as was mentioned earlier, took the risk of putting on Durand-Ruel's impressionist show.

Little by little, the great American collections of impressionist painting were being formed. Such an important collection was that of Mrs. Berthe Honoré Palmer, the famous Mrs. Potter Palmer of Chicago. Mrs. Palmer was in charge of the Women's Art Building at the Columbian Exposition in 1893, and loaned several of her impressionist paintings to the special Loan Collection of Foreign Masters owned in the United States which was a part of that Exposition; she subsequently bequeathed her collection of impressionist pictures to the Art Institute of Chicago. Mary Cassatt's brother, A. J. Cassatt, also loaned paintings to the Loan Collection, as did Albert Spencer who sold his collection in 1888 in order to buy impressionist painting.

Americans were collecting advanced art during the very period when the French government rejected the famous Caillebotte bequest of impressionist paintings as well as a sizeable number of Toulouse-Lautrecs offered to the state by the family of the artist. In the meantime, French impressionism

prospered and increasing recognition came to a group of American painters who were influenced by those French artists whom Albert Wolff had called "a group of unfortunate creatures, afflicted with delusions of grandeur." Such painters as Hassam, Weir, Robinson, Dewing, and Cassatt, to name a few, found the public in general receptive to their work. And some of them in turn—Mary Cassatt, Sargent, Weir, and Chase—had already helped to foster an understanding of those modern French artists by whom they had been stimulated.

The influence of the paintings seen in the few but excellent exhibitions of French impressionist painting in America or acquired by far-sighted American collectors was largely inspirational. The direct technical and aesthetic influences on the American impressionists fall roughly into four areas: Monet; the *plein-air* painting of Bastien-Lepage's approach; the tradition of "quietism" in American landscape painting; and the works of Whistler.

Monet was of course the single most salient influence; but Monet was not "discovered" until the late '80s. Most Americans studied at the *Ecole des Beaux-Arts* or the *Académie Julian,* working under the leading Salon painters of the day. They studied with people like Gérôme, Bonnat, and Carolus-Duran, and most of all under Boulanger and Lefebvre, the chief critics at Julian's, where they received what they considered to be sound training in draftsmanship and pictorial composition. However, for those painters who wanted something other than the artificial atmosphere of the studios and the confections of the French academicians, or for those painters who wanted to be a bit more daring, yet were too conservative for the "lunatic" painting of the impressionists, Jules Bastien-Lepage (1848-1884) was the teacher for them. Bastien-Lepage was an important influence. His attempts to fuse sound and accurate draftsmanship with *plein-air* painting was an approach to the problem of form in landscape which would have appealed to the feeling for the "integrity of the object," the love of the factual in the nineteenth-century American painter.

(*see pages* 44, 75)

This concern for descriptive form, for the quiet observation of fact was inherent in the American landscape tradition itself, and that, as well as the strain of idealism, also inherent in the tradition, constituted, of course, another factor in the development of American impressionism. Aspects of the luminist style—a detachment and restraint; the feeling that the subject and the handling of it were held at arm's length—were carried over into the painting of the '80s and '90s. This restraint of handling and reticence of feeling evoked a certain kind of mood, a sentiment which has been labeled "quietism" or "tonalism." However, since tonalism implies a description of the technical process in which a painting depends for its effect on the use of tonal values, quietism is perhaps a better word to describe some of the muted color harmonies of the American version of the impressionist style. And although present in earlier American landscapes, its appearance in the midst

of the color explosions of impressionist painting was largely reinforced by the work of James McNeill Whistler.

Whistler's art seemed to reflect the mood and temper of the last quarter of the nineteenth century. He was a brilliant polemicist, and his defense of the artist's right to paint in his own way had its effect on his contemporaries. Not only his independent stand, and the quietism of his Nocturnes, but his idea of art as abstraction, his experiments in the use of white as a color and in the mediums of pastel and etching were to have a pervasive influence on the American artists of his day. Whistler then was a major influence—even on those painters who became major figures in the American impressionist movement. Along with Whistler there was a group of artists who can be considered "pre-impressionists," painters whose work was *impressionistic* rather than impressionist in style and represents a step toward the full development of the impressionist manner in this country. In the overall picture of impressionism in America, they appear to provide a kind of bridge between earlier landscape painting and the arrival of the new painting in the '80s.

facing page:

JOHN LA FARGE
Vase of Flowers (1864) 18½ x 14 inches
Museum of Fine Arts, Boston
Gift of Louise W. and Marian R. Case

JAMES McNEILL WHISTLER
Thames Nocturne (circa 1872) 18¾ x 30 inches
Art Association of Indianapolis, Herron Museum of Art
Gift of the Herron Museum Alliance

The Pre-Impressionists 1860=1885

"Many of its [the late nineteenth century's] most distinctive traits—its cosmopolitan inspirations, its exoticism, its cult of bohemianism and of art for art's sake—were established for English-speaking peoples by James A. McNeill Whistler." E. P. RICHARDSON

WHISTLER was probably the most famous of that trio of great expatriates: Whistler, Mary Cassatt, and John Singer Sargent. He painted in Paris, London, Venice, and he moved with ease through an international world of art which he helped to establish. Whistler was born in Lowell, Massachusetts, lived in Russia for six years, studied painting in Paris, and died in London, and although he never came back to the United States, he always considered himself an American. Yet, after his death and particularly after the Armory Show of 1913, his artistic reputation in this country suffered. The qualities for which Whistler was originally admired— his subtlety and understatement, his muted color, the elegance and fastidiousness of his taste—came to be ignored in favor of a more immediate and direct approach to painting. His work was considered too "tasteful," and his conception of art as abstraction was often overlooked. Today the assessment of his art is better balanced, and there is a renewed interest not only in his work but also in his wide sphere of influence.

James Abbott McNeill Whistler was involved in the advanced art movement of his time; in some respects he went beyond it. Although he was a contemporary of the impressionists and was in sympathy with their aims, his mature art has more in common with the work of the post-impressionists than with that of Monet and his friends. His late work in many ways is closer to that of Vuillard, Eugene Carrière, and even Gauguin and Maurice Prendergast, than to anything Pissarro or Sisley ever painted.

In 1854, Whistler was expelled from West Point where he had studied drawing under Robert Weir, the father of J. Alden Weir. From 1854 to 1855, he spent part of his time working in the drawing division of the United States Coastal Survey in Washington where he was employed as a draftsman, etching maps and topographical plans. He was twenty-two then, and he decided to become an artist. Accordingly he set out for Paris, arriving there in 1855, in the same year as Pissarro. Whistler entered Gleyre's studio, and he copied old masters in the Louvre; but he did not do very much or work very hard. He was at once more responsive to the art found outside the Academy, especially to that of Gustave Courbet. In 1859, he moved to London, and although he crossed over to France frequently during the years

facing page:

JAMES McNEILL WHISTLER
Nocturne in Black and Gold: The Falling Rocket
(circa 1875) 23¾ x 18⅜ inches
Detroit Institute of Arts
The Dexter M. Ferry, Jr. Fund

immediately following, his early work of this period is actually closely related to the pre-Raphaelites; to that of Millais and Rossetti in particular. By the time Whistler made his appearance in London, both British artists were ahead of him in stressing the importance of formal qualities over subject matter, a principle that Whistler strongly espoused. In fact it became one of the cornerstones of his art, and he ultimately carried it much further than they; for example, the little watercolor *Southend Pier*, c. 1880, in its reduction to bare essentials, is a marvelous example of his stress on formal qualities, as is his earlier painting *The White Girl*.

(*see page* 16)

(*see page* 35)

In 1862, Whistler took a studio in Paris where he painted *The White Girl*, which was rejected by the Royal Academy in that year and by the Paris Salon of 1863. Instead it was exhibited, along with Manet's *Le déjeuner sur l'herbe*, in the *Salon des Refusés*. There it caused as much comment as Manet's picture. The public found it shocking and weird. The painters were divided in their opinions. Courbet, for example, hated it, but Millais thought it splendid. Millais would have liked it, of course, for it had more to do with the pre-Raphaelites than with the plodding realism of Courbet. And in *The White Girl*, Whistler began to move away from just that kind of realism. Yet despite its suggestive overtones, Whistler claimed that it was an exercise in pure painting, a study in subtle color harmony; and, for a later exhibition in 1872, he changed the title to *Symphony in White, No. 1*. Whistler was correct. The use of white as a color in itself was something that interested him, and his use of white in this picture is fascinating. It is subtle, yet there is a great deal of movement in it, movement in close harmony and movement approaching discord. It begins, for instance, with the cool white of the dress; warm shadows move toward the warmer white background drape, and the warm almost-beige white of the drape takes on a chalky yellow hue in the carpet until it finally emerges as yellow ochre in the bearskin rug. It is a well-orchestrated picture with pink-flesh color, repeated in the carpet, and the burnt-sienna color of the girl's hair providing the contrasting notes. Also the organization of its forms is no less considered. The folds of the dress repeated in the folds of the drapery on the right, the diagonal fold in the drapery on the left repeated in the diagonal bottom of the dress on the right, complete the thoroughly orchestrated effect.

Whistler began his series of paintings using the motif of the woman in white in 1861, and the problem continued to intrigue him. He later said of Canaletto that he "could paint a white building against a white cloud. That was enough to make any man great." To paint white against white was the problem; and others were fascinated by it as well, possibly through Whistler's influence. Both John La Farge, in *Flowers on a Window Ledge*, and John H. Twachtman, in *Winter Harmony*, worked with the idea, each in his own way. La Farge's picture, painted in the early 1860s, is closest to Whistler's in time, and close also in handling. The delicate linear approach, the tonal

(*see page* 90)

refinement in the passages from white to gray, the feeling of fragility were either influenced by, or at least parallel to, Whistler's work at that period. Actually there were a number of parallels in their respective careers. They both were almost contemporaries, they both shared a cosmopolitan background, and many of La Farge's ideas on the philosophy of art were close to those held by Whistler. On the other hand, although Twachtman's *Winter Harmony,* painted in the mid-1890s, shows a concern for the use of white as a color, and although its mood of hushed silence is close to some of Whistler's "Harmonies," it is not an arrangement of color and form for their own sake. Twachtman had a definite attitude toward the landscape as a subject, a romantic and philosophical attitude akin to that of the luminists. And in addition, the technique of *Winter Harmony* reveals the obvious influence of Monet as well. Thus Whistler's style did have its effect, even on those

JOHN H. TWACHTMAN
Winter Harmony. (circa 1900) 25¾ x 32 inches
National Gallery of Art, Washington, D.C.
Gift of the Avalon Foundation

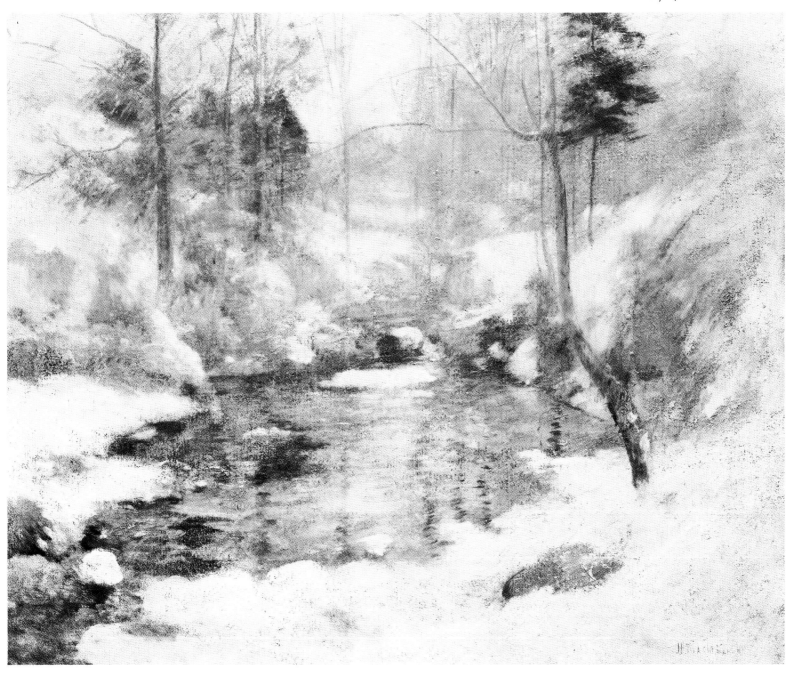

American painters who brought back from Europe the full panoply of French impressionist methods.

All through the 1860s, Whistler was trying to shape his art, to find a direction and perfect it. Japanese art showed him the way. His reaction to the art of the Orient was in part an attempt to break away from what he considered the baleful influence of Courbet, and in part a recognition of an art form which had a deep appeal to his own sense of elegance and perfection. The Japanese print, in its simplicity and boldness, its delicacy and strength, its new approach to pictorial construction, and its novel presentation of space, provided Whistler with the means to pursue his search for an art based upon "the science of color and picture pattern." And its decorative qualities were not lost on him either. He used some of the principles of Japanese art in the interior decoration of his house and in the installation of exhibitions, both of which were well in advance of their time. For his exhibitions he designed a simple space, creating what he considered a proper *setting* for the pictures. The walls were painted in a single color, usually

JAMES McNEILL WHISTLER
Courbet at Trouville, Harmony in Blue and Silver
(circa 1865) 19½ x 29¾ inches
Isabella Stewart Gardner Museum, Boston

pale yellow, and this color was carried throughout the room as the white was carried throughout the painting of *The White Girl*. The pictures were hung "on the line," that is, all on the same row at eye level, with plenty of space between each work—a startling idea for Victorian England.

However, like Monet's, Whistler's early response to the art of the East was to include various oriental objects and accoutrements in his pictures for their exotic appeal. In the mid-1860s, though, he began to incorporate some of its principles in his work. It is evident, for example, in *Courbet at Trouville—Harmony in Blue and Silver*. Whistler painted in Trouville, France, in 1865, together with Courbet, Daubigny, and Monet. The real subject of the picture is space; the two yachts in the distance and the figure of Courbet standing on the beach only serve to emphasize the oriental concept of space and distance.

From 1868 to 1878, Whistler concentrated on making his way in England, and by 1873, he had arrived at the kind of painting for which he would ultimately become famous. He painted portraits and "Nocturnes," and in 1874, he had his first one-man show. He was beginning to attract patronage, to acquire an audience. Then in 1877, Whistler exhibited *Nocturne in Black and Gold: The Falling Rocket* of circa 1874 at the opening exhibition of the Grosvenor Gallery. John Ruskin, in reviewing that show, was so incensed by Whistler's painting that he called him in print, "a coxcomb" and accused him of "wilful imposture." Whistler sued for libel and won—but the cost of the trial forced the artist into bankruptcy.

Nocturne in Black and Gold was inspired by a fireworks display at Cremorne Gardens, a famous pleasure resort. This painting is extraordinary and very daring. The subject was closely observed and exhibits, in its gradations of green to blue, the artist's superb mastery of subtle color harmonies. However, the spontaneous treatment of the fireworks themselves is reminiscent of the later work of Turner; and the painting could almost pass as an abstract expressionist work of the 1950s. It is no wonder that Ruskin was so upset.

After the trial Whistler moved to Venice to try to recover his financial losses by making a series of etchings of that city for the Fine Art Society, a London gallery. While there he produced not only a large number of etchings, but also watercolors, oil paintings, and numerous pastels for which he devised a new technique. In *Fishing Boats,* for instance, he employed only four colors: black and white, blue and yellow, on a special brown paper which in itself constituted a fifth color and unified the feathery touches of the others. The use of the brown paper was an idea of his own devising, and it allowed him to make a complete statement with the utmost economy of means. "Don't you like that brown paper as a background?" he asked Mrs. Havemeyer. "It has a value, hasn't it? But it sets the critics by the ears, you know they think I'm mad."

When Whistler returned to England from Venice, his attitude was bitter,

JAMES McNEILL WHISTLER
Fishing Boats. Pastel, 11⅝ x 7¹⁵⁄₁₆ inches
Cincinnati Art Museum
Bequest of Mary Hanna

and from the 1880s on he became an energetic pamphleteer and propagandist. In this period he wrote *Whistler vs. Ruskin: Art and Art Critics,* and *The Gentle Art of Making Enemies,* and gave the celebrated "Ten O'Clock Lecture." This was the period also when he had to seek patronage abroad, on the Continent and in America, where he was beginning to gain a reputation. American artists began to seek him out, and his friendship with most of them dates from this time. They were fascinated by his personality, his reputation, and naturally by his technique.

In his charming book *With Whistler in Venice,* Otto Bacher describes Whistler's method of painting. "His wonderful effects were generally reached by his delicate mixing and frank application. . . . In portrait work, he employed very long handled brushes, especially made for his use. The background for the sitter was generally a piece of cheese-cloth hung over a Japanese screen with the ends dangling to the floor. The canvas, with space large enough to allow a margin of a foot above and below the figure, was placed next to the model. Standing about fifteen or twenty feet from both, Whistler mixed his colors upon a table palette of his own design which he could move from place to place. . . . With a brushful of paint, he walked to the canvas, made a single stroke much as one would with a rapier. . . . Stroke after stroke he applied in this way until the picture satisfied him. . . . As a general rule, he never worked over a former brush stroke. 'Paint,' he said, 'should not be applied thick. It should be like a breath on the surface of a pane of glass.'" The lovely portrait of Mrs. F. R. Leyland, *Symphony in Flesh Color and Pink,* was painted in this way. Theodore Duret, the well-known art critic and connoisseur, who met Whistler in 1863 and remained friends with him until Whistler's death in 1903, also recounted his experience of sitting for him. "It was always his plan to make an 'arrangement,' and when that arrangement was completed in his head, he sought to realize it upon the canvas. In other words, he held that when a painting is completed it should speak for itself. This was one of the things that Whistler felt very strongly about."

Another thing Whistler felt very strongly about was the colors he used and their arrangement on his palette. His range of color was severely limited, but carefully considered, and as he put it, "scientifically" organized. He eschewed the bright palette of the impressionists, never using the cadmium colors; his brightest yellow, for example, was yellow ochre. Of greater importance, however, was the way in which he graded his main colors. In the yellow family he placed, in a descending scale from light to dark, yellow ochre, raw sienna, and raw umber; the red family, arranged in a similar way, was vermilion, venetian red, indian red; and in blue, cobalt blue and mineral blue. In moving from a higher to a lower passage of light, he would use the appropriate pigment from each group. This principle of grading each color family in corresponding steps made Whistler's palette, within its

JAMES McNEILL WHISTLER
Mrs. Leyland (1872–73) 77⅛ x 40¼ inches
The Frick Collection, New York

66

limited scope, an instrument of delicate precision; and as he pointed out to his students, his "apprentices" in Paris, he had learned to control this quiet group of colors "but someday we shall control the full orchestra."

From the time Whistler scored his first sensation with *The White Girl* in 1863, he became a figure to contend with, and in the 1880s he began to attract a number of followers; even Degas copied one of Whistler's sketches when he painted *Mlle Fiocre in the Ballet "La Source."* Many of his followers were students, of course, or "apprentices" as he liked to call them. In Britain, there were Walter Greaves and his brother Henry, neighbors of Whistler's in Chelsea, Mortimer Menpes and John Lavery, and Walter Sickert, who was the most important of Whistler's English pupils—in fact, he was a talented painter whose work deserves more attention in America. Of the Americans, there were Joseph Pennell, the irascible biographer of the artist, and Alson Clark, Lucia Mathews, Frederick Frieseke, and Leon Dabo, who were all students of Whistler in his Paris school which he formed in 1898. Dabo's style was more closely imitative than any of the others.

Even before Whistler opened his school there were few American painters studying in Europe in the 1870s and '80s who were not, in one way or another, affected by his art or by his ideas. Who, if any, of these artists could paint twilight or a gray day and not have it compared to Whistler's wonderful Nocturnes or Harmonies? Childe Hassam, in *Fifth Avenue Nocturne,* for example, clearly shows the influence of Whistler. Gradations of blue from dark to the middle tones of a foggy evening are complemented by the yellows in the street lamps and the reflections on the pavement. The use of the graduated tones combined with near complementary colors is similar to Whistler's *Falling Rocket,* and it is not only the use of (*see page* 60) the word "Nocturne" in the title of Hassam's picture, but the spirit, the mood, which is very much Whistler. This mood of Whistler's is evident also in some of Birge Harrison's paintings, and in *The Luxembourg Gardens at Twilight* by John Singer Sargent. The tonal harmonies and horizontal construction of Sargent's picture recall Whistler's *Cremorne Gardens, No. 2.* Some of Sargent's work in Venice in the early '80s also (*see page* 68) bears resemblances to Whistler's of the same period. The two men were both in Venice in 1880, and of course, as well-known expatriate artists living in London, the two knew each other. Sargent was an admirer of Whistler as he was of Monet, and through his connections in America, he tried to get Whistler one of the commissions for the Boston Public Library in 1892. Sargent also tried to buy the notorious Peacock Room for Mrs. Jack Gardner, but it went to Charles L. Freer instead, and is now in the Freer Gallery in Washington, D.C.

William Merritt Chase was one of the many artists who admired Whistler before they actually met. He first visited Whistler in 1885, and subsequently the two painted portraits of each other. Chase's painting, now in the Metro-

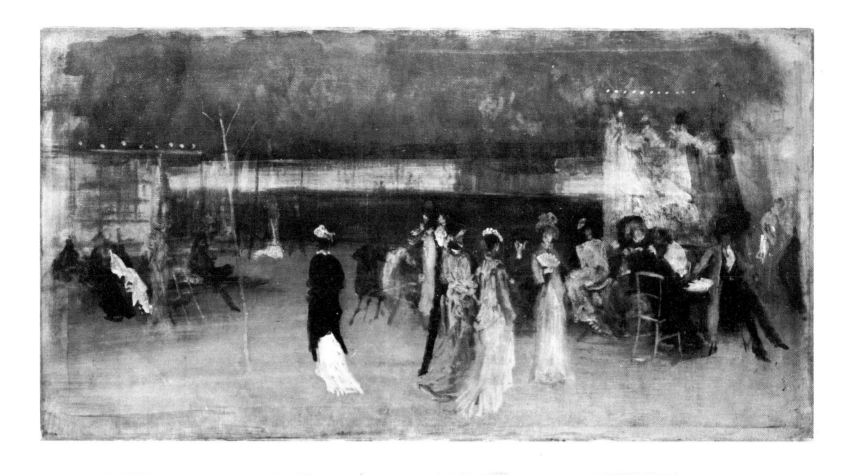

68

politan Museum of Art, captures the flamboyance of the famous expatriate, and is painted in Whistler's own style. Chase, always an eclectic artist, painted in a style reminiscent of Whistler at various stages of his career, when he felt the mood suited the subject. From portraits of his family in Japanese costume, such as the portrait of his daughter Alice, called *The Mirror*, to seascapes and harbor scenes, such as the one in the Cleveland Museum of Art, Chase paid homage to his great friend. He paid homage in other ways as well. He and J. Alden Weir tried to persuade the Metropolitan Museum to buy *The White Girl*, and during Chase's first visit, he arranged a sale of Whistler's etchings and loaned him the money to repossess *The Portrait of Carlyle* which Whistler had put up as security for a loan.

Whistler's ideas were pervasive in their influence on American artists. He

facing page:

JAMES McNEILL WHISTLER
Cremorne Gardens, No. 2 (circa 1875) 27 x 53⅛ inches
The Metropolitan Museum of Art, New York
Kennedy Fund, 1912

JOHN SINGER SARGENT
The Luxembourg Gardens at Twilight (circa 1879)
29 x 36½ inches
The Minneapolis Institute of Arts
Gift of the Martin B. Koon Memorial Collection

WILLIAM MERRITT CHASE
The Mirror (circa 1901) 36 x 29 inches
Cincinnati Art Museum

was an important member of the Aesthetic Movement which held that art is a way of life and that its standards should permeate everything—from painting and sculpture to manufactured goods, from dress to interior decoration—that art is important, a higher ideal. This point of view had a profound effect on the Detroit collector Charles Lang Freer, who was to become Whistler's principal American patron. Whistler's ideas and personality matched Freer's fastidious tastes, and he was influential in confirming Freer's idea that art was not a matter of individual objects, but was a whole way of life. Freer's house in Detroit is still standing, and although it is now used for other purposes, vestiges of its old elegance are discernible yet. It was the perfect setting for Freer's oriental *objets d'art,* for his collection of Whistler's paintings, and for the work of such painters as Dwight Tryon and Thomas W. Dewing, who were akin to Whistler in style. Freer felt that the work of Dewing was especially close to Whistler's, and in fact, Whistler and Vermeer were the two artists Dewing admired most. Dewing's *The Piano,* for

THOMAS DEWING
The Piano (1891) 20 x 26⁹⁄₁₆ inches
Freer Gallery of Art, Washington, D.C.

example, is charged with a Whistlerian ambiance as a result of the simplicity of the composition, the considered placement of the image, and the handling of large areas of abstract space.

Whistler has been the most widely discussed, publicized, and written-about artist in the annals of American art history; the portrait of his mother, next to the Mona Lisa, is probably the world's best-known painting. He was as famous (or infamous) for his wit and sarcasm, for his endless battles with art critics and a great many of his fellow artists, and for his promotion of modern art, as he was for his own painting—perhaps even more so. He was a flamboyant self-promoter as well. Concerned with developing the right "public image," he dressed for the part, and in the same way all of the time: a black frock-coat, white trousers, patent-leather shoes, top hat, a monocle, and he carried a long cane, his celebrated "wand." For himself, his appearance was part of the "joke of life." And in his own house he created a setting for *himself,* using gradations of yellow throughout, with notes of blue provided by his collection of porcelain carefully situated and placed. When Homer Martin and his wife visited Whistler in 1881, Mrs. Martin's "attention was riveted by the artist and his surroundings . . . the man grotesque as a caricature in attitude and aspect, the rooms all pale blue and lemon yellow, even to the many vases and the flowers therein contained." And in her memoirs, Mrs. H. O. Havemeyer has also left an account of Whistler's *mise en scène.* In the early 1880s, she wanted to buy something from Whistler, whose work she so admired; so, together with a friend, she presented herself at Whistler's door and was "immediately admitted into a room I shall never forget. Although we sat down, I do not recall any furniture in the room, not even chairs; I was so impressed with the lovely yellow light that seemed to envelope us and which began at the floor and mounted to the ceiling in the most harmonious gradations until you felt you were sitting in the soft glow of a June sunset. . . . Near the window stood a blue and white Hawthorne jar which held one or two sprays of long reedy grass, and in the center of the room there was a huge Japanese bronze vase. . . . Whistler entered almost immediately. . . . I gave a second glance and I was persuaded that Whistler had made that room as a background for himself." Mrs. Havemeyer bought five of his Venetian pastels, which she later presented to the artist's friend and patron Charles L. Freer.

This self-promotion of his, the theatricality, the dandyism, and the public belligerence, particularly after the Ruskin Trial of 1878, almost obscured his merit as a serious artist; yet in 1898, he opened a school in Paris, and in his last years he gave a lot of attention and kindness to younger artists. This is surprising, considering his ego—the ego of a man who once said, "As far as painting is concerned there is only Degas and myself." But as far as painting was concerned, Whistler was completely serious; in fact, besides himself, painting was the only thing he really cared about. Despite his flippancy and

wit, which were attributes of his public "image," he was a tireless worker. He was innovative and willing to take risks. As Otto Bacher observed of Whistler in Venice, "He rose early, worked strenuously, and retired late. He seemed to forget the ordinary hours for meals and would have to be called over and over again, unfinished work frequently being taken in hand just at this time."

Whistler made his mark, not only as a painter, but as an influence on his generation; and the delicate wings of his butterfly signature brushed not only his immediate circle of admirers, but such diverse talents as Sargent and Chase, Twachtman and Birge Harrison, Dewing and Hassam. The quietism of his style is close to that of the luminists—and certainly to the pre-impressionism of a Dwight Tryon or a Homer Martin.

WILLIAM MERRITT CHASE
Harbor Scene. 9¼ x 13⅜ inches
The Cleveland Museum of Art
Gift of Mrs. John B. Dempsey

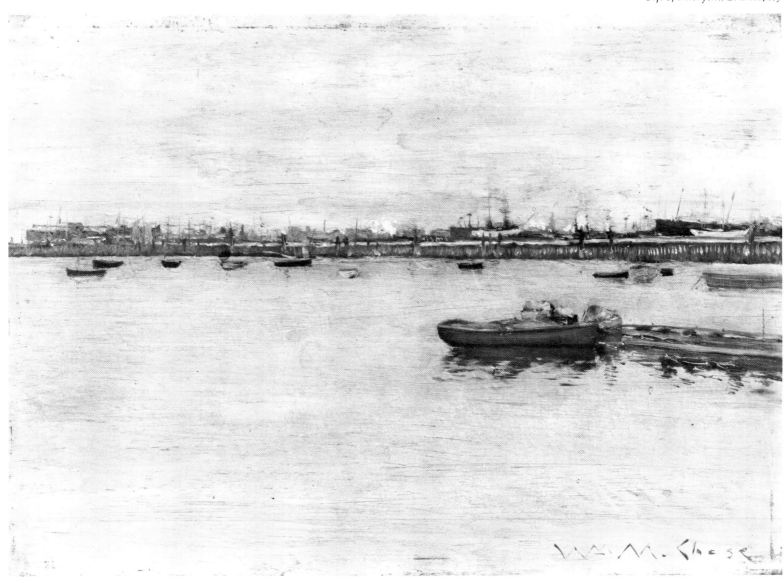

OVER the years American artists had been going to Europe to pursue their studies; and during that time, depending on the kind of training that was sought, as well as what was fashionable at the moment, various European cities became training grounds for American artists. London, Florence, Rome, Düsseldorf, Munich, and The Hague were successively or simultaneously places of study for American painters. Throughout the nineteenth and early twentieth centuries, Paris was the main attraction, the major center for intellectual and artistic excitement.

Although many of the American painters in Paris were probably aware of French impressionism, especially after 1874, they were possibly not ready for such a radical style; and some, such as J. Alden Weir, who was to become a leading figure in the American impressionist movement, were positively horrified by it. In a letter dated April 15, 1877, Weir wrote to his parents, "I went across the river the other day to see an exhibition of the work of a new school which call themselves 'Impressionists.' I never in my life saw more horrible things. They do not observe drawing nor form but give you an impression of what they call nature."

What the Americans sought was the excitement of learning technique, of participating in what to them was a time-honored tradition of proper French craftsmanship. Throughout the nineteenth century, the observation of drawing and of form was a constant concern of American painters, who were generally conservative in approach; and when they did tire of the diet of pastry served by the Salon painters, they were attracted to the "middle-of-the-road" style of Jules Bastien-Lepage (1848-1884). Contemporary with Whistler, and preceding the "discovery" of Monet, Bastien-Lepage exerted an influence on many American artists. Twachtman was fascinated by his work, as was J. Alden Weir; Alexander Harrison studied with him, and so did Robert Vonnoh and Ridgeway Knight, to name a few. Bastien-Lepage himself started his career in the usual way. He studied painting and drawing with Cabanel, but even as a student he found that the emphasis on certain kinds of subject matter was unnatural and slightly ridiculous. Greeks and Romans, gods and goddesses were not for him. About 1878, he made his first appearance as a painter of peasant life, and it became evident he was a plein-air painter to contend with. It was his work as a plein-air painter, his attempts to reconcile accurate draftsmanship with atmospheric outdoor painting, as in his painting *Pas Mêche*, that interested the Americans and that became his particular contribution to art history. Bastien-Lepage was a middle-man, his painting was full of compromises for which

(*see page* 44)

the turn-of-the-century historian Richard Muther coined the delightful term "amiable concessions." Muther, however, in *The History of Modern Painting* of 1907, stated further, "All the forms and ideas of the Impressionists, with which no one, outside the circle of artists, had been able to reconcile himself, were to be found in Bastien-Lepage, purified, mitigated and set in a golden style." *Joan of Arc*, his most famous painting, demonstrates his attempts to combine studio draftsmanship with plein-air painting, along with historical overtones. Although the figure, with its attendant vision in the background, is contrived and artificial, the outdoor setting is carefully observed and sensitively rendered. Its pictorial construction, overall feeling, and muted color appear later in Robert Vonnoh's *November*. Although Degas called Bastien-Lepage the Bouguereau of naturalism, he was nonetheless influential in the eventual acceptance of impressionism. And the particular qualities to be found in the *Joan of Arc* continued to appear in the work of American painters up to, and even beyond, the advent of Monet's influence.

Just as Bastien-Lepage straddles the middle ground between the Academy and the impressionists, there are those American painters who occupy that ground midway between the Hudson River School and the impressionist conception. They went beyond the smoothly rendered technique of the American luminist approach, yet for the most part they were not quite ready to embrace impressionist practice. Representative of this group are Homer Martin (1836-1897), Joseph R. Woodwell (1842-1911), Dwight Tryon (1849-1925), Alexander Harrison (1853-1930), Will Low (1853-1932), Birge Harrison (1854-1929), and Henry Ward Ranger (1858-1916). *(see pages 77-80)*

Of the American "pre-impressionists," the work of Homer Dodge Martin, with its quiet lyricism and shimmering light, comes closest to the impressionist idea. In fact, he was called, in his day, "the first of American impressionists." *On the Seine*, for example, stylistically falls somewhere between Boudin and Sisley; but its classically ordered composition and muted lyrical mood are closer in spirit to John Kensett or Sanford Gifford. At first *(see pages* 41, 50) Martin painted landscapes in the Adirondacks, rather monotonous in color, but showing an early concern for light and atmosphere. Then he discovered Corot, and went to France in 1876. He also visited England, where he met Whistler in whose studio he occasionally painted. Martin and his wife settled in Vierville, France, a fishing village about midway between Honfleur and Trouville, picturesque seaports favored by Monet and Boudin. Homer Martin stayed in Normandy for about five years; and it was in Normandy that he painted some of his most important and gently lyrical pictures. Homer Martin was a cultured and sensitive man; besides painting, poetry and music were his two great passions, and like his good friend John La Farge, Martin was an intellectual painter who was fascinated by color relationships. His *Wild Coast, Newport* of 1889 bears strong similarities in style

JULES BASTIEN-LEPAGE
Joan of Arc (1879) 100 x 110 inches
The Metropolitan Museum of Art, New York
Gift of Erwin Davis, 1889

ROBERT WILLIAM VONNOH
November (1890) 32 x 40½ inches
The Pennsylvania Academy of the Fine Arts
Philadelphia. Temple Fund purchase, 1894

75

to La Farge's *Paradise Valley* of circa 1868; it was painted perhaps at the same site.

The Pittsburgh painter Joseph Woodwell was more eclectic. He studied for a while with the genre painter David G. Blythe, and in 1861, his father sent him to France. He studied at the *Académie Julian* in Paris, but he soon discovered the Barbizon painters. He also became friendly with Pissarro, Renoir, Sisley, Monet, and Mary Cassatt; and he absorbed, into his style, bits and pieces from both the Barbizon and impressionist painters as revealed, for example, in *Sand Dunes*. Woodwell returned to Pittsburgh in 1865 and plunged immediately into civic affairs. He was a trustee of the Carnegie Institute for many years, and he may well have stimulated his friend Henry Clay Frick's interest in French painting, which might account for the latter's unexpected purchase of a Monet in 1895.

Dwight Tryon was the master, the major exponent, of what has come to be called the "quietist" strain in American art. Quietism, sometimes referred

JOHN LA FARGE
Paradise Valley (circa 1867) 32 x 41½ inches
Private collection

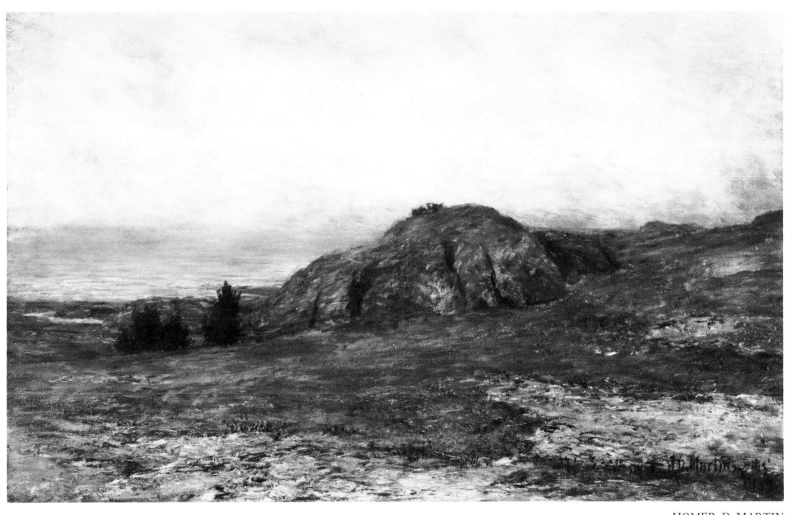

HOMER D. MARTIN
Wild Coast, Newport (1889) 23½ x 36 inches
The Cleveland Museum of Art
Leonard C. Hanna Jr. Collection

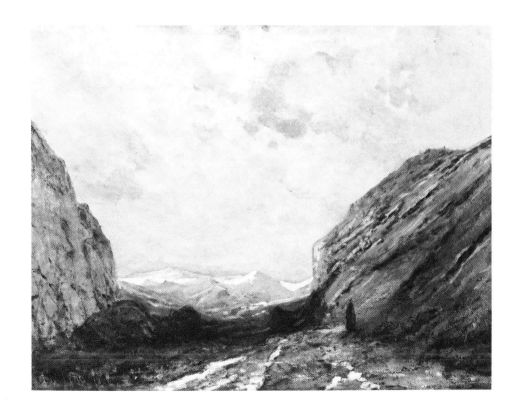

JOSEPH WOODWELL
Sand Dunes (1909) 30 x 40 inches
Museum of Art, Carnegie Institute, Pittsburgh
Gift of Mrs. Joseph Woodwell and
her daughter, Mrs. Johanna K. W. Hailman

77

to as "tonalism," developed from the idealistic approach to American landscape which had its beginnings in the Hudson River School and is carried on strongly in the work of the luminists. It reached its apotheosis as a style in the work of Dwight Tryon, Alexander Harrison, and Leon Dabo. Quietism, a term coined by Edgar P. Richardson, is an apt description of the style in which these artists and others like them would pick a quiet corner of the world and attempt to represent—by the use of the horizontal format, muted tones, and low-key colors—the serenity and stillness of nature. It is an intimate, contemplative approach to nature, exemplified by the quiet poetry, the hushed silent mood, of Tryon's work. *Morning in May,* for example, one of the loveliest and most sensitive of his pictures, captures fully this mood. Nature's stormier moods do not exist in this world. Tryon, who went to Paris in 1876, was influenced by Daubigny, Harpignies, and Guillement. He admired Rousseau, but Corot was his real mentor, and Whistler was almost as influential. Tryon died in relative obscurity, although collectors Charles Lang Freer and William T. Evans were both very interested in Tryon's work.

Alexander Harrison studied with Bastien-Lepage and brought that French artist's sense of realism, his "Golden Style," back to Harrison's home town of Philadelphia. While he was in France he spent a great deal of time painting beach scenes on the Brittany coast; the seascapes he painted there were a sensation in his day and made this now obscure artist known the world over. *The Wave* received a place of honor in the Paris Salon of 1884, and was subsequently exhibited all over Europe. Today his work is considered extremely banal, but to his contemporaries, Harrison's seascapes were the epitome of poetic realism.

LOWELL BIRGE HARRISON
A Glimpse of the St. Lawrence (1904) 30 x 24 inches
The Pennsylvania Academy of Fine Arts
Philadelphia. Gilpin Fund Purchase, 1904

DWIGHT W. TRYON
Morning in May (1911) 20 x 30 inches
The Paine Art Center, Oshkosh, Wisconsin

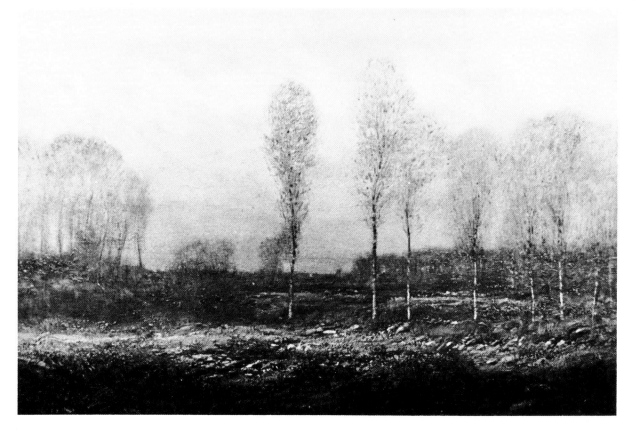

78

"Poetic" also was the critical description for the painting of Birge Harrison, Alexander Harrison's brother. Birge Harrison made his name as a painter of winter landscapes. Like Whistler and Twachtman, Birge Harrison was concerned with the use of white as a color. He painted in Canada and the north, even to the extent of spending several weeks in a logging camp. *A Glimpse of the St. Lawrence,* part of a series of paintings of the river, was painted on one of his trips to Quebec; and it is a good example of his preoccupation with white in all its nuances. Harrison founded the Woodstock School, which is the summer school for the Art Students League of New York, and he was probably responsible for the growth of Woodstock as an artist's colony.

Will H. Low loved artists' colonies; he liked the company of his fellow artists, and he felt about them the way an enthusiastic alumnus feels about class reunions. In his own work he was something of an American pre-Raphaelite, his style probably stemming from the kind of illustrating he did to earn a living. In 1877, Low was instrumental in founding the Society of American Artists, a group which broke away from the older and more conservative National Academy. The younger men were returning from Europe armed with more sophisticated training and new techniques; the European experience was beginning to show. Will Low's charming *Reading in a Meadow* of 1877 has some of that pre-Raphaelite feeling in the idealization

WILL H. LOW
Reading in a Meadow (1877) 24 x 30½ inches
Hirschl & Adler Galleries, New York

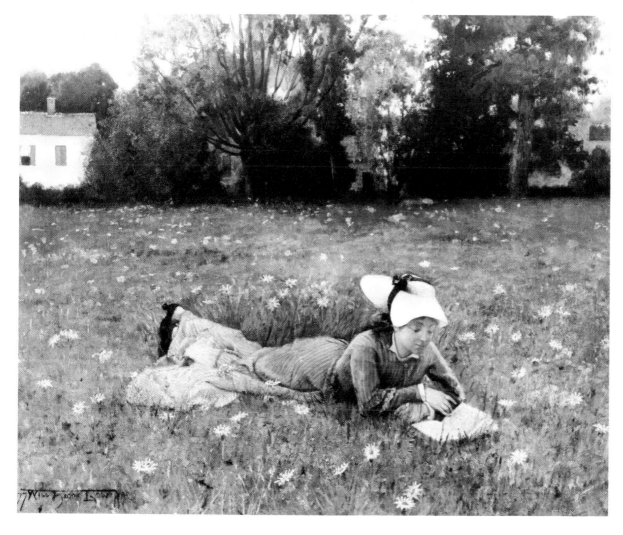

and tight execution of the woman, although the combination of the tightly drawn figure in a painterly landscape is close to Bastien-Lepage or, at least in color, to the Belgian impressionist Alfred Stevens.

If the painting of Will Low reflects a kind of pre-Raphaelitism, that of Henry Ward Ranger reflects Monticelli, or still more, Diaz. Ranger started with the Dutch painters, studying with the masters of The Hague School. And he became a friend to most of them: the Maris brothers, Jozef Israels, and Van Gogh's uncle, Anton Mauve. He later went to France, of course, and became a follower of Barbizon painting. He became known for the rich jewel-like texture of his paint, and the glimmering light of his woodland scenes, which were similar to those of Diaz or to the much later paint surfaces of Ernest Lawson. Although Ranger adhered to the tonalism of The Hague and the Barbizon schools, he did sometimes use bright color—in some of the wooded landscapes, and in a picture such as *Brooklyn Bridge,* painted around 1899. *Brooklyn Bridge* is a marvelous painting, but somewhat atypical of Ranger's work in its closeness to the overall light of impressionism, which is perhaps indicative of the fact that by 1899 the new style had become a fixture in the American art world, and no artist was totally untouched by its influence. When Henry Ward Ranger died, he left a fund to the National Academy of Design to be used for the purchase of paintings by American artists; the paintings purchased by the Academy were to be presented to various art institutions and museums around the country.

If, in the overall view of the development of American impressionism, these "pre-impressionists" appear to be a kind of link between the older methods and viewpoints of picture-making, there were two American artists, John La Farge (1835-1910) and Winslow Homer (1836-1910), whose work and ideas in the 1860s show interesting parallels to those of the French

HENRY WARD RANGER
Brooklyn Bridge (circa 1899) 28½ x 36 inches
The Art Institute of Chicago
The C. L. Hutchinson Bequest

impressionists in roughly the same time period. And although they later pursued different paths and divergent careers, they did anticipate, each in his own way, some of the same problems that would interest such American painters as Hassam, Weir, and Twachtman twenty years later. It is for this reason that Homer and La Farge deserve consideration here.

When Henry James was writing art criticism, La Farge, as an artist and as a person, became the subject for a most perceptive comment by the celebrated novelist. In 1872, in his review "French Pictures in Boston" of an exhibition including some works by La Farge, James remarked, "The most important of these is a large landscape by Mr. John La Farge, the view of a deep seaward-facing gorge, seen from above, at Newport. This is in every way a remarkable picture, full of the most refined intentions and the most beautiful results, of light and atmosphere and of the very poetry of the situation. We have rarely seen a work in which the painter seems to have stored away such a permanent fund of luminosity." The painting which James described was probably *The Last Valley*. It is indeed full of light and

JOHN LA FARGE
The Last Valley (1867) 32 x 41½ inches
Private collection

atmosphere, and when La Farge put it up for auction at Pierce and Company in Boston around 1878, he wrote in the catalogue entry: "This picture has been painted entirely from nature and out of doors, except where an accident has necessitated repairs." La Farge worked on *The Last Valley* over a long period, from about 1859 to 1870, when he was pursuing a direction of plein-air painting unaware of the similar experiments which were being carried on in France; had he continued in this direction, he might have been the first American impressionist.

John La Farge's childhood was spent in a New York house full of books and paintings; and he was taught to draw by his grandfather, Louis Binsse de Saint-Victor, who was trained as a miniature painter. From 1854 to 1855, he studied law, and in the following year he went abroad to travel and study, for further "polish." In other words, he went to Europe as a dilettante, in the manner of an eighteenth-century English gentleman making the Grand Tour. In Paris there was his cousin Paul de Saint-Victor, writer and critic, at whose house La Farge met some of the intellectual celebrities of the day, including Théophile Gautier, the Goncourts, and Charles Blanc. Charles Blanc, a friend of Delacroix's, would publish his *Grammar of the Arts of Design* in 1867, the same year in which Helmholtz would publish his handbook on color. In this way, John La Farge drifted into the fine arts taking up painting as a kind of "graceful accomplishment" and as an aid toward becoming a connoisseur—not a professional artist. Accordingly, in 1856, he entered the studio of Thomas Couture.

La Farge did not stay very long with Couture; he soon perceived the shortcomings of his teacher, and of the work of the students around him. La Farge wrote that Couture's methods seemed to be "only ways of rendering some locality of the things depicted, and not a successful attempt at a synthesis of light and air. . . . I was becoming more and more dissatisfied with the systems of modelling . . . in tones that were arbitrary, and of using color, after all, merely as a manner of decorating these systems of painted drawing. . . . I already became much interested in the question of the effect of complementary colours."

In 1859, he decided to become a professional painter after all, settling in Newport, Rhode Island, in order to study with William Morris Hunt. Newport was quiet in those days; the Neo-Babylonian splendor of the Vanderbilts had not yet changed its character. Its seaside ambiance, beauty of locale, and its wonderful light and atmosphere were ideally suited to La Farge's early experiments in impressionism. La Farge learned a good deal from Hunt, particularly about figure painting. The early *Portrait of the Artist,* painted in 1859, is an indication perhaps of the older artist's influence, but the sinuous line of the figure is reminiscent of the style of the pre-Raphaelites—and of Whistler. The little landscape *Hillside, Long Island* is also an early work, probably painted at the La Farge family estate in Glen Cove. It was an

JOHN LA FARGE
Portrait of the Artist (1859) 16 x 11½ inches
The Metropolitan Museum of Art, New York
Samuel D. Lee Fund, 1934

unusual picture for an American to be painting at that time. The subject is slight: two trees, a field, and the sky, making it appear as though the real subject of the painting is painting itself—a very modern conception. With its variation of color and the "snapshot," slice-of-life feel to it, it is very nearly an impressionist picture. Here are also hints of the Japanese. La Farge was a great admirer of Japanese art; he collected it in the early 1860s and wrote a great deal about it. In *Vase of Flowers,* 1864, painted with great delicacy and refinement, La Farge seemed to sense, in an almost oriental way, the impermanence and fragility of the subject, capturing what Henry James called "the very poetry of the situation."

La Farge painted a series of flower pieces during that decade in Newport, but it is to landscape affected by light and atmosphere, the "enveloppe," that he gave his most serious consideration at that time. He noticed, as the French impressionists did, the changes this "enveloppe" made on local color. Light, "the rendering of the gradations of light and air through which we see form," became the focal point of the study of John La Farge. And as he further pointed out to a student struggling to paint a landscape: "The sky that we are now looking at is not only modelled by what we call light and shade, so delicately that we find it difficult to trace, but it is modelled by varieties of color. . . . The clouds that float in it, of which we mainly see shadows, are more violet; the upper sky, where the clouds are thinner, is greener, meaning that there is the faintest suggestion of blue."

La Farge's experiments in perceptual painting, in the observation of color and light, were tentative at first—and muted. *Snow Landscape with Evergreen Tree,* in its arrangement of forms, refinement of color, subtle handling, and its high horizon, foreshadows the painting of John H. Twachtman. Later on, expressing his ideas with more assurance, he approaches the painterly execution and chromatic range of Manet and Monet; for example, *The Last Valley* of 1867, and *Paradise Valley* circa 1867-68. *The Last Valley,* "painted entirely from nature and out of doors," is perhaps closer to the French, closer to a painting such as Monet's *Road in the Forest with Woodgatherers* than is *Paradise Valley.* In the latter, the approach, particularly in the placement of the sheep, is reminiscent of the pre-Raphaelites, in particular of Holman Hunt, whom La Farge admired when he first went to Europe. These large canvases were two of the most important landscapes of his impressionist decade in Newport. Important as well is *Bishop Berkeley's Rock, Newport.* Strikingly modern in its rich hues and in its fluid and decisive handling, it approaches abstraction. As was the case with his French counterparts, La Farge sold few, if any, of the Newport landscapes. Mrs. Gardner bought one in 1878, and Durand-Ruel offered to sell his work, but La Farge was not that interested. He was already preoccupied with other projects, such as murals, figure work, and of course, his work in stained glass for which he is best known today.

(*see page* 59)

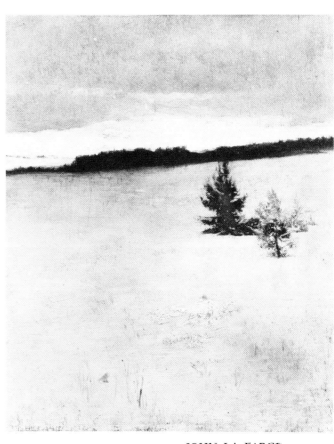

JOHN LA FARGE
Snow Landscape with Evergreen Tree (circa 1867)
12 x 10 inches
Kennedy Galleries, Inc., New York

(*see pages* 76, 81)

(*see page* 37)

In the 1870s La Farge turned to decorative work. In 1876, he executed his famous mural decorations for H. H. Richardson's Trinity Church, Boston. In 1877, he began experimenting with glass, and in *The Education of Henry Adams,* his friend Henry Adams said of him, "La Farge alone could use glass like a thirteenth century artist." In 1889, for his invention of a certain kind of opalescent glass he received The Legion of Honor from the French government. And although Paul Gauguin was the first well-known artist consciously to borrow from stylistic sources outside the mainstream of Western European art, to conceive of art history as a "Museum without Walls," John La Farge was equally at home in his use of other cultures and other periods. He was a complicated man, full of genuine emotion for many things; a man of incisive intellect and acute perceptions, of wide curiosity and experience; he was a man aptly fitted for what has been called "the Renaissance complex" in the art and life of late nineteenth-century America. His circle of friends included, besides Henry Adams, H. H. Richardson, Stanford White, Augustus Saint-Gaudens, the designer David Maitland Armstrong, Russell Sturgis, who published La Farge's writings, William James, and of course, Henry James. He was a prolific writer and speaker; and he served as a member of the committee which planned the Metropolitan Museum of Art. Obviously he was a person of fastidious taste (or he would not have been a friend of Henry James) and wide-ranging interests, but perhaps that was his weakness as well as his strength. It is unfortunate that he never pursued his experiments in impressionism to their logical conclusion. It does not matter, really, whether or not he would have become known as "America's first impressionist"—precedence is not important—however, his art was deeply personal, and he probably would have created the most beautiful and evocative landscapes ever produced in this country during, and perhaps after, that era.

Like that of John La Farge, the work of Winslow Homer closely parallels that of the impressionists in many ways. He went to Paris in 1867, ten years after La Farge, and it was an exciting time for him to be there. It was the year of the *Exposition Universelle,* the Exposition which the Goncourts called "that great monster," and which they deplored as representing the "Americanization of France." Actually, they really meant "mechanization," referring to the Exposition's emphasis on industry and the machine; but of more interest to Americans, and especially to Homer, would have been the exhibition of American paintings in the fine arts section. It not only was probably the first serious consideration of American art in any exposition in Europe, but two of Homer's paintings were in that show: *Prisoners from the Front* and *On the Bright Side,* "a couple of little pictures taken from the recent war, by Mr. Winslow Homer of New York." Although Homer's work was exhibited, Manet's was not; and in a grand gesture of independence, Manet exhibited fifty of his pictures in a wooden shed on the Avenue

WINSLOW HOMER
A French Farm (1886) 10⅝ x 18⅛ inches
Krannert Art Museum
University of Illinois, Champaign

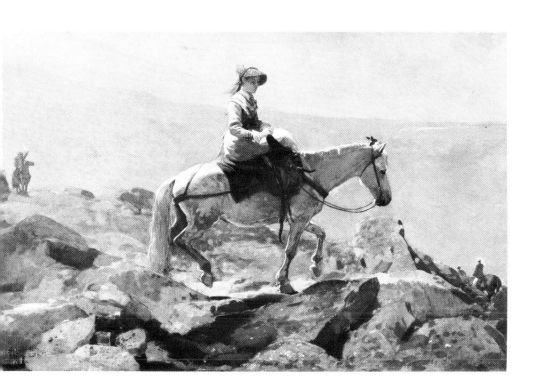

WINSLOW HOMER
The Bridle Path, White Mountains (1868) 24 x 38 inches
Sterling and Francine Clark Art Institute
Williamstown, Massachusetts

de l'Alma at his own expense. The show was the talk of the town; and although it was treated as a scandal by the French public, Manet's work probably impressed Homer.

One of the highlights of the official Exposition, as it would be several years later at the Philadelphia Centennial of 1876, was the exhibition of Japanese arts and crafts. Artists had been aware of Japanese prints a little earlier, but this was probably the largest showing of its kind ever assembled in Europe up to that time. This exhibition of Japanese prints was to have a decided influence on Homer's work after his return to this country from Paris. The dry illustrative approach and the fussy details of his earlier painting gradually disappeared; instead, he began to develop a more freely brushed technique and broader masses of color and tone as in *A French Farm*. It is a technique strikingly similar to that of Manet, and even to early Monet as, for example, in *Jardins de l'Infante, Louvre*, painted the same year Homer arrived in Paris. In Homer's work, a new feeling for the texture, the fluidity of paint, and a stronger sense of immediacy developed. There

WINSLOW HOMER
Promenade on the Beach (1889) 20¼ x 30⅛ inches
Museum of the Fine Arts
Springfield, Massachusetts

is also a stronger sense of pattern derived from the key point, as in *The Bridle Path, White Mountains,* part of a series he painted in the White Mountains in 1868. The striking silhouette of horse and rider and the patterning in the rocks indicate this influence. The riders in the distance, to the right and left, suggest continuous movement; and the whole scene is bathed in strong sunlight. the hard American light, as well as the light of Monet's *Terrace at Ste Adresse.* In *Promenade on the Beach* of 1889, one of the women holds a Japanese fan, and the treatment of her clothes suggests a Japanese kimono; but the importance of the oriental influence lies not in that kind of superficial detail, but in the careful and asymmetrical design of the picture, the diagonal shadow created by the women, the considered *placement* of each element, and the indication of depth without the use of mechanical perspective, creating a constant awareness of the picture's surface.

(*see page* 32)

There is no doubt that Homer was deeply impressed by Japanese art, but he never let his admiration carry him to the extreme of, for example, Whistler's self-conscious use of oriental motifs. The massing of form and color in *On a Lee Shore* of circa 1900, for instance, is stronger and less obvious than in Whistler's work. By the use of the rocks in the foreground and the huge and threatening spray of ocean breaking on them in the extreme left of the painting, a feeling of the powerful presence of the sea is evoked. The solitary sailing ship in the background gives the work its sense of scale and adds to the cool, but nonetheless passionate, grandeur of his conception. Homer was most interested in incorporating what he felt he could reasonably use in order to improve his art and better express his ideas. He did the same thing with impressionism. And just as his earlier aims were similar to those of the pre-Raphaelites, his new direction after 1867 paralleled that of the French impressionists. In his book *Hours with Art and Artists* (1882), the critic George W. Sheldon quotes Homer as saying, "I prefer every time . . . a picture painted out-of-doors," and later, "you will be glad to hear that I am painting again. I work hard every afternoon from 4:30 to 4:40, that being the limit of the light I represent, the title of my picture being *Early Evening.*" Obviously Homer was concerned with light, but he also studied what were then the laws governing color harmony, and he said of Chevreul's celebrated book on color, "it is my bible" and "you can't get along without a knowledge of the principles and rules governing the influence of one color upon another."

Thus Winslow Homer progressed, in his treatment of light, from a luminist concept and tight manner of the monumental genre pieces of his pre-Paris days to the impressionist concept of light through color in the manner of Manet or early Monet. But he never carried that principle as far as the French did, he never obscured form; in fact, although he eliminated unnecessary detail, he stuck to that "quiet observation of fact" which was characteristic of American painting in the nineteenth century. Although his

work from the beginning bore similarities to impressionist practice, he retained his "yankee independence." In other words, Homer was a conceptual artist, who used elements of impressionist practice and elements from the Japanese print as a *means* to an end. In this he differed appreciably from the followers of Monet, who tried to adopt that French painter's later perceptual style. And although Homer's style was quite different, his career was similar to that of his contemporary John La Farge in as much as they both, for a brief time, paralleled impressionist thinking, and they both later opted for what seemed like alternatives to the French style, a move which became more evident as impressionism gained more acceptance in America.

La Farge and Homer were early experimenters in the study of impressionist light and atmosphere, and although they went on to other things, their work during the 1860s is more exciting than that of some of the other pre-impressionists previously discussed. For despite a general brightening of the palettes of most of these painters after their period of European study, especially of Low, Ranger, and Homer Martin, their colors never reached the pitch of intensity to be found in the painting of their French counterparts or, for that matter, in the work of any of the bona fide American impressionists. There seems to be an old-fashioned point of view, a Barbizon or Hudson River School approach, in their work. There is an adherence to a classical landscape form, a sense of stability, and a feeling of muted melancholy—absent in Hassam or Cassatt for example. Absent also are the feeling of change and the "expansion of sensual perception, a new sharpening of sensibility" which was expressed in the impressionist style and which constitutes the beginning of modernism.

However, that was left to other, more adventurous artists: Robinson, Cassatt, Hassam, Twachtman, Weir, and Chase—the major figures of the American impressionist movement, who received their training abroad and came home equipped with the full paraphernalia of impressionist practice.

JOHN LA FARGE
Hollyhocks and Corn (1865) 23½ x 16½ inches
Museum of Fine Arts, Boston
Gift of Dr. William Sturgis Bigelow

facing page:

THEODORE ROBINSON
Boats at a Landing (1894) 18 x 22 inches
Collection of Mr. and Mrs. Meyer Potamkin

The American Impressionists 1875=1900

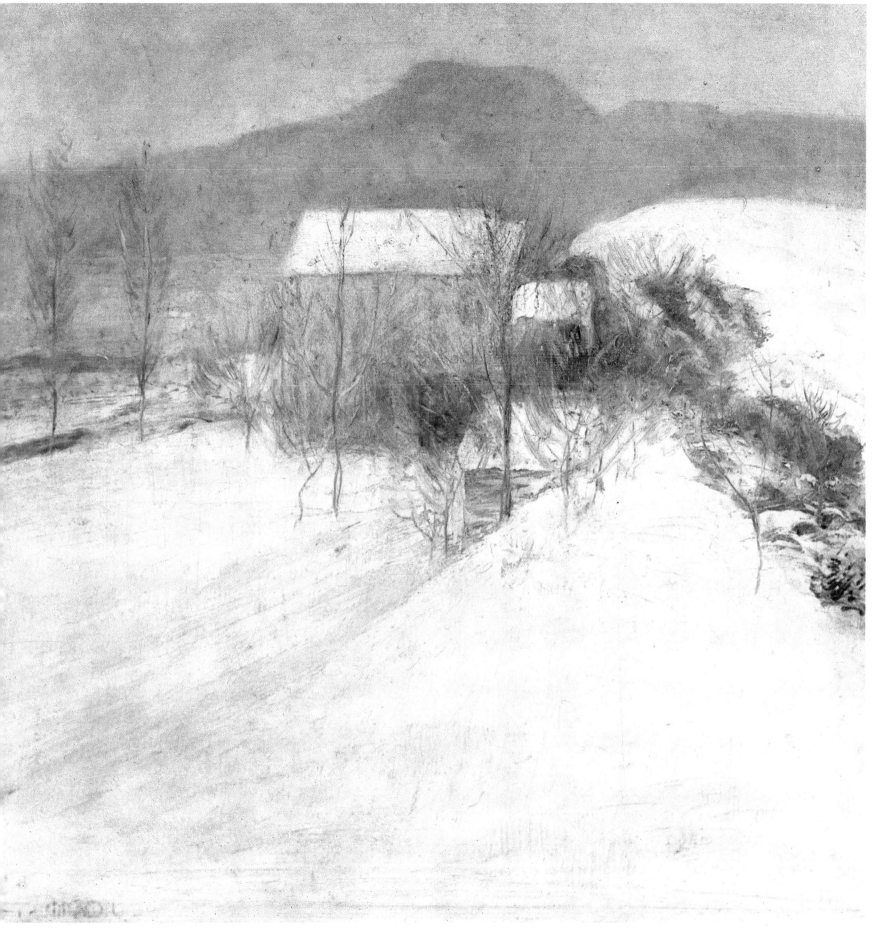

facing page:

JOHN LA FARGE
Flowers on a Window Ledge
(circa 1862) 24 x 20 inches
The Corcoran Gallery of Art, Washington, D.C.

JOHN TWACHTMAN
Snow (circa 1895) 30 x 30 inches
Collection of Mr. and Mrs. Meyer Potamkin

THEODORE BUTLER
The Mill in Flood, Giverny (1910) 23½ x 26 inches
Maxwell Galleries, Ltd., San Francisco

facing page:

JOHN TWACHTMAN
Old Holley House at Cos Cob (circa 1890–1900)
25 x 35 inches
Cincinnati Art Museum

94

W. ELMER SCHOFIELD
Winter (circa 1899) 29½ x 37 inches
*The Pennsylvania Academy
of the Fine Arts, Philadelphia*

facing page:

JOHN TWACHTMAN
Tiger Lilies (circa 1895) 30 x 22 inches
Collection of Mr. and Mrs. Meyer Potamkin

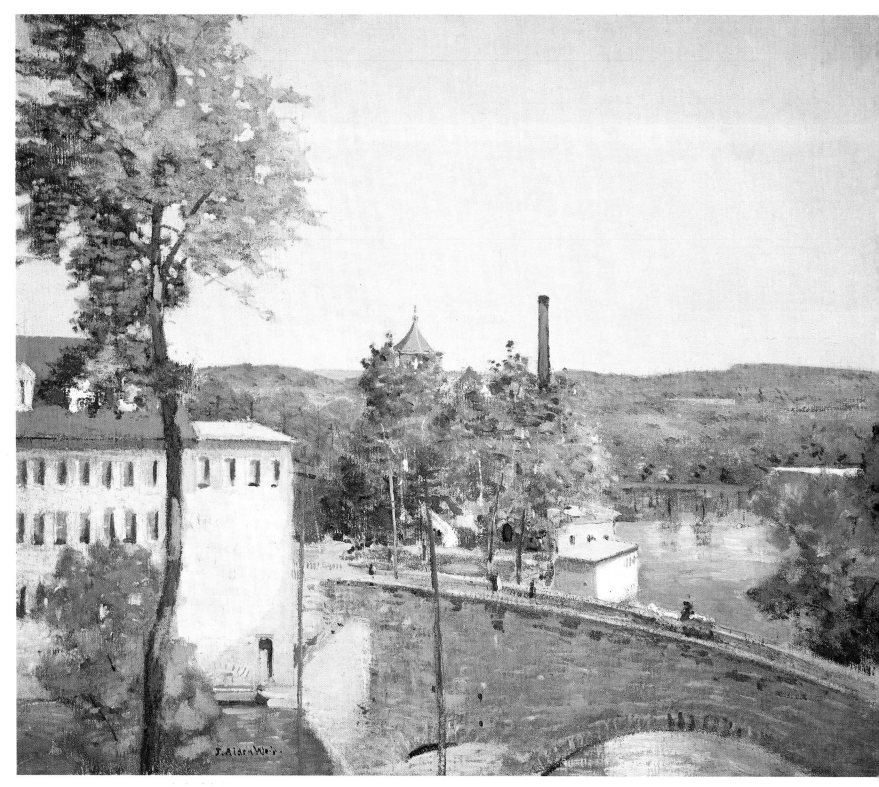

J. ALDEN WEIR
U.S. Thread Company Mills, Willimantic
(circa 1893-1897) 20 x 24 inches
Collection of Mr. and Mrs. Raymond J. Horowitz

J. ALDEN WEIR
Building a Dam, Shetucket (1908) 31¼ x 40¼ inches
The Cleveland Museum of Art
Purchased from the J. H. Wade Fund

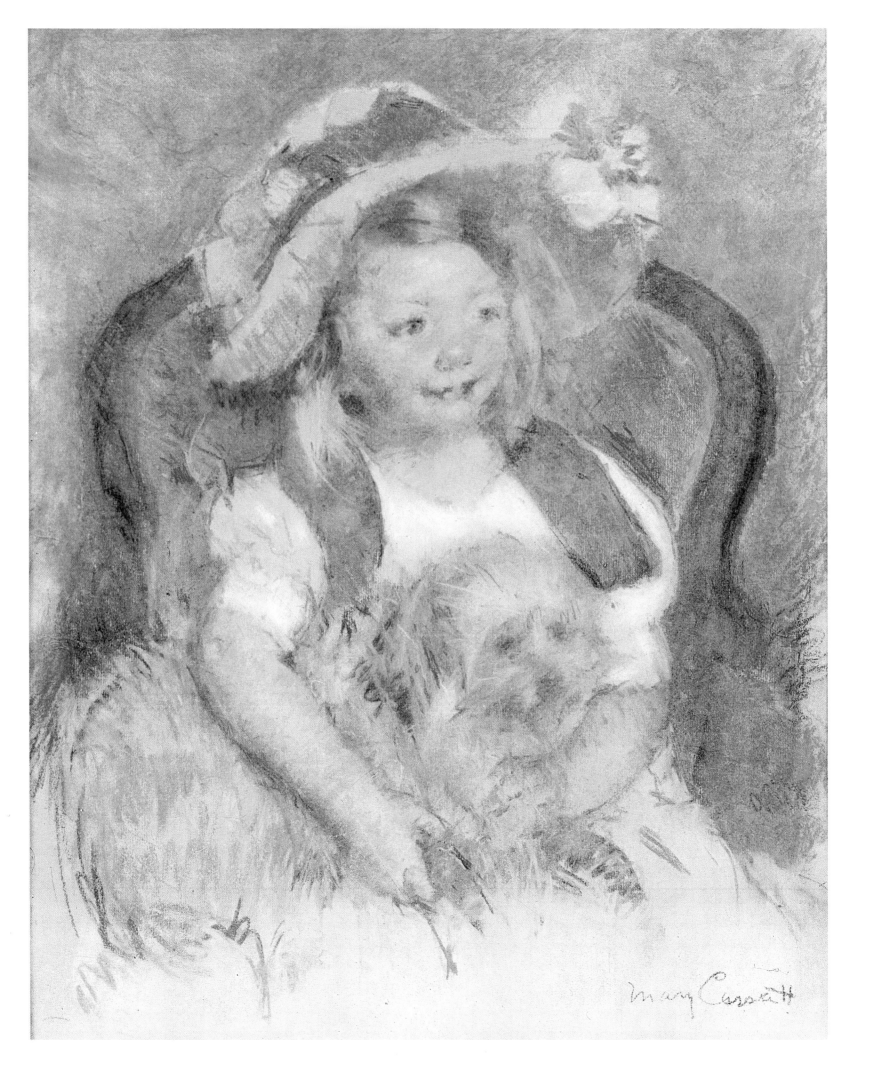

Mary Cassatt

facing page:
MARY CASSATT
Young Girl with Dog (circa 1895)
Pastel, 23½ x 19 inches
Collection of Mr. and Mrs. Meyer Potamkin

WILLARD METCALF
Early Spring Afternoon, Central Park
(1911) 36 x 36⅛ inches
The Brooklyn Museum, Frank L. Barbott Fund

THEODORE ROBINSON
Low Tide, Riverside Yacht Club (1894) 18 x 24 inches
Collection of Mr. and Mrs. Raymond J. Horowitz

EDWARD POTTHAST
Swimming at Breakwater
(circa 1915) 24 x 30 inches
Collection of Mr. and Mrs. Jack Kartee

J. ALDEN WEIR
Midday Rest in New England
(1897) 39½ x 50 inches
*The Pennsylvania Academy
of the Fine Arts, Philadelphia*

102

ROBERT WILLIAM VONNOH
Poppies (1888) 13 x 18 inches
Indianapolis Museum of Art, James E. Roberts Fund

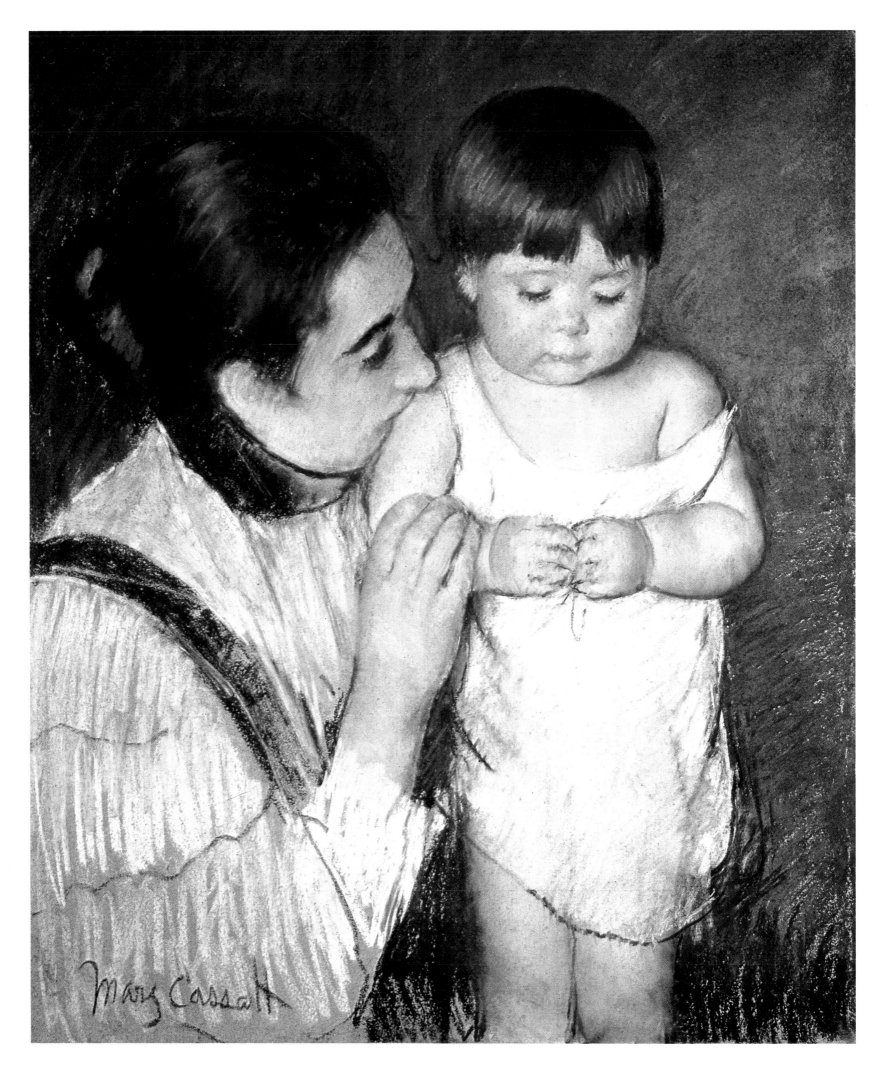

*"At some future time I shall see New York
the artist's ground. I think you will create an
American School."*

MARY CASSATT to J. ALDEN WEIR

MARY Cassatt was the first major American figure to adopt success-
fully the impressionist palette and make of it a strong personal
statement. Moreover, she not only absorbed the style, but was considered
an actual member of the French impressionist group to which she was
invited by Degas in 1877; she exhibited with them from 1879 until 1886.
She was also the first American impressionist to exhibit some of her work
in her native country. In 1878, she sent three of her paintings to an exhibi-
tion held in the Department of Fine Arts of the Massachusetts Charitable
Mechanics Association; in 1879, she participated in the Annual Exhibition
of the Society of American Artists; and in 1886, her work was included in
Durand-Ruel's New York triumph.

Like Whistler and John Singer Sargent, Mary Cassatt has been tradi-
tionally seen in the context of American expatriates alienated from their
country. None of them apparently felt that way at all. They considered
themselves American artists who happened to be living abroad, but moving
through what was really an international world of art. All three of them
knew each other of course, but because of their disparate personalities
they did not get along very well. Sargent was too conventional and "middle-
class" for Whistler, and Whistler was too unconventional for Mary Cassatt,
who was a bit of a prude. Neither Cassatt nor Whistler cared very much for
Sargent's painting, echoing Degas who claimed that he was a clever painter,
but no artist; and Mary Cassatt snubbed Sargent because, as she said, he
had done a "dreadful portrait" of her brother Alex. All three, however, were
well aware of the new ideas, of current trends. Sargent understood the im-
pressionist technique from the beginning, and he was influenced by it; but
his direction was quite different and his particular contribution will be
considered in another context. Mary Cassatt and Whistler, on the other
hand, had more in common besides a dislike of Sargent's painting. While
they were never close friends, they knew, understood, and respected each
other's work. In 1883, Whistler painted a portrait of Cassatt's sister-in-law.
Cassatt liked the painting and remarked that it was a "good thing to have a
Whistler in the family." Both Whistler and Mary Cassatt had many mutual
friends; they both shared an avid interest in the Japanese print and were
deeply influenced by its new idea of form. And they both were dedicated
admirers of Edgar Degas.

facing page:

MARY CASSATT
Young Thomas and his Mother (1893)
Pastel, 24 x 20 inches
Pennsylvania Academy of the Fine Arts, Philadelphia

105

Although Cassatt was already working in an impressionist manner before Degas asked her to join the group, his work had meant a great deal to her since her arrival in Paris, and she told Mrs. H. O. Havemeyer that she used to study his things in shop windows. She also reported to her biographer, Achille Ségard, that she hated conventional art, and her "true masters" were Manet, Courbet, and Degas. Yet her early schooling was conventional enough.

Mary Cassatt was born in Allegheny City, Pennsylvania; her family moved after a short time to Pittsburgh, and later to Lancaster County. As a young girl she lived for a while in France, traveled in Europe, and then settled in Philadelphia. From 1861 to 1865, she studied at the Pennsylvania Academy of the Fine Arts. Thomas Eakins was a fellow student, and like Eakins, she found the course of study tedious, although she stayed for four years. Then also like Eakins, Cassatt left Philadelphia for Paris in 1866. She returned to the United States during the Franco-Prussian War, and in 1872, she went to Italy. There she studied with Carlo Raimondi at the academy at Parma for about eight months, after which she traveled to Spain; to Belgium to look at Rubens; then to Holland, where she copied Frans Hals. In the same year she had her first picture accepted in the Paris Salon under the name of Mary Stevenson. In 1873, she was back in Paris where she met Louisine Waldron Elder, who was to become Mrs. H. O. Havemeyer, thus beginning a friendship which was to have important consequences for American art, especially for American collecting.

Mary Cassatt's early work in the late 1860s and early '70s, inspired by her study of the Spaniards and of Frans Hals, was strongly modeled and dark in tone. Her painting was academic at this time, but it was altogether professional. She painted tonal pictures, portraits and figures emerging from a dark ground, which were fairly close in method to the Munich School popular with many American painters of the time. Frank Duveneck (1848-1919) was the major American exponent of that style and in 1875, the year when Mary Cassatt began to emerge as an impressionist painter, Duveneck created a sensation with his one-man exhibition at the Boston Art Club. (Henry James, in reviewing the exhibition, found it filled with "the excitement of adventure and certitude of repose.") In addition to Frans Hals, there were elements of Courbet in the Munich style. Mary Cassatt admired Courbet immensely; she admired his realism and his insistence on the honest, direct rendering of contemporary subject matter. But she soon began to move in a direction closer to Manet, with whom her relationship was more personal. They lived near each other, had mutual friends, and shared similar ideas, but Mary Cassatt's acute and refined sense of style, her intellectual and analytical approach to form was obviously much closer to Degas than to any of her American contemporaries—except Whistler—or to any of the French painters. Degas was the most conceptual painter of the impressionist

group, and like Degas, Cassatt came to use a high-keyed palette and developed an intense luminosity. But form was always important to both, and they both concentrated primarily on the figure.

In 1874, her *Portrait of Madame Cortier* was accepted by the Salon. Fairly dark in the treatment of the background, the color of the flesh-tones and the handling of the features have something of Rubens about them. Yet Degas remarked, "It is true. There is someone who feels as I do." After 1874, her palette brightened and as in *Picking Flowers in a Field,* she began to work more and more in an impressionist manner. Painted about 1875, it is one of her few paintings in which the landscape is so important. A wonderful painting—the sparkle is there, the brilliant color, all the shimmer of light and atmosphere associated with the impressionist style. Clever too is the evocation of movement implied in the title. From the standing woman in the distance, to the bending figure in the middle distance, and finally to the child in the foreground stooping to gather flowers, the movement suggested

(*see page* 39)

MARY CASSATT
The Blue Room (1878) 35 x 51 inches
National Gallery of Art, Washington, D.C.
Lent by Mr. and Mrs. Paul Mellon

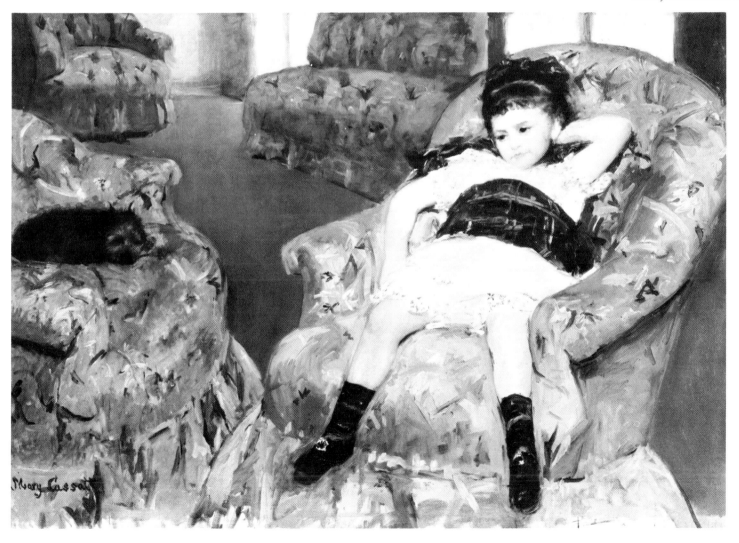

is somewhat reminiscent of the photographic motion studies of Eadweard Muybridge. It is no wonder that Degas was enthusiastic.

Degas liked her work from the start, and they maintained a close relationship for forty years. Degas criticized her art, and even worked on one of her paintings, *The Blue Room* of 1878. Adelyn Breeskin, in her *Catalogue Raisonné of the Artist,* quotes a letter from Cassatt to Ambrose Vollard in which she states: "It was the portrait of a child of a friend of Mr. Degas. I had done the child in the arm chair and he found it good and advised me on the background and he even worked on it." That must have been a singular honor, especially considering his well-known vitriolic temper. *The Blue Room* is an unusual painting, very direct, indicating her strong sense of form, her intuitive feeling for abstract pattern. The chairs, for example, are like mountains, and the brown floor in the background is not treated as just a negative backdrop shape, but a firmly positive one which acts on the other shapes around it, giving strength and surface tension to the canvas. Throughout the late 1870s and early '80s, Cassatt continued to benefit from Degas's influence and his serious criticism. The asymmetrical placement of the girl in *The Blue Room* and the cut-off view of the horse and the general cropping of the foreground in *Woman and Child Driving* of 1879 are compositional devices, derived from the photograph and the Japanese print, frequently used by Degas. In his painting *The Rehearsal,* the position of the violinist in the extreme lower left-hand corner, and the leg of an unseen dancer on the extreme right create an atmosphere of intense immediacy and suggest a feeling of continuous action. These ideas are implemented in *Woman and Child Driving,* a portrait of Cassatt's sister Lydia and Odile Fèvre, a niece of Degas.

(*see page* 107)

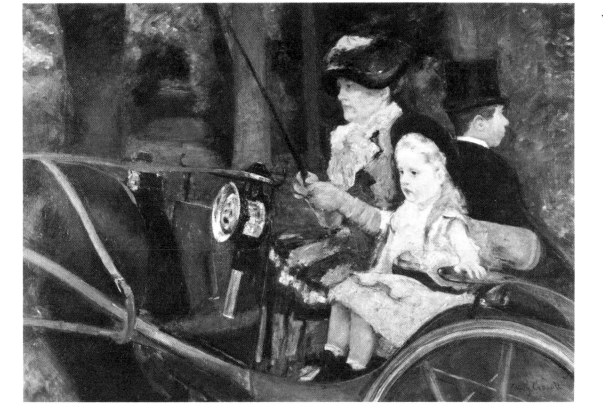

MARY CASSATT
Woman and Child Driving (1879) 35¼ x 51½ inches
Philadelphia Museum of Art

In 1880, she began her celebrated studies on the mother and child theme and *A Mother About to Wash Her Sleepy Child* is one of the first. Thereafter she became known as the painter of *maternité,* and to some, a painter of limited imagination who restricted herself primarily to this theme. However, Mrs. Breeskin points out that in Mary Cassatt's total *oeuvre,* there are more portraits and figure pieces than there are of the mother and child motif. Such figure pieces, for instance, as *A Cup of Tea* of 1880 and *Susan on a Balcony Holding a Dog* of 1883, with their juxtaposition of clarity of line with painterly method, are soundly conceived and beautifully painted in their interplay of contrasting textures and organization of form. But even though she might have painted a greater number of other subjects than is generally thought, she certainly painted enough variations on the theme of mother and child to justify being "type-cast" by the public. And like those artists who were indefatigable painters of self-portrait, Mary Cassatt's pattern of development can be traced by way of a series—her mother and child pictures. The mother and child paintings are detached, aloof, and certainly lacking in sentimentality. They are strikingly modern in their monumental sense of form, in fact, especially so due to the simplicity of their imagery. *A Mother About to Wash Her Sleepy Child* was painted in 1880 in a loose impressionistic style. It also has the feeling of Dutch genre painting or Chardin in its homeliness, directness, and simplicity, and the lovely gradations of the white in the child's frock to the gray in the mother's dress is very Whistlerian. In the late '80s and '90s, she departed from a loose impressionist approach, and her style became more linear and schematically inclined. She developed a large and luminous style, a feeling of permanence

(*see page* 111)

(*see pages* 110, 113)

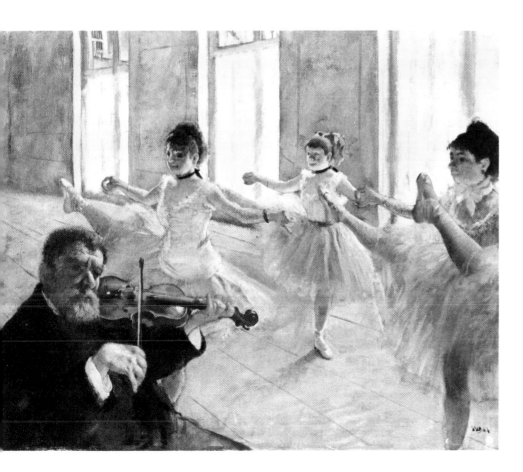

such as that evoked in *Emmie and Her Child* of 1889. Also called *Maternité*, it is one of the most beautiful and impressive of Cassatt's mother and child pictures. It owes much to Degas, of course, but in the arrangement of its shapes and patterns, it also owes not a little to the Japanese print.

It was in the 1880s that she began to incorporate elements of Japanese art in her pictures, and she was one of the first to admire Persian miniatures. In 1891, she showed a group of ten color prints in her first one-man exhibition at Durand-Ruel's Paris gallery. They were deliberately done with the idea of imitating Japanese prints, but the principles of Japanese art were so thoroughly absorbed that they had become an extension of her own aesthetic expression; and the prints are unique. The drypoint and aquatint *La Toilette* was in that show and impressed Degas. In fact, this print was the cause of his celebrated remark that he would not admit that a woman could draw so well! In its composition, its fastidious draftsmanship and delicate hue, Mary Cassatt pays homage to the Japanese. The print is also a celebration of her own receptivity, her sensitivity to form.

Degas was also full of praise for her painting *Mother and Boy*, which

(*see page* 14)

MARY CASSATT
A Cup of Tea (circa 1880) 25½ x 36½ inches
Museum of Fine Arts, Boston
Maria Hopkins Fund

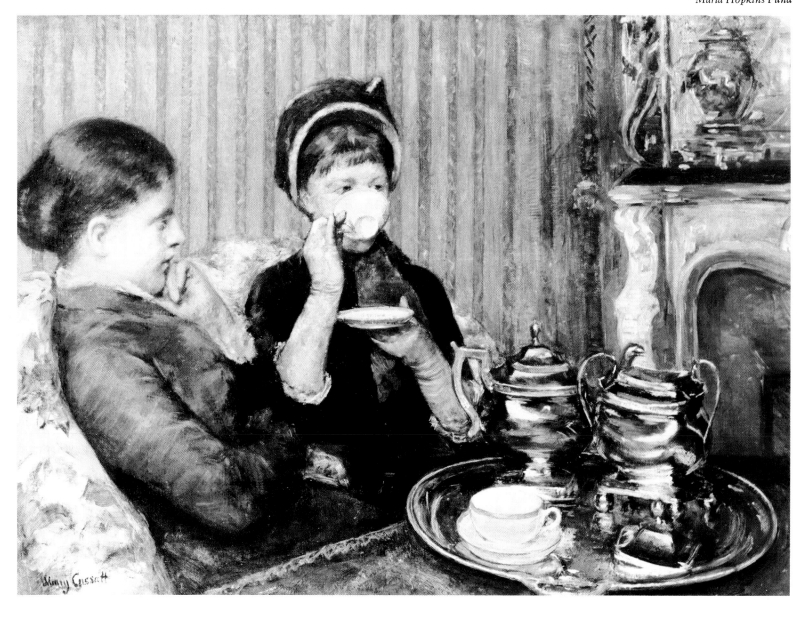

once belonged to Mary Cassatt's good friends the Havemeyers. He said it was like an infant Jesus with "his English nurse." This picture has also been called *The Florentine Madonna,* suggested no doubt by the oval mirror which creates a kind of nimbus behind the boy's head. The boy himself, in his classical stance, is wonderfully done, and alive; yet even here the viewer might be as aware of the largeness of the drawing, the superb technique, and the monumental quality of the picture as a whole—a monumental quality akin to the schema of early Italian painting—as well as of the feelings generally evoked by the subject. The overtones of early Italian art in *Mother and Boy* might be ascribed to the fact that in 1901, the year the picture was painted, Cassatt traveled with the Havemeyers in Europe, visiting Italy and Spain, helping them to build their collection.

In 1892, Mrs. Potter Palmer commissioned her to do a mural for the

Women's Building in the upcoming World's Columbian Exposition in Chicago. In 1903, the year Whistler died, she had a one-man show at Durand-Ruel's New York gallery, and in 1908, she visited America for the last time. Not many years later her eyesight began to fail, and like Degas, to whom the same thing happened in his old age, she turned more and more to pastel as her principal mode of expression. She probably first used it in the late 1870s, and as revealed in *Woman Arranging Veil*, which is executed with dash and precision, the technique suited her temperament; and she was good at it.

The pastel was an important medium for Cassatt and her technique in using it was similar to Manet's, but particularly, of course, to Degas's, from whom she probably learned it. For example, he would blow steam on a work, changing the chalk particles into a paste which he worked over with a brush. Often he would "fix" a first sketch, then he would work on it again, then he would apply fixative, and so on, until he got what he wanted. He would also use oil, pastel, and gouache in different combinations, creating a "mixed-media" effect which Mary Cassatt also used in some of her early work.

Cassatt made the most complete statement of the *maternité* theme in her time, creating many memorable images; and as with Whistler's Nocturnes, anyone else handling this subject would inevitably be compared with Mary Cassatt and her fine work. She was a marvelous draftsman with a superb grasp of form. Although she delighted in painting the children of her family and friends, there is a detachment present which suggests as much an interest in the formal qualities of the picture as there was in the subject. Her style was perhaps not as original as Whistler's although it was very personal, indicative of her independence of mind; yet unlike Whistler she never had a following. Her style per se was not as influential as Whistler's.

Mary Cassatt's primary importance was her role as tastemaker. She was instrumental in introducing French impressionist paintings into American collections. She introduced the work of Degas, Pissarro, Monet, Renoir (her "little band of independents," as she called them) to her collector-friends, including the Havemeyers, the Sears, the Potter Palmers. Of the forty works by Degas now in the collection of the Metropolitan Museum of Art, thirty-two are Havemeyer gifts; and it all started when Cassatt persuaded Louisine Havemeyer to buy her first Degas in 1873. And of course, by introducing American collectors to the works of her French friends, she helped spur the acceptance of her fellow American artists.

Mary Cassatt was probably the only American impressionist to be strongly influenced by Degas. The influence of Bastien-Lepage continued to be felt through the 1880s, and the work of Edouard Manet was looked at with strong interest, but the major inspiration, the main catalyst for the style as it was exported from France in the late '80s, was Claude Oscar Monet (1840-1926).

MARY CASSATT
Woman Arranging Veil (circa 1890)
Pastel, 25½ x 21½ inches
Philadelphia Museum of Art

MARY CASSATT
Susan on a Balcony Holding a Dog (1883)
39½ x 25½ inches
The Corcoran Gallery of Art, Washington, D.C.

MARK FISHER
Springtime—Southern France
32 x 40 inches
Vose Galleries, Boston

"The stream of American humour flows on unceasingly, and in the intervals of, or after, painting, the tennis racquet is brought forth and the game is played."

THOMAS SERGEANT PERRY

WITH this amused and amusing comment, Thomas S. Perry, husband of the painter Lilla Cabot Perry, described the American occupation of the French town of Giverny in the 1880s. The occupying forces were painters and would-be painters, and they formed an artists' colony at Giverny because it was a lovely country town within a reasonable distance of Paris; and because Claude Monet had a studio there. In 1883, when Monet found a house at Giverny, he had begun to achieve some success. The year before, Durand-Ruel held the seventh group exhibition of the impressionists, and the thirty paintings Monet included in that show were very well received. In 1883, he had a large one-man exhibition at Durand-Ruel's gallery, and in the following months Durand-Ruel arranged exhibitions for him in Berlin, Boston, London, and Rotterdam; in 1886, his work was included in Durand-Ruel's celebrated New York exhibition of *Les Vingt*. In 1889, Georges Petit's gallery gave him a retrospective, a showing of sixty-five canvases done since 1864. This show was a resounding success. Octave Mirbeau wrote the catalogue preface, and the public was enthusiastic. Monet also showed three paintings at the Paris World's Fair of 1889, the Fair which was dominated by Eiffel's famous tower, and where Whistler, Sargent, and La Farge were awarded the Legion of Honor. It was a good year for American artists in France, prizes and medals being awarded to such American painters as William Merritt Chase, J. Alden Weir, Childe Hassam, and Carroll Beckwith. Two years later, through the intervention of Georges Clemenceau, the French government bought Whistler's portrait of his mother. Gradually the French establishment began to acknowledge the influence of impressionism, and the style was soon receiving official and public acceptance.

By this time, Monet had become a celebrity. In 1890, he was able to buy his house in Giverny, where he was to stay until his death in 1926. The village, apparently, was favored by artists even before he arrived; but Monet, his immediate followers, and the constant stream of American visitors transformed it into an artists' colony. Studio skylights appeared on thatched roofs; there were two outdoor cafés, without which French artistic life would have been at a loss; and across the street from the town's one hotel were the tennis courts alluded to by Thomas Perry. There was the attraction of the Norman countryside, farmers' fields, soft hills, the river Epte with its row of poplars. The Haystack series was painted there, and *Poplars*. Then there was Monsieur Monet himself. The *maitre*, big, bearded, and patriarchal, had the kind of personality that attracts disciples. And attract them he did—first

Theodore Robinson, who came as close as anybody to being a formal pupil; Lilla Cabot Perry (1848–1933) and her husband, who spread Monet's influence in America; Theodore Butler (1860–1936), devoted admirer and eventual son-in-law; Monet's friend Sargent; and Willard Metcalf, who later adopted the impressionist style and became a member of "The Ten."

Although Theodore Robinson, like Homer Martin, has been called "the first American impressionist," and although he is one of the most important and best known American painters to adopt the French style, there were some earlier than he—minor artists to be sure, yet not without interest, and deserving of consideration in the context of the rise of American impressionism. Among them are Mark Fisher, Carroll Beckwith, and William Lamb Picknell. (The last two artists were not, in fact, influenced by Monet.)

In 1962, the Vose Galleries of Boston held an exhibition of the paintings of Mark Fisher (1852–1917), one of the earliest of American artists to essay the impressionist style. Essentially this exhibition was a discovery of Fisher, who was not well known in the art world until then. Yet he was a pupil in Gleyre's studio along with Monet, Renoir, and Sisley, and he was painting impressionist pictures as early as 1869. Fisher left France just before 1870 and returned to Boston; but Boston did not appreciate his work, so he went back to Europe in 1872. However, he settled in England rather than France where he had a good deal of success. In 1893, in his book *Modern Paintings,* George Moore called him "the best landscape painter alive in England"; and as though he were describing Fisher's painting *Springtime–Southern France,* Moore further observed, "Mark Fisher's painting is optimistic. His skies are blue, his sunlight dozes in the orchard, his chestnut trees are in bloom . . . his lanes and fields reflect a gentle mind that has found happiness in observing the changes of the seasons."

(*see page* 114)

Carroll Beckwith (1852–1917) was primarily a figure painter who used a combination of Beaux-Arts draftsmanship and a modified form of impressionism in his practice of portrait painting. At the same time, however, he produced full impressionist landscapes done in the Catskill Mountains near his country studio. In *Woman in White Hat with Veil,* he reveals a trend toward decorative impressionism and an idealization of the female figure, both of which were strong elements in American painting at the turn of the century. There is something of Sargent in it as well, which is not surprising since Beckwith and Sargent shared a studio in Paris and they both attended Carolus-Duran's classes, where Will Low was also a fellow student. Although not a major painter, Beckwith was important as a teacher and tastemaker who helped to spread the new style. He returned to New York City in 1878, and together with William Merritt Chase, started the painting and drawing classes at the newly established Art Students' League of New York. In 1883, he and Chase organized the exhibition—an exhibition that included the French impressionists—to raise funds for a pedestal for the Statue of Liberty;

CARROLL BECKWITH
Woman in White Hat with Veil
21 x 25 inches
Collection of Mrs. Joseph T. Calloway,
Selma, Alabama

Beckwith is thereby on that roster of American artists who helped to intro-
duce impressionism to America.

William Lamb Picknell (1853–1897) worked primarily in France, where
he was beginning to acquire a reputation when he died suddenly at the age
of forty-three. He had decided to become a painter when he met George
Inness in Rome in 1874. Arriving in France in 1876—before Giverny was
the mecca—he went to the Breton fishing village of Pont-Aven, which
Gauguin made famous a decade later. He worked there in the company of the
Anglo-American artist Robert Wylie, who painted tedious subject pictures,
but who handled a palette knife with a virtuosity worthy of Courbet. In
1880, he painted *Road to Concarneau*. Somewhat reminiscent of the Shin-
necock landscapes of William Merritt Chase or the paintings of the Belgian
Alfred Stevens, *Road to Concarneau* is beautifully painted. Built up in a

117

series of small brush strokes, it is a tightly knit structure filled with a vibrant light and atmosphere. Picknell's work contains more detail than most impressionist paintings, reflecting, perhaps, in the realistic rendering of details a trace of Ruskin; but his handling of the overall light is powerful.

In 1889, Lilla Cabot Perry and her husband visited Monet at Giverny, the first of many such visits. It would prove to be a fruitful association—Perry helped to bring Monet and the impressionists to the attention of Americans, and Monet in turn exerted a strong influence on her work. She did, however, come prepared. Perry received her early training at the Cowles School in Boston, where she absorbed a kind of Bastien-Lepage *plein-air* painting as taught by Robert W. Vonnoh and Dennis Bunker. She also studied with Alfred Stevens, but it was Monet of course who had the biggest impact on her work. In her work she reflected his advice: ". . . not the object isolated as in a test tube, but the object enveloped in sunlight and atmosphere."

Lilla Cabot Perry, held in high esteem by her fellow artists, was highly

WILLIAM LAMB PICKNELL
The Road to Concarneau (1880)
42⅜ x 79¾ inches
The Corcoran Gallery of Art, Washington, D.C.

regarded in general, but she was no Mary Cassatt. Perry's work has not the drive, the intellectual clarity, or the luminosity of that of her better-known contemporary. *Bridge—Willows—Early Spring* has the feeling of a gifted and perceptive amateur, of someone who painted for her own satisfaction and delight, a satisfaction and delight that are an integral part of the charm of her point of view. Yet her pictures, despite all their charm, are somewhat static; there is a feeling of "design," a conscious striving for what is permanent. Though a pastel, that most fragile of mediums, *Bridge—Willows* looks like an oil painting.

This sense of solidity seems characteristic of other American followers of Monet as well—for example, Theodore Butler, who married Monet's step-daughter, Suzanne Hoschedé. Butler's *The Mill in Flood, Giverny,* one of his best works, painted in 1890, shares what seems to be a deliberate sense of pattern and solidity with Perry's *Bridge—Willows.* Butler's talent was a bit slight, but his work has merit; on occasion a strong personal quality comes through and, like the works of Lilla Cabot Perry, the paintings of Theodore

(see page 92)

LILLA CABOT PERRY
Bridge—Willows—Early Spring (circa 1905)
Pastel. 25¼ x 31¼ inches
Hirschl and Adler Galleries, New York

119

Butler have a great deal of charm. *The Mill in Flood, Giverny,* is the result of an impressionist method, but the linear arabesques in the drawing would be foreign to an artist such as Monet.

The paintings of these American artists seem as similar to each other as they are different from the work of Monet, especially in the sense of permanence. *"La nature ne s'arrête pas,"* said Monet; Theodore Robinson pinpointed the difference when he said of the French artist's painting that "there is always a delightful sense of movement, vibration and life." And Robinson himself, Monet's most professional and talented follower, never really let go of the object, and although his handling was close to Monet's, he executed paintings of great sensitivity and delicacy, paintings imbued with a feeling of poetic tranquility which are quite different in a basic way from those of the master.

THEODORE ROBINSON
Women Sewing (1891)
26 x 32 inches
Wichita Art Museum,
Roland P. Murdock Collection

120

"This wedding of French-born Impressionism to American art was one of Robinson's achievements."
JOHN I. H. BAUR

AFTER Mary Cassatt, Theodore Robinson was chronologically the next major American painter to achieve successfully the "wedding of French-born Impressionism to American art"; and he was the first to bring it back to the United States. A very quiet man whose understated work was not as well known in his lifetime as that of William Merritt Chase or J. Alden Weir, he was one of the pioneers of American impressionism and one of the most talented artists of the period.

Although Robinson often visited Monet and sought his advice, he was never a formal pupil. More of a follower, he was also a delicate and individual painter, a master of the quiet, intimate *vue*. Even such a panoramic picture as *Valley of the Seine* has the intimacy of a-little-quiet-corner-somewhere about it. His work is lyrical, tender, a little diffident—the work of a man who felt that perhaps he was born to make sketches. *Valley of the Seine* was painted in 1892, and it is a beautiful visual counterpart to his belief in the "continuous loving study of nature." He pursued his studies of nature under the watchful eye of Claude Monet from 1887 when Robinson first appeared at Giverny. The French artist and Theodore Robinson formed a deep friendship. In 1892, Robinson wrote an article about Monet which appeared in *Century Magazine* and Robinson's diary is full of references to Monet and his family: there were frequent invitations to dinner, discussions about painting; Monet's comments on Robinson's work; his encouragement when he visited Robinson's studio to find him enduring one of his attacks of asthma.

(*see page* 122)

In 1888, Robinson began painting his first fully realized impressionist pictures. Monet was the ultimate, the final influence. But in viewing the span of Robinson's career, there are several other important factors which contributed to the development of his art, to the development of the substructure onto which the color and method of the famous French impressionist were superimposed. The linear realist tradition of Eastman Johnson and Winslow Homer was one of these factors, as was his training at the school of the National Academy of Design in New York, and his study with Carolus-Duran and Gérôme in Paris. The camera also played a large part in his creative life, as did his reticent personality and the fragile state of his health.

Although born in Vermont, as a boy he was taken to Evansville, Wisconsin. He started to draw at an early age, and he began his training at the Art Institute of Chicago. But because of his asthma, which troubled him from childhood and would continue to trouble him the rest of his life, he was sent to Denver, Colorado. In 1874, he made his way to the school of

the National Academy of Design in New York City, and while in New York he became one of the founders of the Art Students' League whose name he suggested. In 1876, he went to Paris where he met Will Low, who became a lifelong friend and who wrote a nostalgic account of Robinson in his book, *A Chronicle of Friendships*. Some time in 1878 Robinson went to Venice, where he stayed about a year, met Whistler, and was possibly influenced by him. In any case, there must have been a good relationship between the two men, for Whistler gave him a little painting, a "Souvenir de Venice to Theodore Robinson from James McNeill Whistler."

By 1879, he was back in the United States, first in New York, then in Evansville again; but Evansville, as Robinson said, "was not Athens," and he soon returned to New York. Will Low, who was teaching drawing as well as working for John La Farge, endeavored "to extricate Robinson" from his surroundings and arranged for Robinson to replace him as drawing master in a fashionable school. In 1881, he was elected to the Society of American

THEODORE ROBINSON
Valley of the Seine (1892)
25 x 32½ inches
Addison Gallery of American Art,
Phillips Academy, Andover

Artists, and also in that year he started work for John La Farge, probably once again through the offices of his friend Low. They helped La Farge with his murals and decorative commissions, persuading themselves, in Low's words, "that the days of the Italian Renaissance were revived on Manhattan Island." The experience with La Farge was valuable in one sense, since Robinson was able to turn to decorative work whenever he needed money. And he needed the money until 1884, when he had saved enough of it to go back to France. He did not paint very much during his "Italian Renaissance" period, except for the summer of 1882, which he spent on Nantucket Island in the company of his friend, artist Abbott Thayer. The paintings he did that summer were lighter in color and basically realistic, but more broadly painted and concerned with light and atmosphere; John Baur, in his sympathetic monograph, compares Robinson's work of this period—in which the figures and objects he painted were more solidly and realistically treated—to that of Winslow Homer or Eastman Johnson. Robinson owned one of Homer's watercolors, but his own painting was not as virile or rugged as that of the taciturn Homer. *The Girl with the Dog*, although undated, appears to fit the description of his work at that time. The girl and dog are tightly composed and realistically rendered very much in the style of Johnson's genre pictures and some of Homer's early studies of children. However, there is a stylistic disparity in Robinson's picture. The figure, which is painted realistically, stands out from the landscape, which is painted impressionistically. There is also an element of sentimentality against which Robinson, apparently, had to be continuously on guard. In addition to Robinson's temperament and his lyrical, delicate approach, "sentiment" in general pervaded the art world in those days. It was popular and it sold. This was the era of the subject picture, and exhibition catalogues were loaded with such titles as "Grandma's Tale," "The Wolf at the Door," "The Kiss." It would have been a temptation for any artist without money or patronage to give the public what it wanted, and particularly easy for a painter such as Robinson, who had a sentimental tendency in any case; but after meeting Monet, it was easier not only to avoid that pitfall, but to unify his stylistic disparities.

In 1884, Robinson sailed once again to France where he spent the better part of the next eight years. In Paris he lived on and off with Will Low, and he painted in the country along the Seine. His work at this time was tentative and, in some cases, sober. He also did an occasional decorative picture in the manner of La Farge or Low, both of whom probably influenced his figure painting. He returned to New York briefly late in 1888, and in 1889 he exhibited a group of impressionist paintings at the Society of American Artists. These were among the first impressionist paintings by an American to be exhibited in the United States since Mary Cassatt had sent a couple of canvases to the Society ten years earlier.

THEODORE ROBINSON
The Girl with the Dog (circa 1880)
19¼ x 13¼ inches
Cincinnati Art Museum,
Gift of Mrs. A. M. Adler

123

In *Girl with Goat* of 1886, the inconsistencies of style in *The Girl with the Dog* have been resolved to a certain extent. The subjects are better integrated with the environment to form an overall picture unified by patches of bright sunlight. The subject of a single female figure in a landscape appears to be a persistent theme in Robinson's work. It is possible that this was derived from Diaz or Theodore Rousseau, but it is more likely that Robinson was carrying through on the earlier genre ideas of Eastman Johnson and Winslow Homer, but interpreted in an impressionist palette and with impressionist methods. There is also a possible influence based upon the paintings of his friend Will Low, and the decorative work they both did under John La Farge. The girl in *Girl with Goat* is treated in a generalized manner with hints of the idealized American woman, prevalent at the time in the work of Dewing, Abbott Thayer, Robert Blum, and others, but "translated" into a French peasant amid Norman surroundings in Robinson's painting.

Another characteristic evident in this picture is the feeling that the model was posed for a photograph rather than composed for a painting. In fact, it is quite possible and even probable that Robinson used a photograph as the inspiration for *Girl with Goat*. For even though the handling of the light pattern is similar to that of Homer in *The Bridle Path, White Mountains*, the patterns themselves are also very similar to those captured on film; particularly, for example, in the area under the legs of the goat, where it is possible that Robinson picked up the blur of light from the photograph and carried it over to the painting. In any case, it is well known that he relied on the camera extensively for many of his figure compositions, for his genre oils as well as watercolors. This fact was made evident by the discovery of a group of the artist's photographs in the early 1940s. They were found in Robinson's old hotel in Giverny and, along with another group owned by the artist's niece, formed the basis of John I. H. Baur's article "Photographic Studies by an Impressionist" for the *Gazette des Beaux-Arts* in 1946.

Theodore Robinson probably first began to use a camera in the early '80s and although he made some changes when he transposed the image to the canvas, as he did in *Two in a Boat* (see page 29), for the most part he followed the photographic image quite literally. In this he was the opposite of Degas, who made adaptations from the photograph in order to represent a feeling of continuous movement. Robinson, on the other hand, wanted everything to stand still. "Painting directly from nature," he wrote in the early '80s, "is difficult as things do not remain the same; the camera helps to retain the picture in your mind." A typical example of Robinson's use of the photographic image can be found by comparing his painting *Girl Lying in Grass*, a well-known painting during his lifetime, with the photograph from which it was derived. There is a close correspondence in pose and in the details of the clothing, yet the face of the model is once again generalized

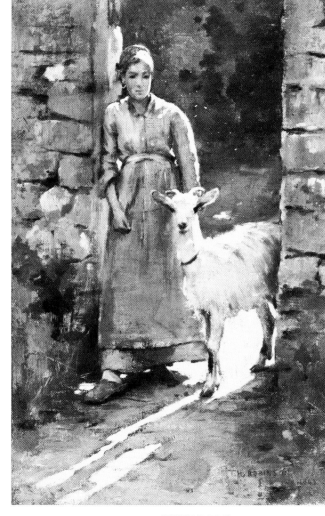

THEODORE ROBINSON
Girl with Goat (1886) 15 x 12 inches
Collection of Steven Straw, Seabrook, New Hampshire

facing page:

Photograph by Theodore Robinson

THEODORE ROBINSON
Girl Lying in Grass (1886)
Watercolor. 5½ x 10 inches
Colby College Art Museum

and the whole picture is transformed by impressionist methods. A delicate balance is thereby created between the concern for "the quiet observation of fact" characteristic of American painting and the dissolution of form in light characteristic of the impressionism practiced by Monet. It was a problem that would preoccupy not only Robinson, but most American painters throughout the nineteenth century.

Although Robinson was also following a practice that was accepted as legitimate by his contemporaries, he occasionally had ambivalent feelings toward the use of the camera. In 1893, he noted in his diary: "I don't know just why I do this"; and later, in 1895: "I must beware of the photo, get what I can of it and then go." At the end of his life, however, he did attempt to use the camera in combination with the actual observation of nature (in painting straight landscape, he presumably did not use the camera at all). Of his painting *Correspondence* of 1895, he notes in his diary, July 21, that he "took two photos of Miss Rean in her hammock writing letters, a little white table nearby, and the cat on the ground. . . ." Thereafter he makes no mention of photography. It seems he used the photograph to help him compose the picture, to "get what I can of it and then go." Robinson's ambivalence probably had something to do with the fact that the camera spared him the necessity of paying models; and for a man in his delicate state of health, it aided him in husbanding his time and energy. "It drags . . ." he wrote in 1894. "A photo would have saved me time as I would have made fewer changes."

THEODORE ROBINSON
Scene at Giverny (1890)
16 x 25¾ inches
The Detroit Institute of Arts

In 1890, Robinson won the Webb Prize, a monetary award for the best landscape painting by a young American artist in the Society of American Artists' annual exhibition. It was the first time it had been awarded to an impressionist painter. There were a great number of impressionist works in that show, and the new painting was gradually replacing the influence of the Munich School. By 1890 or before, Weir and Twachtman, Hassam and many other American painters began to take up the impressionist palette. Also in that year Robinson went back to Giverny; and from 1890 on, he painted some of his best "pure" impressionist pictures, such as *Scene at Giverny,* 1890, or *By the Brook,* c. 1891. The latter was painted, as he said, with conviction and persistence; the figure and landscape are an integral part of the total structure, part of the same aesthetic. *By the Brook* belonged at one time to William T. Evans, who helped to found the Montclair Art Museum and who became one of the most avid supporters of American art. *Road to the Mill* is one of the most successful paintings in Robinson's final impressionist style. Painted in 1892, his last summer in France, *Road to the Mill* is a thorough and consistent impressionist painting. The light color is there, the "all-over" feeling, the seemingly casual execution; yet there is a personal note, a gentleness and intimacy which is Robinson's own. In December 1892, leaving some of his unfinished canvases and some sketches and other odds and ends of materials with French friends, he sailed for America. He had four years to live.

(*see page* 128)

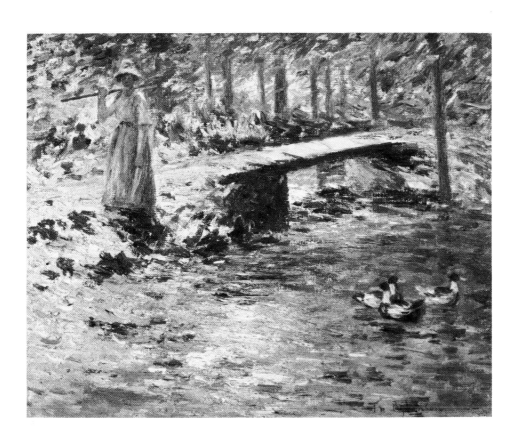

THEODORE ROBINSON
By the Brook (circa 1891) 18¼ x 23 inches
Montclair Art Museum, Montclair, New Jersey,
Gift of William T. Evans, 1915

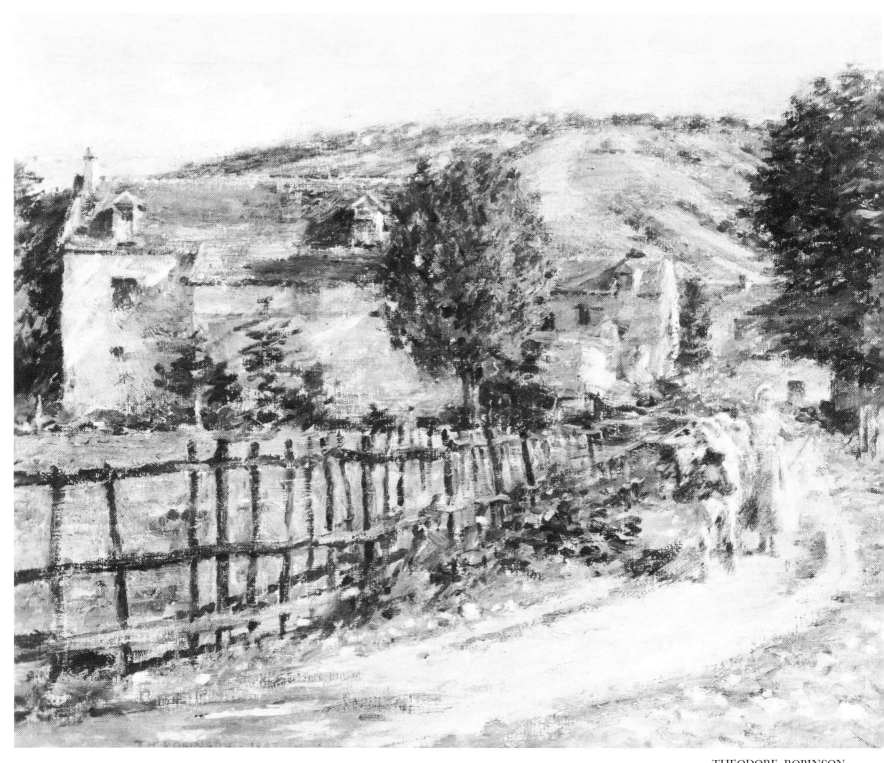

THEODORE ROBINSON
Road to the Mill (1892)
20 x 25 inches
Cincinnati Art Museum,
Gift of Alfred T. and Eugenia I. Goshorn

128

He established a studio in New York in 1893 and then set out to interpret the American landscape with his French technique. He visited Virginia with friends, then went to the World's Columbian Exposition in Chicago where three of his paintings were on exhibition. In the spring he went to Greenwich, Connecticut, where he stayed with the Twachtmans; in the summer he painted at Napanoch, New York, near the Old Delaware and Hudson Canal, where he taught a summer class for the Brooklyn Art School. In the summer of 1894, he did some more teaching, which he hated, and returned to Greenwich. In 1894, he began teaching at the Pennsylvania Academy, and in 1895, he had his first one-man show at the Macbeth Gallery in New York. The show traveled around the country, from Atlanta to St. Louis; Fort Wayne to Cincinnati; and it continued to travel after his death. Theodore Robinson was finally beginning to achieve some success. That summer he found Vermont, where he had been born and which he had left when he was three years old. He not only liked the "line" of the country, but he found at last his American motif, his American Giverny, a place where he could relax and "learn" to paint. But that was in 1895; a year later he was dead.

Theodore Robinson's art appears to have been as fragile as his health. It seems to have flowered in France and withered in America. Perhaps he should have become an expatriate and remained in Europe, but he did not. He felt a need to bring to the United States his French-trained vision, to interpret the landscape of his native soil through his own type of impressionism. As he said, he tried to break away from what was interesting or beautiful "from the European standpoint," to replace the thatched-roof cottage with the "little square, box-shaped white houses," the typical American frame building; but he had difficulty adjusting to the new subject matter. The landscape was different, it was "ragged"; and the light was not the same. And there were other problems. Unlike Sargent or even Childe Hassam, Robinson was not a facile painter, and because of his ill health he had to conserve and concentrate his energy. Moreover, in addition to coping with what seemed to have been the problem common to most American painters of the period, that of combining the visual effects of French impressionism with the linear and descriptive strain of American painting, Robinson had to control a tendency toward sentimentality. Monet helped him to overcome the latter, and to control the unity of his painting, but Robinson was never able to reach the pitch of energy (*"la nature ne s'arrête pas"*) the French master attained in his work. Robinson's work was more static, yet from his remarks about Monet's work, he recognized the need for movement, even just movement of the eye. This perhaps accounts for Robinson's consistent and repeated use of diagonal compositional lines in two and three dimensions since the use of a diagonal thrust on a canvas presupposes movement. It seems as though Robinson's fragile constitution could not cope even with

the *representation* of energy as it appears in Monet's work, so he had to turn to a traditional device for the successful realization of his ideas. His muted color might also be part of this problem, but muted or somewhat quiet color was a characteristic he shared with his American contemporaries.

Robinson was also beset by the feelings that his paintings should be "American"; in other words, he believed he should strive for a more robust execution, a more pronounced virility of style. And although the best expression of his unique style and temperament is seen in *Valley of the Seine* or *Road to the Mill* or *Two in a Boat*, he felt compelled to paint *Branch of the Seine, Giverny* in a more obvious and self-consciously "rugged" manner. The question of an American "school" was much in evidence at that time. The search for an American style was not new, of course, but to many American artists, even at the height of European influence—or perhaps because of it—the question of a national style seemed particularly pressing.

THEODORE ROBINSON
Branch of the Seine, Giverny
(1888) 21¼ x 25½ inches
Museum of Fine Arts, Boston,
Gift of Waldo Pierce

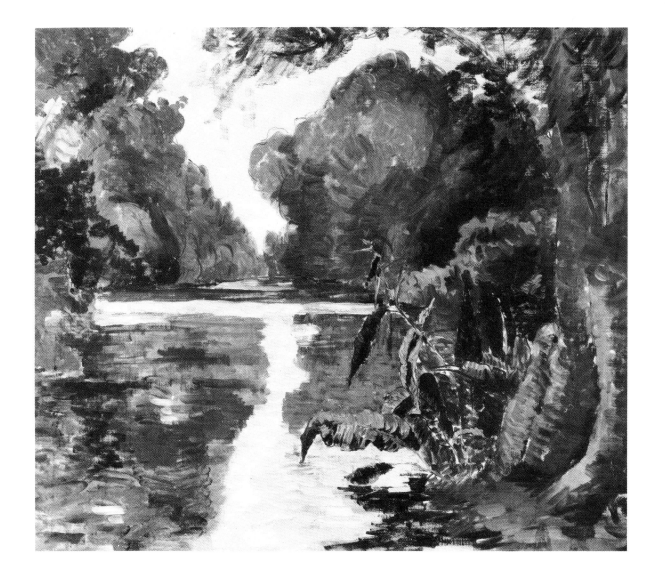

The American Impressionists 1880=1915

CHILDE HASSAM
Flag Day (1918) 36¾ x 25 inches
Los Angeles County Museum of Art
Collection of Mr. and Mrs. William Preston Harrison

131

J. ALDEN WEIR
Fishing Party (1910–1919) 28 x 23 inches
The Phillips Collection, Washington, D.C.

AT the annual exhibition of the Society of American Artists in 1890, the one at which Theodore Robinson won the Webb Prize, there were more impressionist pictures hanging on the walls than at any of the Society's previous exhibitions. The acceptance of the impressionist manner by the art world in America was accelerating rapidly. It would soon become popular, and even fashionable, with the general public as well.

In the late 1880s and early '90s there were four main factors which contributed to the successful rise of American impressionism. The first and most obvious was the sheer number of talented painters who practiced the style. The second factor was the widespread inclusion of American impressionist paintings in annual exhibitions, to which the World's Columbian Exposition at Chicago in 1893 was a climax. The third was the teaching of the style in art schools—an almost definite indication that the particular mode is not only accepted, but, in many cases, practically passé. The fourth factor was the reemergence of the American collector dedicated to acquiring American art. These new collectors had a completely opposite point of view from those who, early in the 1880s, acquired European or modern French art. Like William T. Evans, who wanted to establish a national gallery, the collector of American art at that time was more chauvinistic and, like the collectors of 1830-1860, wanted to see the emergence of a strong national school. However, it was a desire not without irony, as the principal style from the mid-'90s on was American impressionism, which was basically and obviously derived from the French.

The Philadelphia Centennial of 1876, with its crude eclecticism, its giant Corliss engine, and the impact of Japanese and European artifacts, symbolized a rising interest in technology and an increasing cultural dependence on Europe; the Fine Arts section allotted to the United States, however, was dominated by the work of the Hudson River School and its adherents. In the 1893 World's Columbian Exposition it was different. The technology was there, of course, but hidden beneath the frosting of Beaux-Arts architecture. In fact, the Exposition in Chicago could be considered the culmination of European influences, and a particular triumph for Paris-trained American painters, sculptors, and architects. Beaux-Arts historicism, the style of the Second Empire and the Third Republic, French pastry in gleaming white plaster, rose on the shores of Lake Michigan. As described in the official catalogue, the architect of the art gallery itself "is Ionic of the most refined type, the order being taken from the Erechtheum of the Acropolis at Athens. The galleries and courts are lighted from above, and the structure is fireproof. . . . The roof is of iron, steel and glass, and all columns, staircases, etc., are of iron."

133

Also unlike the Philadelphia Centennial, the largest amount of exhibition space in the art gallery was reserved for the United States. The number of American entries in the categories of paintings, prints, and drawings came to a total of 2,395 items, most of which, both impressionist and non-impressionist, were French influenced; and even though there were only 141 paintings by 25 artists in the American impressionist style, all things considered it was not a bad showing for that time. The best painters working in that manner were represented, and it did create interest and it did occasion comments such as that made by Hamlin Garland in his book *Crumbling Idols* of 1893. "If the Exposition had been held five years ago," he observed in his chapter on impressionism, "scarcely a trace of the blue shadow idea would have been seen outside the work of Claude Monet, Pissarro, and a few others of the French and Spanish groups." By 1893, impressionism had affected "the younger men of Russia, Norway, Sweden, Denmark, and America." Mary Cassatt painted murals in the Women's Building; Frank Myers Boggs exhibited two oils; John J. Enneking, five; Mark Fisher, eleven; Leonard Ochtman, three; Lilla Cabot Perry, seven; Theodore Robinson, three; William Lamb Picknell, six, including *Road to Concarneau*. Robert W. Vonnoh had the greatest number accepted, with thirteen canvases which included his *November*. The future members of The Ten American Painters, which would be formed in 1897, were all represented. Frank Benson and William Merritt Chase exhibited three and six oils respectively; Joseph De Camp, one; Thomas Dewing, seven, three of which were loaned by Freer and two by Stanford White; Childe Hassam showed six oils and four watercolors, and *Grand Prix Day* was one of his oils; Metcalf entered three; Robert Reid and Edward Simmons, four and three; Tarbell, three; Twachtman, five; J. Alden Weir showed twenty-six prints and eight oils. Whistler exhibited six, but he was also represented by fifty-nine of his etchings.

These painters were among the best talents of their generation, but most of them could not support themselves by their work alone. Like their counterparts today, many of them taught in art schools and art academies which, along with museums, were springing up in many cities from New York to California. With the return to the United States of artists such as Robert Vonnoh, and John Enneking, Theodore Robinson, William Merritt Chase, and Carroll Beckwith—in other words, artists who had to earn all or part of their support by teaching—impressionist practice gradually became part of the curriculum in American art schools. The generation of American painters who were born in the 1860s and '70s could and, in some cases, did receive instruction from Americans who had already assimilated the new style. Philip L. Hale (1865-1931), for example, studied at the Art Students' League under J. Alden Weir, before continuing his studies in Paris at the *Académie Julian*. Upon his return from Europe, he accepted a position at the Boston Museum School, where he remained for thirty years. He was an

PHILIP L. HALE
The Rosetree Girl
40¼ x 20¼ inches
Mann Galleries, Miami

134

influential teacher, but his painting tends to be weak, decorative, and "sweet," as in *The Rosetree Girl*. He served as art critic for the Boston *Herald*, and in 1913, he published a book on Vermeer. Hale was a contemporary of the Boston painters Frank Benson and Edmund Tarbell; and he also wrote a sympathetic review of the work of another New England contemporary, Walter Griffin (1861–1935), for *The New York Times* in 1908. Griffin's *Paris Countryside*, painted in 1894, has a loose, free, watercolor quality about it and a brush stroke somewhat reminiscent of Maurice Prendergast. Like William Merritt Chase, Frank Duveneck (1848–1919) returned from Europe in the late '80s to become head of an art school, the newly organized Art Academy of Cincinnati. Although Duveneck was not an impressionist painter, many of his colleagues and students began in that style or adopted it later on. One of the more interesting of these painter-teachers in the midwest was Lewis Henry Meakin (1850–1917), an artist whose work is now virtually unheard of outside Cincinnati. He was well known in his day for his Western landscapes, and for his paintings of still life, which, executed with dash and brilliance, are reminiscent of William Merritt Chase.

In San Francisco, the California School of Design provided a post for Emil Carlsen who arrived there from Paris to assume the directorship in 1887. Carlsen was born in Denmark, and studied architecture at the Royal Academy in Copenhagen. He soon decided to become an artist instead, and accordingly he left Copenhagen for Paris. While he was in San Francisco, he came under the influence of Arthur Mathews (1860–1945), whose ec-

(*see page* 136)

WALTER GRIFFIN
Paris Countryside (1894)
35½ x 58 inches
*Collection of Mr. and Mrs. Patrick Coffey,
Birmingham, Michigan*

135

centric ways and personality dominated the art world of California from about 1895 to 1910. A sort of William Morris of San Francisco, Mathews created an eclectic style called California Decorative, elegant and chic, deriving from Puvis de Chavannes, from Art Nouveau, and from Whistler. California Decorative included not only painting, but furniture and useful objects as well. Carlsen was a close friend and colleague of Mathews, and the Danish painter's architectural training may have made him sympathetic to the movement, as well as instilled in him a sound sense of craftsmanship. Carlsen's special concern was still life, and his paintings are beautifully crafted and delicate of surface, reminiscent of Whistler and especially Dewing. Carlsen was concerned with an ideal "beauty" as well as the beauty inherent in the subject, in texture and in color; as in Dewings works, the placement of the objects on his canvas is extremely important, and as in *Blue and White Jug and Vase,* this placement is always just right.

William Merritt Chase was by far the best known of the painter-teachers in his day. But an individual just as important, and perhaps even more so—at least concerning impressionist practice—was Robert W. Vonnoh (1858–1933). In 1884, he taught at the Boston Museum School and at the Cowles Art School, where Lilla Cabot Perry was a pupil. He went abroad for a second time in 1887 and stayed until 1891. He discovered Monet and the impressionists, and his painting changed. When he returned from Europe in 1891, he brought the French manner back to the Pennsylvania Academy, where he was the principal instructor in portrait and figure painting until

LEWIS HENRY MEAKIN
Still Life with Chrysanthemums
(circa 1890) 24 x 36 inches
Cincinnati Art Museum,
Gift of the Meakin Estate

1896. During his term at the Academy, he taught a number of well-known artists. Edward Redfield was a student of his, and so was Elmer Schofield, both of whom became impressionist painters. He also taught William Glackens, John Sloan, and Robert Henri, who were to form the nucleus of "The Eight" in the following decade. Vonnoh's *November,* painted in 1890, considered revolutionary in its day, became his best-known picture. It is indeed a beautiful painting, but hardly rebellious; it bears a resemblance to the spontaneous execution, yet classical structure, of early Pissarro. The solidity in the structure of the buildings and the strong verticals of the trees balanced by the basic horizontal and planar construction of the picture give it a sense of balance and stability. And the general feeling of the point of view relates also to the *Joan of Arc* by Bastien-Lepage. When the critics became better acquainted with his work, they recognized his basic conservatism and felt that he had the good sense and judgment to stop when he had gone far enough. The critics, however, probably did not see *Poppies.* With its close-up worm's-eye view, no horizon, and bright red hues, it is a painting very close to Monet.

(*see page* 75)

(*see page* 103)

EMIL CARLSEN
Blue and White Jug and Vase
23 x 23 inches
*Canajoharie Library and Art Gallery,
Canajoharie, New York*

In the last decade of the nineteenth century there were very many competent American artists, now little known, who espoused the impressionist cause. One of the most interesting was John J. Enneking (1840–1916). Enneking went from Ohio to Boston to study painting, but he began his real artistic training when he went to Europe in 1872. He studied with Bonnat for three years, until he met Daubigny, with whom he studied for a short time before returning to America in 1876. In 1878, he went back to Europe and lived in Holland for six months, studying the Dutch masters. When he eventually returned to this country, he settled in Boston, where his work was already known, and where he evidently had patronage. Enneking was something of a tastemaker as well, and he was not only active in promoting art in his adopted city but he had an important role in the development of Boston's park system. His work was at first tight and linear, but his taste, like many artists at the time, was eclectic. He passed from the Barbizonism of Daubigny to the romanticism of Monticelli, whose work he so

J. J. ENNEKING
Early Autumn (1894)
20 x 24 inches
Vose Galleries, Boston

avidly admired. He soon adopted impressionist principles, and in *Early Autumn,* the localized jewel-like color of Monticelli has spread all over his canvas. In 1893, Hamlin Garland wrote of him, "Only Enneking and some few others of the American artists, and some of the Norwegians have touched the degree of brilliancy and sparkle of color which is in the world today."

In its subtlety and delicacy, the work of Leonard Ochtman (1854–1934) resembles that of John H. Twachtman. Even George Inness admired his painting and Charles H. Caffin, in his *History of American Painting,* said of him in 1907, "He is keenly sensitive to the quiet moods of nature and to the manifestations of the subtlest quality." His work was popular, and he exhibited widely. After his death, his reputation dimmed and his work was stored away in attics. Frank Myers Boggs (1855–1926), on the other hand, received more recognition in France than he did in his native country. In 1882, the French government purchased one of his paintings. Boggs, preferring the lifestyle in France, chose to live there, where he became a citizen toward the end of his life. He specialized in marine pictures and views of the Seine, and although his work was loose and free, he never approached the brilliance of Monet. Rather his work was closer to that of Jongkind, who was a good friend; and like many American painters at the time, Boggs hesitated to give up a linear approach altogether.

Theodore Wendel and Edward Henry Potthast pursued, for a time, parallel careers. They both studied at the McMicken School of Design in Cincinnati (later incorporated into the Art Academy of Cincinnati), and afterwards in Munich. And they both went East, Potthast to New York and Wendel to Boston. Wendel, however, became known for his painting of landscape, and Potthast for his beach scenes. In 1892, Wendel participated in a two-man show with Theodore Robinson; afterwards he disappeared from public attention. Potthast was basically conservative and did not take up the impressionist style until about 1900. The seashore was his theme, his "smiling aspect," which he painted *ad infinitum;* and to a number of critics, *ad nauseam* as well. He was a vivid colorist though, and he used color to good effect.

Gari Melchers (1860–1932), born in Detroit, was primarily a portraitist, skilled and sensitive, who used a modified impressionist style when working in that genre. Arthur Clifton Goodwin (1866–1944) was self-taught. He grew up in Boston and spent a good part of his life painting views of Boston and New York in all seasons, and with great sensitivity. His work definitely deserves to be better known. *Celebration of Armistice Day, 1918,* is a Hassam subject, but Goodwin treats it with a feel for abstraction, and it has the nuance of a Twachtman.

Elmer Schofield (1867–1944) and Edward Redfield (1869–1965) were exponents of "manly" American painting, and such terms as "virile and out-stepping," "crisp and candid," were used to describe their work by the critics

GARI MELCHERS
Portrait of David B. Jones
(1902) 46⅛ x 27 inches
The Art Institute of Chicago

(*see page* 140)

A. C. GOODWIN
Celebration of Armistice Day, 1918
(1918) 50½ x 40 inches
The Metropolitan Museum of Art,
Gift of Raymond Horowitz, 1970

of their day. After studying with Vonnoh at the Pennsylvania Academy, Schofield made his way to Paris. In 1903, he went to England, settling in St. Ives, Cornwall, where he spent four years; and thereafter he traveled back and forth between England and America. Like Birge Harrison, winter was the season he liked best, and his painting, *The Landing Stage, Boulogne,* recalls, in this respect, the Dutch impressionist George Breitner and Whistler's friend Walter Sickert. Schofield was a big, bluff, and hearty man. He liked to paint on six-foot canvases, to tackle "those wonderful things out of doors" and in all kinds of weather, "rain, falling snow, wind—all these things to contend with only make the open-air painter love the fight." Edward Redfield also liked to depict the scenery of winter. After his student days in Paris, he returned to the United States in 1890, settled in Delaware Valley country, and began to produce the big, "virile and thoroughly American" canvases, such as *Center Bridge, Pa.,* that made him famous in his time. Redfield was a friend of Ernest Lawson, William Glackens, and George Bel-

W. ELMER SCHOFIELD
The Landing Stage at Boulogne
54½ x 66½ inches
Cincinnati Art Museum

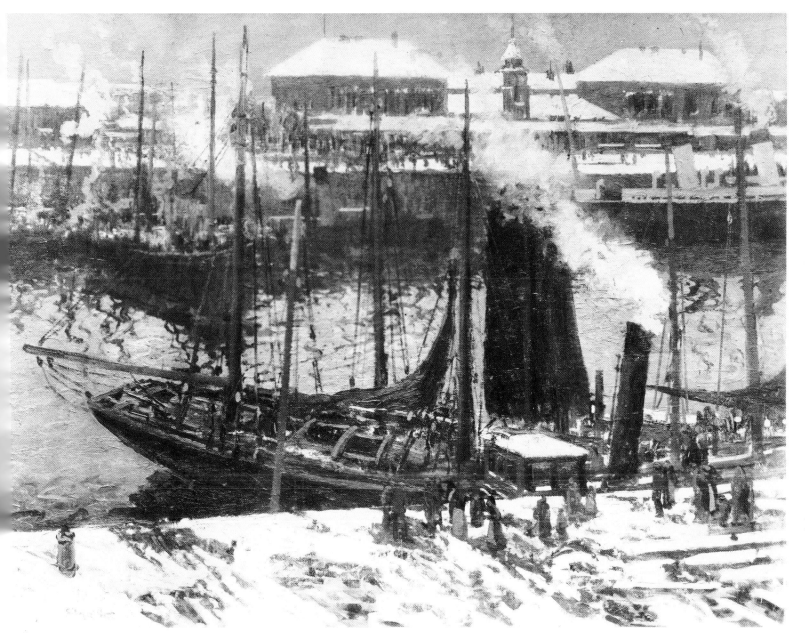

lows. In a sense, both Redfield and Schofield, in their pursuit of a style that was thoroughly "masculine" and "typically American," echo the sentiments of Robert Henri and "The Eight." The subtlety of Twachtman was not for them, and they deplored the "artiness" of Whistler and reacted strongly to his influence. They both reached their maturity around 1910, and like Lawson and Glackens, they tried to instill a new vigor into the American impressionist style, which had taken a decorative, almost quiet, and in many cases sentimental turn. Yet, for all their aesthetic chest-thumping and their real competence, neither Schofield nor Redfield had the *esprit*, talent, or strength of Lawson or Glackens. They did not have the sensitivity or perception of any of the better-known practitioners of the style they were trying to change.

Many of the better-known American impressionists were endowed with great sensitivity indeed; they had insight and a high degree of personal poetry as well. But even if their paintings were imbued with that "brilliancy and sparkle of color" about which Hamlin Garland was so excited, they still

EDWARD WILLIS REDFIELD
Center Bridge, Pennsylvania (1904)
36 x 50 inches
The Art Institute of Chicago

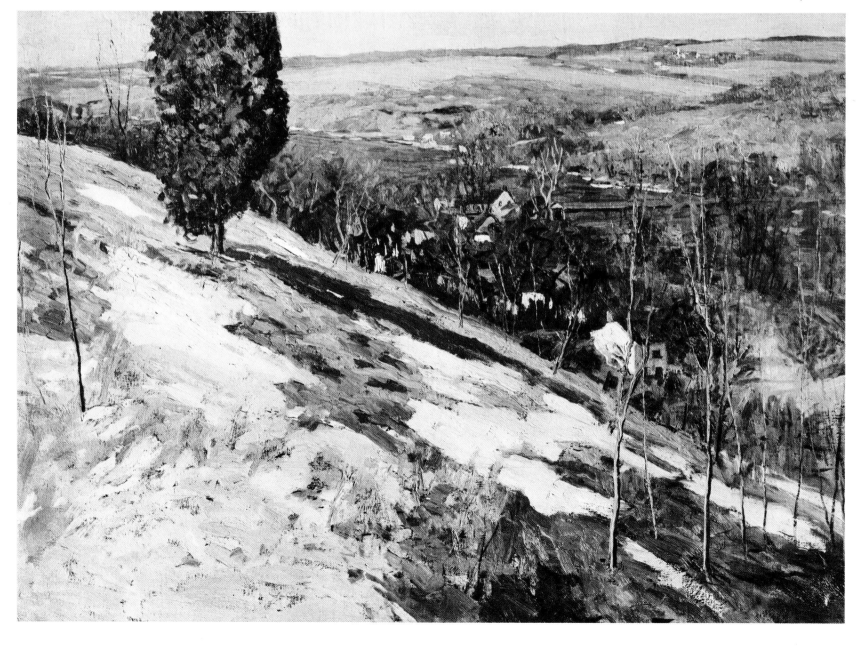

did not inspire the enthusiasm of the well-known and important collectors of their day. Did the Potter Palmers, the Havemeyers, the Mrs. Jack Gardners, who were ahead of their time as collectors, compete to acquire the American disciples of the modern French painting they were among the first to buy? Hardly. In fact, they had little interest in American art in general, and it is most likely that they considered American impressionism a pale imitation of the original French style. Mrs. Potter Palmer, for example, the first collector to introduce impressionism to the Mid-west, (and who was advised by the critic Sarah Hollowell, who herself is credited with introducing Rodin's work to America), bought some American paintings when she and her husband began collecting seriously in 1889. The Palmers bought work by Inness, Tryon, and Mary Cassatt, whose advice they sought in building their famous collection of French impressionists. However, the Palmers' attitude toward American artists was apparently condescending, and when Tryon was kept waiting several months while they were casually thinking about buying one of his paintings, which he, at their request, had set aside for them, the annoyed painter vowed he would sell the canvas to the very next visitor to his studio. He did; and the visitor happened to be Charles Lang Freer, and thus began a happy and beautiful association between the landscape painter and that elegant and most fastidious collector. Isabella Stewart Gardner, "Mrs. Jack," who, with the help of Bernard Berenson, began the boom in Old Masters, also bought a few American pictures; but her buying of American paintings was primarily limited to the canvases of John Singer Sargent, John La Farge, and others of her circle.

However, not all of the early collectors of modern French painting were unsympathetic to American art. There was James F. Sutton, one of the founders of the American Art Association, who was responsible for bringing Durand-Ruel's impressionist exhibition to New York, and who liked to help younger American artists. Irwin Davis, on the advice of J. Alden Weir, bought Manet's work, and also bought paintings by Weir himself, Chase, and Twachtman, the latter being a most "difficult" artist in his time. Mr. and Mrs. Montgomery Sears gave their support to Maurice Prendergast, thereby becoming two of the earliest patrons of modernism in America. But in the main, collectors who acquired advanced French painting as well as American art in an important way were virtually nonexistent. And those collectors whose walls held serried ranks of Old Masters, portraits of the English nobility, fairy tales by French academicians, or the trees of the Barbizon forest, collected American art not at all. The feelings of American painters were forcibly expressed and their situation summed up by John H. Twachtman in an address to students at the Art Institute of Chicago in 1893: ". . . some day some of you will become painters, and a few of you will do distinguished work, and then the American public will turn you down for second and third rate French painters."

Conversely, Mrs. H. O. Havemeyer expressed the collector's point of view. In the early years of their collecting, the Havemeyers bought landscapes by Tryon and pictures by Dewing; Mrs. Havemeyer purchased a set of Whistler's Venetian pastels, and paintings by her friend and adviser Mary Cassatt. But when they began collecting modern French painting and later on the work of the Old Masters, they disposed of most of their American pictures. European art was art with a capital "A", and Mrs. Havemeyer was properly shocked when her daughter, Electra Havemeyer Webb, came home with a cigar-store Indian. Mrs. Webb, who was later to found the Shelburne Museum in Vermont, was enchanted by Americana in all its forms. Her mother was more than shocked—she was appalled. "How can you, Electra," she said, "you who have been brought up with Rembrandts and Manets, live with such American trash?"

No, the American collectors of European art, modern or otherwise, were not interested in American art or artists. But there were a few dedicated collectors who devoted their collecting careers to acquiring substantial numbers of American paintings. Such collectors as Charles Lang Freer, Thomas B. Clarke, George H. Hearn, William T. Evans, and John Gellatly obviously ran counter to the prevailing attitude as enunciated by Mrs. Havemeyer. Barbizon and Salon pictures still brought higher prices than American work, but the famous Thomas B. Clarke sale of American paintings in 1899 helped to bring American prices up somewhat. Thomas B. Clarke, an independent and elegant man who pursued art and pleasure simultaneously, first started collecting Chinese porcelains in 1865 about the time Whistler developed an interest in blue and white; Clarke was only fourteen when he started his collecting career. He later turned to American paintings and his unique and extensive collection was first shown in 1883, the same year in which Chase mounted his exhibition of modern French painting to raise money for a pedestal for the Statue of Liberty.

While Thomas B. Clarke concentrated on George Inness and Winslow Homer, becoming a dedicated patron and promoting their work among his friends, three of the important collectors of American art of the time, Charles L. Freer, William T. Evans, and John Gellatly, concentrated on American impressionist painting. Freer and Evans, who both bought pictures from the Clarke collection sale, were decidedly different, almost opposite, in personality and approach.

Charles Lang Freer, a friend of the Havemeyers, built a fortune in the manufacture of railroad cars in Detroit. By 1900, he had enough money to retire and make collecting a way of life. In 1904, Freer offered to give his entire collection to the Smithsonian. He proposed to pay for the building to house his collection, with the proviso that he would be its first, and unpaid, director. Although this was the first important gift of works of art to the government by an American collector, the Smithsonian trustees were slow-

144

moving, a bit suspicious of Freer—an aesthetic and intellectual dandy—his "impressionistic collection," and the nature of his unusual offer. It was not until Theodore Roosevelt intervened that Freer's offer was finally accepted in 1906. Freer's extremely refined taste was limited to those artists—Dewing, Thayer, Tryon—he felt were kindred spirits to his great friend Whistler. In fact, according to his own statements, he would not acquire the work of any American painter whose style in some way did not bear a relationship to Whistler's thought and achievement. Although the Freer Gallery is famous today for its holdings of exquisite examples of Chinese and Japanese art, it is also a monument to the famous expatriate, the *contemporary* artist whom Freer admired most. And it was Whistler who aroused in Freer his consuming interest and passion for oriental art. Freer began collecting Whistler's prints in 1887; he became a friend and patron of the artist about 1894, and during the artist's lifetime he purchased as much of Whistler's work as he could acquire.

William T. Evans, a man of more modest means than Freer, was by 1900 on his way to a scandalous bankruptcy brought about by the use of his company's funds to buy his considerable collection of paintings. The scandal was averted when the company, of which he was president, was reorganized in 1913. But by that time his most active collecting years were over. In 1907, he went a step beyond Freer in the promotion of American art, and certainly much further than the noted collector George H. Hearn, who created a fund in the Metropolitan Museum of Art for the acquisition of American pictures. From 1907 to 1915, Evans donated American paintings to the Smithsonian with the goal of founding a national collection in Washington. Evans' choices were more wide ranging than Freer's, and the former's aims were more ambitious, nationalistic even. Evans presented the nation with 150 American pictures, representing 105 artists. Although Blakelock appeared to be his favorite painter, with thirty-four in the collection, Evans showed a marked interest in the American impressionists, particularly Dewing, Hassam, Robert Reid, Robinson, Twachtman, and Weir; he had four Dewings, eight Hassams, eight Reids, seven Robinsons, twenty Twachtmans, and five Weirs.

William T. Evans performed a great service to American art, and he inspired other collectors to follow his example. One of the most notable was John Gellatly, who gave his collection of 142 American pictures to the Smithsonian in 1929. Something of a mystic, Gellatly acquired seventeen Ryders and twenty Thayers; but he also leaned toward the impressionists, with seventeen Dewings, fifteen Hassams, and a dozen Twachtmans. The Evans and Gellatly collections form the basis for the present National Collection of Fine Arts, and a substantial portion of this collection is given over to the work of the American impressionists, many of whom were members of The Ten American Painters, which was organized in 1897.

CHILDE HASSAM
Church at Old Lyme
(1903) 36⅝ x 28⅝ inches
Collection of Mr. and Mrs. Irving Mitchell Felt

". . . the exhibition of the Ten American Painters (my idea) started by J. Alden Weir and myself, with Twachtman first,"

CHILDE HASSAM

L ATE in December of 1897, Childe Hassam, J. Alden Weir, and John Twachtman submitted their resignations to the Society of American Artists. They were joined by seven other sympathetic painters, who, dissatisfied with the huge size and increasing mediocrity of the Society's annual exhibitions, decided to form a loosely knit group of their own; they felt that the Society was just as stuffy and conservative as the National Academy of Design from which it had separated in 1877. On January 9, 1898, under the heading of "Eleven Painters Secede" (the eleventh was Abbott Thayer, who in fact joined only briefly), *The New York Times* reported: "Eleven painters, who say that they no longer felt the atmosphere of the Society of American Artists congenial to their views and purposes of art, have withdrawn from membership in the Society. They are J. Alden Weir, once president of the Society; Edward Simmons, Abbott H. Thayer, John Twachtman, Robert Reid, Childe Hassam, Willard Metcalf, and Thomas Dewing of New York, and Joseph DeCamp and Messrs. Benson and Tarbell of Boston.

"It is not the intention of these gentlemen to organize a rival society, or indeed, to form any organization at all, Mr. Weir said last evening. He said that the seceding artists grew dissatisfied with their membership in a large body which is governed by form and tradition, and having sympathetic tastes in a certain direction in art, they had withdrawn from the Society of American Artists to work together in accordance with those tastes. Mr. Weir said that one object of his friends and himself, following the Japanese view, is to get rid of the barbaric idea of large exhibitions of paintings, and so they propose to give each year a small exhibition limited to the best three or four paintings of the men interested in the new movement."

The name was arrived at by the number of members in the group and as it was originally planned, there were to be twelve. They had asked Abbott Thayer and Winslow Homer to join, but Thayer, who was mentioned in the *Times* article, backed out before the first exhibition; and in a letter to Weir of January 20, 1898, Homer replied, ". . . On receiving your letter I am reminded of the time lost in my life in not having an opportunity like this that you offer—The chance that each member will have of showing their work in a group—the larger the better, and under their own directions will be a great spur in tempting them to great effort and enterprise. I know on my own part that I have been kept from the Academy exhibitions by the fear of the corridor and the impropriety of my trying to make terms as to placing my work. You do not realize it, but I am too old for this work and I have already decided to retire from business at the end of the season." It seems

as though Homer was alienated, even to the point of not exhibiting with artists he admired.

And so the group of The Ten American Painters, or the Ten, was formed; and Edward Simmons, in his autobiography, *From Seven to Seventy,* recalls its beginnings: "The Ten American Painters was started quite by accident, and when the too-human elements began to enter, it died a natural death. We never called ourselves the 'Ten'; in fact, we never called ourselves anything. We were just a group who wanted to make a showing and left the Society as a protest against big exhibits. At our first exhibition at the Durand Ruel's Gallery we merely put out the sign—'Show of Ten American Painters' and it was the reporters and critics speaking of us who gave us the name. In the original group were Twachtman, Dewing, Metcalf, Reid, Hassam, Weir, Benson, DeCamp, Tarbell and myself. After the death of Twachtman, Chase was voted in to take his place. . . . The first few years we divided the wall into equal spaces and drew lots for them, each man having the right to use it as he saw fit, hanging one picture or a number of pictures. . . . But then objections came in. I, being a mural decorator, had large work, and those members with small canvases naturally did not want them hung next to mine. . . . At last to save controversy, we left the hanging to the dealer, and he placed those which sold best in the choice parts of the room. . . . We were accused of starting as an advertisement, and indeed, it proved a big one, but there was no such idea in the mind of anyone of us. Many others took it up, and a group followed us, calling themselves 'The Eight' in an attempt to boil the egg over again."

By disassociating themselves from both the Academy and the Society of American Artists, the Ten hoped to attract more attention from the public, to show their work conspicuously and profitably. As Hassam recollected thirty years later, "These small shows were decidedly a success." In an article for *The Art News* of April 1928, he pointed out, "The exhibitions were not too large to be seen easily. It was not an effort, as larger collections of pictures usually are." And although J. Alden Weir was reported as saying, "there was no ill feeling in the secessionists," the resignations of so many good painters from the Society did raise a considerable fuss; but the first show of the Ten in March of 1898 was successful enough to become a permanent feature of the season for the next twenty years. "Show of Ten American Painters" opened appropriately enough at Durand-Ruel's New York gallery on March 31, and it ran for two weeks, overlapping the exhibitions of the National Academy and the Society of American Artists. There were no officers of the new group and no jury. In addition to each man receiving an equal amount of space, each artist's works were arranged by artist and "hung on the line" with plenty of space in between. The gallery was simply, even sparsely, decorated, "following the Japanese view" so that the installation did not overpower the paintings, the sort of thing Whistler pioneered in

his exhibitions, and in his home. If the color of the walls did not suit the paintings, it was changed to provide a better setting and a unified look, which was another of Whistler's devices. The press was generally favorable, and the critic from *The New York Times* was enthusiastic about the grouping of works by an individual artist, pointing out in his review of March 31, 1898, that it enabled "the visitor to study the work of each painter by itself, and then as compared to his fellows."

Most of the critics, however, expected a more rebellious art, "the most advanced form of painting," but they found no proclamations, no "new views"; instead, they reached the seemingly disappointing conclusion that the show was good solely because of the "intrinsic quality" of the work exhibited. Indeed, the Ten were radical neither in subject matter nor in technique; the "sympathetic tastes" shared by the group was the practice of variations on the French impressionist theme, which by 1898 had already met with a certain degree of success.

Yet it is evident from their invitations to Abbott Thayer and Winslow Homer, who were not impressionist painters, that the break with the Society was not solely caused by the adherence to impressionist methods. As both Weir and Simmons had pointed out, the Ten was formed primarily because of the old-fashioned exhibition practices, overly large membership, and bureaucratic attitude of the Society of American Artists. Nevertheless, in addition to Mary Cassatt and Theodore Robinson, who died a year before the Ten was organized, the members of The Ten American Painters were the leading figures of the American impressionist movement. Like their French counterparts, the Americans were already experienced artists who had been working fifteen years or more by the time of their first exhibition in Durand-Ruel's New York gallery. Not all the Americans had been impressionists for that length of time, but by 1898, their styles were mature and their influences had been absorbed. Their work was imbued with the professionalism of European, particularly French, training. The conceptual and descriptive approach of American landscape painting was infused by the *plein-air* painting of Bastien-Lepage and by the colorism of Monet and the French impressionists. Whistler continued to be an influence, an inspiration in a variety of ways on a number of painters, who, although they shared "sympathetic tastes," were as different from each other as Monet was different from Degas. For just as the label "impressionist" as applied to the French covers a wide range of styles from the conceptualism of Degas to the almost pure perceptual approach of Monet, with Renoir, Pissarro, and Sisley in between, so the term "American impressionist" as applied to the members of the Ten, covers the same wide range—from the conceptual painting of Thomas Dewing to the more perceptual approach of Childe Hassam.

Childe Hassam (1859–1935), John Henry Twachtman (1853–1902), and J. Alden Weir (1852–1919) were instrumental in founding the group,

and were three of its strongest painters. According to Childe Hassam, the Ten was his idea in the first place, but Weir and Twachtman put it into effect. And in regard to individual painting styles, Hassam is of these three, and perhaps of the whole group, the one whose paintings are most closely associated with French impressionism, at least in the public mind. His work was somewhat more superficial than that of Weir or Twachtman, and he was close to Monet in his love of the métier. Hassam was a natural-born painter; he enjoyed painting more than anything else, and his work is particularly fresh, and his color, for the most part, bright and scintillating.

He was born in Dorchester, Massachusetts, the son of a Boston merchant and antique collector. On his mother's side he was related to William and Richard Morris Hunt. His interest in art began early, and instead of going to college, he went to work in a wood-engraver's office in Boston; and later studied painting under the little-known Boston artist I. M. Gaugengigl. In 1883, he went abroad for the first time: to England, the Low Countries, to Spain and Italy; but when he went back in 1886 he settled in Paris, studied at the Académie Julian, and came under the influence of the impressionists. Hassam's early work was basically tonal; and although *April Showers, Champs Elysées, Paris,* painted in 1888, echoes the gray tonality of his

CHILDE HASSAM
April Showers, Champs-Elysées, Paris
(1888) 12½ x 16¾ inches
Joslyn Art Museum, Omaha, Nebraska

Boston pictures, the handling is broad, free, and perhaps not without the influence of Manet. But *Grand Prix Day*, painted a year earlier, has all the vividness, the sparkle, and the charm associated with the impressionist style. The general effect of the composition, particularly the placement of the coach and four at the extreme left, might owe something to Degas; but the evocation of bright sunlight, the freely brushed masses of the trees, the sure and dashing treatment overall suggest early Monet or Alfred Sisley; and suggest also a man in full and independent command of his métier, a thorough knowledge of impressionist practice. *Grand Prix Day* (there is a smaller, more sketch-like version in the Museum of Fine Arts, Boston) was a Salon Picture, and Hassam won a Gold Medal for it in the Paris Salon of 1888; in 1893 it was shown at the World's Columbian Exhibition in Chicago.

CHILDE HASSAM
Le Jour du Grand Prix
(1887) 36 x 48 inches
*The New Britain Museum of American Art,
New Britain, Connecticut*

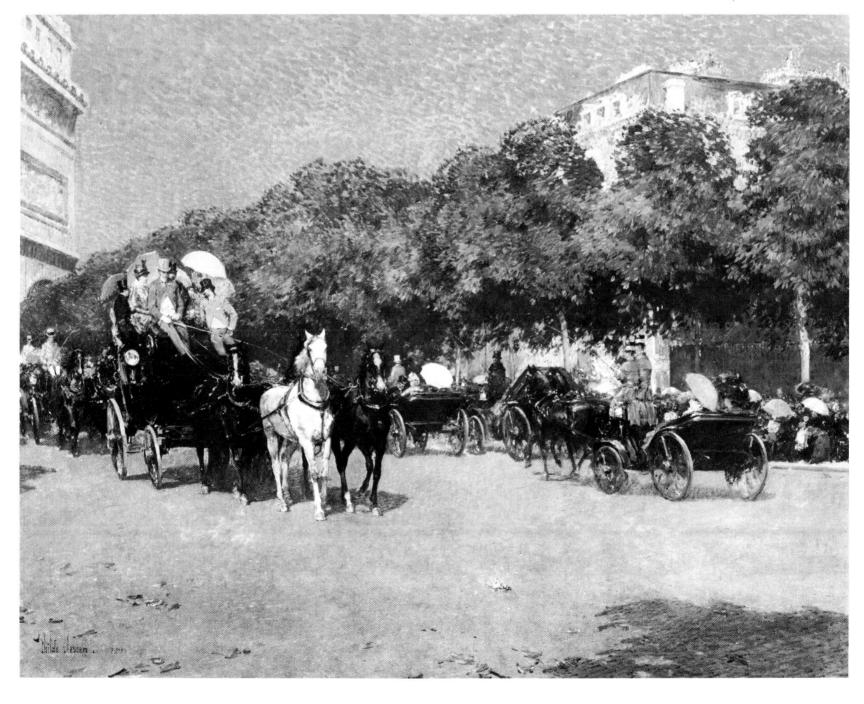

In 1889, Hassam was included in the Paris Exposition and came back to America with a bronze medal and a brighter palette. He established a studio in New York during the winter, and in the summer New England became his painting ground. He worked in Old Lyme and Cos Cob; Gloucester and the Isles of Shoals at Appledore, where he and his wife had spent a good deal of time beginning in 1884 when they were first married. Hassam was introduced to the Isles of Shoals by the writer Celia Thaxter (1835–1894) who had a house there. Celia Thaxter was the poet laureate of Appledore when it was the favorite watering place of Boston's artistic élite. Childe Hassam was Mrs. Thaxter's "spark from the great central fires sublime. . . ." She was a pupil of Hassam's at one time, and she believed in his work. In 1890, she even wrote a poem about him, a sonnet on Childe Hassam, from which the above line was taken. And he in turn painted her many times, in her garden, her house, amid the surroundings in which he produced some of his most cheerful and painterly impressionist pictures. One of the last, and one of his best, is *The Room of Flowers*. Painted in the year Mrs. Thaxter (*see page* 188) died, it is, in retrospect, a kind of memorial to a good friend. Behind the vase of daffodils, the focal point of the painting, Celia Thaxter can be seen reading a book. She almost disappears into the explosion of brilliant color and profusion of detail, yet the flowers in the room are probably meant as a tribute to her. This painting, with its extraordinary vitality and energy, was a high point in the artist's career, and the painting in which he comes closest to Monet. *The Room of Flowers* was painted in 1894, during that decade when his style reached its maturity, and when he was recognized as one of the leading American artists of his day. His work was appreciated from the start, and he had no trouble selling it; he was popular in his day and he is popular still.

The Room of Flowers is cheerful, outgoing, gay, painted in the high-keyed palette and wiry brushwork for which he is best known. However, Hassam was not dogmatic about it, and he returned, every once in a while, to the softer tonal harmonies of his early Boston period. He painted New York on gray snowy days, and he painted New York at night in such pictures as *Fifth Avenue Nocturne* (Cleveland Museum) in which he shows a debt to Whistler. He did a series of interiors, figures in front of windows, about 1911 or earlier, in which there is a quiet feeling of intimacy and an approach to the problem of inside and outside light. One of the best and most charming of these quiet, intimate pictures is *The Children*. Painted in 1897, his tough and wiry style serves a tender purpose, and its carefully orchestrated and muted palette of ochres, grays, and whites echoes Whistler, and to a certain extent, some of the interiors of J. Alden Weir. The children sit at a table in the foreground, but the real subject is the soft, quiet light which filters through the almost transparent curtains, and describes the setting and the mood of the children themselves.

CHILDE HASSAM
The Children (1897)
18¼ x 14½ inches
Cincinnati Art Museum, Bequest of Ruth Harrison

Also in 1897, Hassam went back to Paris, where he painted *Pont Royal, Paris*. One of the most famous of his French pictures from that period, it is also one of his most delicate—airy even; and there is a feeling of Twachtman or Metcalf about it.

When he returned to the United States, he continued to paint in New York, on the Isles of Shoals, and at Old Lyme; he never stopped painting the New England landscape he loved. *Church at Old Lyme* is the quintessence of the white New England church, as it is the quintessence of Hassam's popular style. *Church at Old Lyme* was painted in 1903, and by 1908, when he painted *Bridge at Old Lyme,* his landscape style began to undergo some interesting changes. In *Bridge at Old Lyme,* there is an element of flat patterning; in the clouds and in the line of trees in the distance, for example, the painterly brushwork is enclosed within an outline. The same technique applied to figure painting did not work; thus his figures are flat and unsuccessful, seeming to be pasted on somehow; evidently he had a lot of trouble adjusting an impressionist technique to the painting of the figure. In *Bridge at Old Lyme,* which is not unsuccessful, he seems to have tried to combine both approaches in the painting of landscape. It has a more stylized, almost post-impressionistic look; in fact it is somewhat reminiscent of Van Gogh, particularly the figure with the knapsack crossing the bridge and, of course, the bridge itself. In 1908, Hassam went west, to San Francisco and up into

(*see page* 147)

CHILDE HASSAM
Pont Royal, Paris (1897)
24½ x 28½ inches
Cincinnati Art Museum

154

CHILDE HASSAM
Bridge at Old Lyme (1908) 24 x 27 inches
Georgia Museum of Art, The University of Georgia,
Eva Underhill Holbrook Memorial Collection of
American Art, Gift of Alfred H. Holbrook

CHILDE HASSAM
Fifth Avenue (1919)
24⅛ x 20¼ inches
The Cleveland Museum of Art, Anonymous gift

Oregon, and it is possible that he might have been a little influenced by the painting on the West Coast, by the patterned, flat style of Arthur Mathews and his followers.

He returned to Paris once more in 1910, and at that time he painted the first of the flag pictures in which he tried to unify the flags, buildings, and the movement of the crowd celebrating Bastille Day. It was a theme which he took up again more successfully in New York from 1917 to 1919, in such pictures as *Flag Day, 1918*. Here again there is an interesting contrast between the linear and almost geometric treatment of the flags as pattern, and the blurred handling of the crowds of figures as impression. *Fifth Avenue, 1919,* although short on flags, beautifully joins the static architecture with the fluid crowd, and captures the essence of the ebb and flow of large numbers of people. And in its pictorial construction, it is prophetic of the early work of the contemporary American painter Mark Tobey. Hassam died in 1935, but, by and large, he had done his best work in the 1890s and in the years shortly after. He had outlived impressionism, and although his work after 1908 contains hints of a post-impressionist style, he never pursued those possibilities. Instead he often repeated himself. *Mixed Foursome (First Tee, Maidstone Club),* painted in 1923, is a case in point. The elongated figures are mannered, and his controlled, wiry style has become slack. Compared to Weir and Twachtman, Hassam's style is "easy." His *Isles of Shoals* of 1901, with all of its sparkle and light, misses the depth of feeling, the intensity of Weir's *Upland Pasture,* or the profound statement about nature made in the introspective *Spring Morning* by John Twachtman. In contrasting the work of the three founders of the Ten, in comparing the prose stylizations of Weir, the poetry of Twachtman, Hassam had the most facility, sheer exuberance, the most joy of the three. His best work makes him one of the most important American impressionists, and he made his contribution not only with his painting, but by his activity on behalf of American art.

J. Alden Weir was also a tireless worker on behalf of American art, and he helped his fellow artists, regardless of nationality. For Puvis de Chavannes he procured a commission to do the murals for McKim, Mead and White's Boston Public Library; he was a close friend and ardent champion of Albert Ryder; and he was always trying to sell Twachtman's paintings, even to the point of refusing a sale of one of his own unless a Twachtman went with it. Weir not only was a key organizer of the Ten, but helped to organize the Society of American Artists ten years earlier, acting as secretary during 1879 and 1880. He also served as president of the National Academy from 1915 to 1917.

J. Alden Weir was born in 1852 into an artist's family in West Point, New York. His brother, John F. Weir, was an artist and teacher, and they both received their early training from their father Robert, who taught drawing at the United States Military Academy from 1834 to 1876. In that capacity

(see page 131)

(see page 158)

(see page 159)

CHILDE HASSAM
Mixed Foursome (First Tee, Maidstone Club)
(1923) 27¼ x 44¼ inches
*Milwaukee Art Center,
Gift of Chapellier Galleries*

he also taught future generals Grant, Lee, and Sherman; and James McNeill Whistler during the latter's brief career at West Point. J. Alden Weir then went on to study at the school of the National Academy of Design in New York, and was a classmate of Albert Ryder and William Merritt Chase. In 1873, the widow of his godfather, Captain Bradford R. Alden, generously paid his way to Europe, and he arrived in Paris in October, after spending a month in London. He studied at first under Gérôme, then in the same year he met Bastien-Lepage and became part of his group as well as his intimate friend. Later, in 1896, Weir would write a biographical "appreciation" of Bastien-Lepage, who died in 1884.

In the 1870s, Weir believed, as did Ingres, that "drawing is the probity of art." Consequently he was awed by Raphael but found Velasquez "disappointing" (his drawing filled Weir with "regrets"), and the first French impressionist exhibition he ever saw deeply offended him. Yet he copied Velasquez and Hals; and although Bastien-Lepage was his primary influence then, he also admired Whistler's paintings. However he did not think much of Whistler as a person. Visiting the expatriate American before returning to

CHILDE HASSAM
Isles of Shoals
(1901) 25 x 30 inches
The Metropolitan Museum of Art,
Gift of George A. Hearn, 1909

158

America in 1877, Weir found him "a snob of the first water" and "a harmless man." Nevertheless, around 1894 Weir and Chase tried to get the Metropolitan to buy Whistler's *The White Girl* when it was on exhibition there. It is a pity the museum refused, as it would have made an interesting complement to Manet's *Woman with a Parrot* which, although painted twenty years later, bears many similarities to Whistler's picture. In 1901, Weir and his family visited Whistler; and in 1913, he made a special trip to see the marvelous *Portrait of Carlyle* in Glasgow. Even before that date, however, Weir was influenced by Whistler's work. *Reflections* (or *Reflections in a Mirror*), with its careful use of verticals and horizontals, recalls Whistler's portraits of his mother and of Carlyle; the pose of the figure with her hand on her hip is also reminiscent of some of Whistler's full-length portraits, and the flat patterns of the composition might also derive from Whistler's use of Japanese devices.

(*see page* 35)

(*see page* 11)

J. ALDEN WEIR
Upland Pasture (1905) 40 x 50¼ inches
National Collection of Fine Arts,
Smithsonian Institution, Washington, D.C.

Weir settled in New York, became involved in the Society of American Artists, and looked for portrait commissions. He also started teaching in 1878, first at Cooper Union and later at the Art Students' League. His portraits were straight-forward and solid, and the critics found them full of "manly qualities." His work during this period was relatively tonal; his portraits stood out from a dark background and so did his still lifes. But he was developing an eye for modern European painting, and in 1880, he was delighted when he was commissioned to go to Europe to buy paintings for Irwin Davis, the New York collector. Davis did not want European chic, he did not want any Gérômes in his collection, so Weir brought back Bastien-Lepage's *Joan of Arc,* now in the Metropolitan; and the next summer he went further and bought for Davis a collection of Rembrandt etchings and about thirty paintings, which included Manet's *Boy with a Sword* and *Woman with a Parrot,* a Courbet, a portrait by Reynolds and another by Gainsborough. From that time on, Weir became an admirer of Manet. However, Weir reserved his greatest admiration for Albert Pinkham Ryder, not only admiring that most solitary genius, but believing in his work at a time when most people thought Ryder's art strange, to say the least. Weir became something of a brother to Ryder; he cared for him, took him to the hospital when he was seriously ill, and paid the expenses for the funeral when Ryder died. Professionally, Weir persuaded Ryder to show with the newly formed Society of American Artists, and promoted his work whenever he could. Weir persuaded his boyhood friend, the collector (Colonel) C. E. S. Wood to buy Albert Ryder's masterpiece, *Jonah and the Whale,* which afterwards entered the collection of John Gellatly, and is now in the National Collection of Fine Arts, Washington, D.C.

Although Weir's style leans toward a gentle and intimate prose style, what poetry there is in his work, particularly in his landscapes, probably derives from Ryder. Weir painted Ryder's portrait, now in the National Academy of Design, New York, and in *Pan and the Wolf,* he painted at least one picture in which even the subject recalls Ryder. In Weir's *Fishing Party,* the position of the tree on the left, the treatment of the clouds, and the jewel-like texture in certain areas, especially in the handling of the three figures on the bridge, create an effect that hints of Ryder's personal poetry.

(*see page* 132)

Throughout the 1870s and '80s, even as late as 1888, when Weir painted the lovely still life *The Delft Plate,* his palette was still fairly dark. *The Delft Plate,* once owned by Mrs. Stanford White, is Chardinesque in spirit but more like Manet in its execution and tonal values. Weir's early still lifes, like this one, are outstanding. Emil Carlsen, who specialized in painting still lifes, recalled, "The first painting by Weir I ever saw was a small picture of tea-roses, a few inches square, quite sketchy, an understanding of how blossoms should be painted, a revelation." *Still Life,* painted circa 1889, is natural, easy; it is still tonal, but much lighter. It was not until 1889–1890

facing page:

J. ALDEN WEIR
The Delft Plate (1888) 22 x 13¾ inches
Museum of Fine Arts, Boston
M. and M. Karolik Collection

that his palette really began to brighten, at least in the painting of landscape, and this was perhaps due both to the influence of his friends John Twachtman and Theodore Robinson and to the experience of working in the open air. By the 1890s, he had developed his impressionist style.

In 1891, Weir had the first one-man show of his impressionist paintings at the Blakeslee Galleries in New York, and in 1893, he and Twachtman showed together with Monet and Albert Besnard, who were presumably included for purposes of comparison and explanation. It was an interesting idea and quite forward-looking for the time. The critics praised the French, had reservations about Weir, and understood Twachtman not at all. Also in 1893, Weir was included in the World's Columbian Exposition in Chicago with eight oils and twenty-six etchings. Thereafter, his pictures became more popular and his work began to sell. *The Red Bridge,* painted about 1896, with the bright red of the bridge amid the softer greens and yellows of the foliage, the blue of the sky, is typical of Weir's lighter, more impressionist palette. Typical also is the thoroughly worked out composition with its strong diagonal movement and emphasis on draftsmanship. In spite of the bright red, however, *The Red Bridge* is fairly muted in color. More conservative than Twachtman, Weir espoused a kind of "tonalistic" impressionism with which he conveyed his ideas and his delight in familiar surroundings. And his special delight was the out-of-doors, the fields, the woods, and as in *Midday Rest in New England,* the farm. *Midday Rest* was painted at his farm in Branchville, Connecticut, which the collector Irwin Davis gave him in exchange for a picture. (see page 102)

J. ALDEN WEIR
Portrait of John H. Twachtman
(1894) 21½ x 17¼ inches
Cincinnati Art Museum, Gift of the artist

J. ALDEN WEIR
Still Life
24¾ x 36⅛ inches
Indianapolis Museum of Art, James E. Roberts Fund

His studio work, however, retained some of his earlier dark tonalities, although that varied from subject to subject. In his *Portrait of John H. Twachtman* of 1894, for example, Weir's friend emerges from a background of almost total darkness. It is a moody picture, but then perhaps that is what Weir wanted; the Cincinnatian was a moody man, given to fits of extreme depression. Some years after Twachtman's death, Weir presented the portrait to the Cincinnati Art Museum. *The Gray Bodice*, on the other hand, has a lighter, more feathery touch. Painted in 1898, it is executed with love, simplicity, and charm, and, like all his portraits, without affectation and without mannerism. Like *The Red Bridge, Building a Dam, Shetucket* is a strong picture and points toward the style of Ernest Lawson. *Building a Dam* is tightly controlled in organization and beautiful in color; and although the

(*see page* 164)

(*see page* 97)

J. ALDEN WEIR
The Red Bridge 24⅛ x 33¾ inches
*The Metropolitan Museum of Art,
Gift of Mrs. John A. Rutherfurd, 1914*

palette is bright, the general effect is one of sobriety and solidity. Weir was a solid painter, very straight-forward, prosaic even. He did not have the facility of Hassam or the subtlety, the nuance, the sensitive poetry of his best friend and colleague in the Ten, John Henry Twachtman.

Twachtman was the most sensitive and unique of all the American impressionists. His painting was more searching, his style more personal; he understood abstraction, the essence of things. Emil Carlsen talked of his poetry, and Edward Simmons likened him to a faun; but he was not very well known in his lifetime. His work was not easily understood, and consequently he did not sell very much. Twachtman had a mystical side, he was something of a dreamer. He was also ambitious; he wrote to Weir in 1880— saying almost exactly what Vincent van Gogh had written in one of his letters to his brother—"You do not know how tempting every opportunity is to me, and how I long to go in quest of fame and fortune. Why should it be either and why can't happiness be complete without either or both? No! My star shines brighter and I see greater possibilities. In my mind I have finer pictures than ever before. Ten thousand pictures come and go every day and those are the only complete pictures painted, pictures that shall never be polluted by paint and canvas."

Twachtman was born in 1853 in Cincinnati, where he began his career decorating window shades. "Window shades with milkmaids and ruined castles stenciled on them," as Mark Twain said in *Life on the Mississippi*. He studied drawing at night, first at the Ohio Mechanics Institute, then, beginning in 1871, at the McMicken School of Design. In 1874, Frank Duveneck returned to Cincinnati from Munich and took a teaching position at McMicken. Duveneck was an important influence on Twachtman, and in 1875, Duveneck went back to Munich, taking Twachtman with him. Twachtman worked in Munich from 1875 to 1877, after which he spent a year in Venice with Duveneck and William Merritt Chase. In 1879, the year Whistler arrived in Venice, Twachtman was admitted to membership in the Society of American Artists, and he was hired to teach at the Women's Art Association of Cincinnati, which he did reluctantly until the summer of 1880, when he went East for a while. In the fall of 1880, he was back in Europe, teaching at Duveneck's school in Florence. From there, he and Duveneck and Duveneck's students and colleagues, who were all dubbed "the Duveneck boys," went to Venice for the summer. In Venice he probably met Whistler, who influenced his work in pastel and possibly his etching. When Duveneck's school closed, Twachtman returned to Cincinnati, where he was married. He wrote to Weir soon after that he and his wife were undecided whether to go to New York or abroad; in any case, he was disgusted with his home town where "a good many people, all of them supposed to be up in art matters, have seen my paintings but I am convinced they care little for them. This is a very old foggied place and only one kind

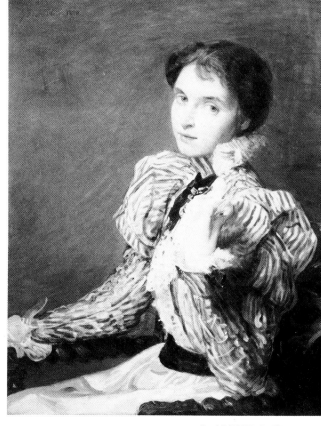

J. ALDEN WEIR
The Gray Bodice (1898) 30¼ x 25¼ inches
The Art Institute of Chicago

of art is considered good. The old Dusseldorf School comes in for its full share of honor." In the end they decided on Europe, visiting England, Belgium, and Holland, where he painted and sketched with J. Alden Weir.

In 1883, Bastien-Lepage had one year to live, Monet had just moved to Giverny, Whistler exhibited the portrait of his mother at the Salon, and Twachtman arrived in Paris to study drawing and rid himself of the dark Munich palette. As he wrote to Weir on December 7, 1883, to thank the latter for selling one of his landscapes to Irwin Davis, Twachtman mentioned his need for drawing. "I don't know a fellow who came from Munich that knows how to draw or ever learned anything else in that place." Twachtman stayed in Paris until 1855, studying at the Académie Julian and painting in the countryside in a manner influenced by Bastien-Lepage, Whistler, and perhaps Japanese prints. The cool gray and green color harmonies and the simplification of form in *Springtime,* for example, are a good indication of his style during this period. In the years 1888–1889, Twachtman was at the height of his popular appeal as a painter. During that time he won the Webb Prize at the tenth annual exhibition of the Society of American Artists, and he had a successful two-man exhibition with J. Alden Weir at the art galleries of Ortgies and Company. He taught with Chase at the Art Students' League, and he bought a farm in Cos Cob, near Greenwich, Connecticut. He was never again to be so popular in his lifetime.

Although a picture like *Springtime* indicates Twachtman's instinct for abstraction, by the placement of the figurative elements, the superb balance

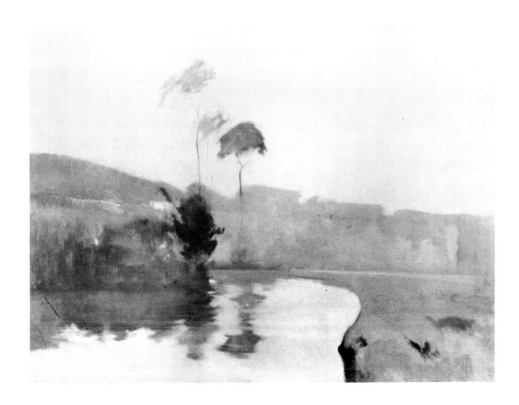

JOHN H. TWACHTMAN
Springtime (circa 1880–1885) 37 x 50 inches
Cincinnati Art Museum

of abstract shapes, and the simplified handling of values, that kind of painting was, he felt, too much of a compromise, too full of "amiable concessions." Dissatisfied with his work, he adopted the impressionist palette about 1889, and in such pictures as *The Rainbow's Source* (City Art Museum of Saint Louis), he began, like Weir, a series using nearby landscape motifs. Like Monet, he tended more and more toward a dissolution of form, toward abstraction. As he wrote to Weir from Paris in January 1885, apropos of the work of Bastien-Lepage, "What tasks the man did set himself in the painting of a white apron with which he was as much in love as the face of a person"; but, "in his painting he seldom went beyond the modern realism which, to me, consists too much in the representation of things." Because Twachtman went "beyond the representation of things," he was thoroughly misunderstood for it—which made him more melancholy than ever, and bitter. Simmons remembers walking up and down Fifth Avenue with Twachtman going to all the dealers in an effort to sell one of Twachtman's landscapes for twenty-five dollars. But in 1893, the year Monet painted his Rouen Cathedral series, Twachtman did win a silver medal at the World's Columbian Exposition, and he exhibited with Weir, Monet, and Albert Besnard at the American Art Galleries in New York. In 1900, he had a two-man show with his son at the Cincinnati Art Museum. That same year he and his colleagues started painting at Gloucester, Massachusetts, where he spent the summers from 1900–1902. In 1901, he had a one-man show at Durand-Ruel's gallery, which also went on to the Cincinnati Art Museum. The show was an artistic success, but his work was considered still "too advanced" for the public. This was to be his last one-man show, for in 1902, bitter and depressed, alone and estranged from his family, he died suddenly at Gloucester.

From the earliest of his student work to his last painting, *The Harbor View Hotel,* there is a dramatic transformation from dark to light; from the bituminous impasto of the Munich style of 1874 to 1883; through his Bastien-Lepage period, where he eliminated the heavy impasto and cleaned up his color while still painting in a low key in the years from 1883 to about 1888; and finally to his impressionist manner from about 1889. Twachtman was a landscape painter from the start, and the few figure pieces he did are not terribly successful. He was more comfortable painting from nature, in its isolation and silence; and his attitude toward it was romantic. "To-night is full moon," he wrote to Weir in December 1891, "a cloudy sky to make it mysterious and a fog to increase the mystery. Just imagine how suggestive things are. . . . To be isolated is a fine thing and we are then nearer to nature. I can see now how necessary it is to live always in the country—at all seasons of the year." Landscape to him was not just a motif; he felt genuinely close to it, he was part of it. In his painting *A Spring Morning,* he observes that "the wild flowers are finer than ever. There is greater deli-

cacy in the atmosphere. . . ." But like Birge Harrison, he liked winter best, "that feeling of quiet and all nature is hushed to silence." Winter scenes constitute a large portion of his work, in which he tackled the problem of working with white as a color, a concept Whistler had pursued in the mid-1860's. However, the hues in atmospheric, deceptively simple paintings like *Snow* or *Old Holley House, Cos Cob*, are far more subtle than anything Whistler ever painted; and the basic pictorial structure of his canvases is stronger. As Childe Hassam said, "His works were . . . strong, and at the same time delicate even to evasiveness." It is in this evasiveness that he comes close to Monet. Twachtman's *Sailing in the Mist* is comparable to some of Monet's paintings of the Thames. And like Monet, the misty atmosphere provides him with an opportunity for a display of pure painting. The sailboat and the figures in it are definable as notes of color in an overall delicate relationship of hue against hue. This procedure also eliminates perspective and concentrates on the tension between the surface of the canvas and the *idea* of a boat within it. Movement in the picture is confined to move-

(*see pages* 91, 93)

(*see page* 169)

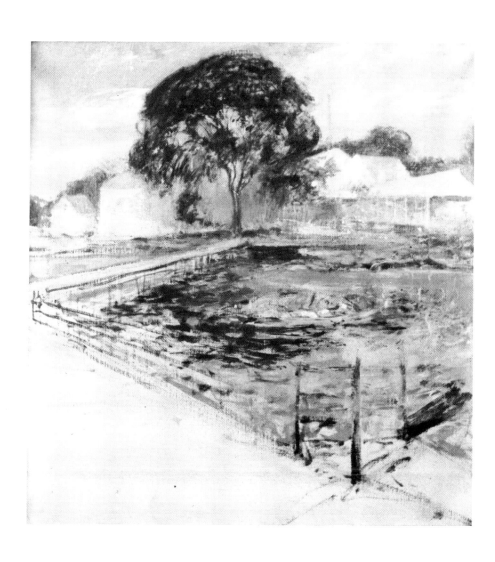

JOHN H. TWACHTMAN
Harbor View Hotel (1902) 30 x 30 inches
William Rockhill Nelson Gallery of Art
Atkins Museum of Fine Arts, Kansas City,
Nelson Fund

ment of color, a limitation which is emphasized by the use of a static format, the square canvas.

During the 1890s, Twachtman often pointedly used square canvases, as on occasion, did Hassam, and frequently Willard Metcalf, the colleague in The Ten who was stylistically closest to Twachtman. The square is the most static of forms—there is no movement in any direction. For that reason it is the sole shape used by the contemporary painter Josef Albers who, in his *Homage to the Square* paintings, wants *no* movement of shape at all. So by using a static square format, he focuses on his "interrelationship of color."

Sailing in the Mist is probably Twachtman's most evanescent painting. He never again went as far as that in obscuring pictorial form. He usually found his own delicate balance between his tendency toward abstraction and his romantic and contemplative attitude toward nature. In *Old Holley House,* the canvas is squared, the horizon high; snow shrouds the house, softening its sharp outlines. The white of the house on the left merges with the white of the snow on the ground; and although the expanse of snow in the foreground contains beautiful passages of warm to cool tones, bright but delicate, and an emphasis on the canvas surface, the forms are definitely there. They are suggested, and the treatment is subtle, but they are there. It is close to Monet, but unlike the work of the French artist, Twachtman's picture has a conscious pattern of design. From the windows of the house, the tree on the left, to the linear, almost Art Nouveau, arabesque of the tree on the right, there are hints of pattern, a basic pictorial structure. Twachtman, like the other American impressionists never went as far as Monet toward the dissolution of form; in fact toward the end of his life, and in particular when he painted in Gloucester, he went back to a somewhat more objective rendering; and, as in *Captain Bickford's Float, Fishing Boats at Gloucester,* and *Harbor View Hotel,* a more open and obvious emphasis on strong linear compositional devices.

Twachtman was a romantic. He was never as systematic as the Monet of the Haystack series or the Rouen Cathedral series. And when Twachtman executed his series of works using motifs from his farm at Cos Cob, motifs such as the hemlock pool, which was used in *Winter Harmony,* and the waterfall, used in the Worcester painting, it was not to catalogue changes of light during a specific time of day or season, but to evoke a mood caused by such changes. These evocations of mood while contemplating a landscape in its changing aspects are closer in feeling to the poetic subjectivity of a Chinese painter of the Sung period than to the almost scientific objectivity of a Monet. Twachtman was not an innovator—almost none of the American impressionists were—but he was a lyrical artist who created many memorable images, an artist who possessed a quiet originality, quietly achieved.

Willard Metcalf (1859–1925) was also a quiet talent, a sensitive artist.

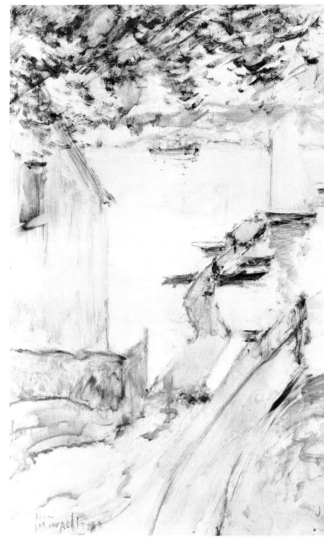

JOHN H. TWACHTMAN
Captain Bickford's Float (1900) 12½ x 18⅞ inches
*Collection of Mr. and Mrs. Raymond J. Horowitz,
New York*

(*see page* 63)
(*see page* 170)

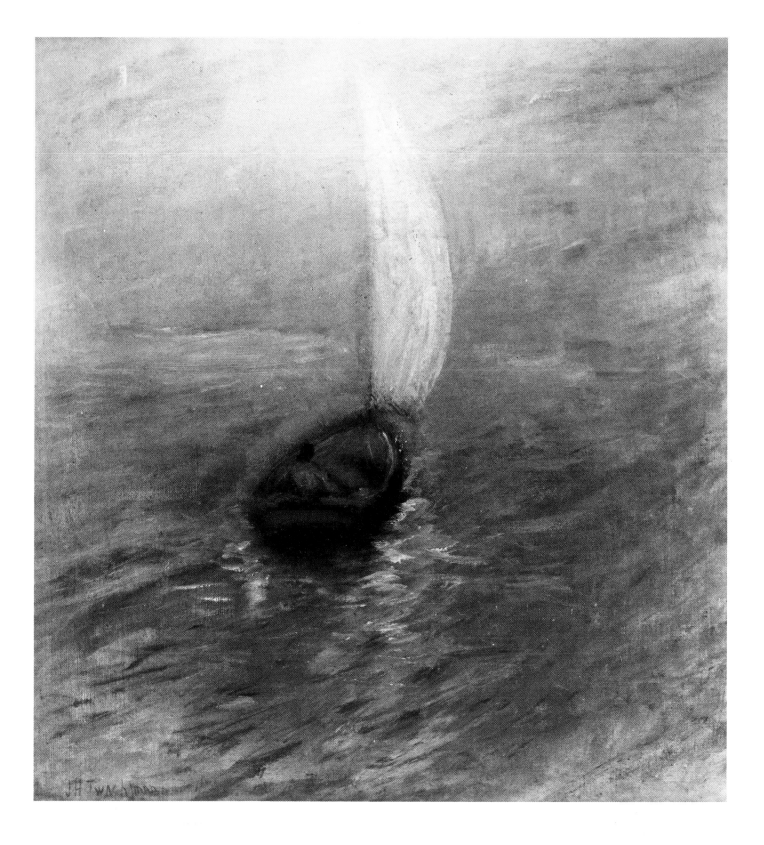

JOHN H. TWACHTMAN
Sailing in the Mist (circa 1900) 30½ x 30½ inches
*The Pennsylvania Academy
of the Fine Arts, Philadelphia
Temple Fund Purchase, 1906*

Born in Whistler's home town of Lowell, Massachusetts, he began his career as an illustrator. He studied at the Boston Museum School for a while, and the Académie Julian in Paris. Metcalf also studied with the Boston landscape painter George L. Brown, before entering the field of magazine and book illustrating in 1890. He was a successful book illustrator and he made a lot of money, but in 1899, when he was forty, he gave it all up and went off to the Maine woods to think and to paint. He stayed in Maine for a year and when he came back to New York he had decided to devote all of his time to painting. His work sold well and he became a popular artist in his time.

Like Twachtman, Metcalf was preoccupied with the rendering of seasonal changes, and probably for the same reasons. His year in the Maine woods brought him in close contact with nature, and this contact gave him his direction and his motivation. But he was a more conventional artist than

JOHN H. TWACHTMAN
The Waterfall (circa 1895) 30 x 30¼ inches
Worcester Art Museum

Twachtman, and he had none of the latter's poetry or profundity. In comparing Metcalf's *Icebound* with winter subjects by Twachtman, like *Snow* or *Old Holley House, Cos Cob*, it is apparent that while Metcalf was a sensitive and skilled painter, he retained, still, an illustrative quality which makes his work pleasing rather than profound. As the critics of the day pointed out, "He did not deal in asperities." In *The Twin Birches* he depicted "the robust landscape of New England divested of its rigors." However, *Early Spring Afternoon, Central Park* is Metcalf at his best. Using an almost square canvas, bird's-eye view, and feathery touch he captured the stillness and lightness of the day and season. The winding bridle path snakes its way back to the city, which is "pushed" into the distance. Nature is paramount, much more important than the town—a way of thinking espoused by most nineteenth-century American painters. Metcalf was known as "the poet laureate" of the New England hills, and he continued to paint "these homely hills" until his death in New York in 1925.

(*see page* 172)

(*see page* 99)

WILLARD METCALF
Icebound (1909) 29 x 26⅛ inches
The Art Institute of Chicago
The Walter H. Schulz Memorial Collection

Quietly original and poetic are terms which would also apply to the painting of Thomas Wilmer Dewing, who was born in Boston in 1851. Next to Hassam, Weir, and Twachtman, Dewing was one of the most important members of The Ten American Painters; and he was unique. Drawing was his forte, and in Paris he excelled at the draftsmanship in the French academic tradition, the tradition of Ingres. In fact he became so good at it, it is said, that, had he been French, he would have won the highly coveted Prix de Rome. His early painting is anecdotal in the manner of the Salon subject-picture, but with an atmosphere and elegance of finish which was personal to him. After Paris he went to Munich where he studied with Frank Duveneck, but he never wholly adopted that blustering German style—his sense of elegance and refinement was too strong. He was never a landscape painter,

WILLARD METCALF
The Twin Birches (1908) 40 x 39 inches
*The Pennsylvania Academy
of the Fine Arts, Philadelphia
Temple Fund Purchase, 1909*

172

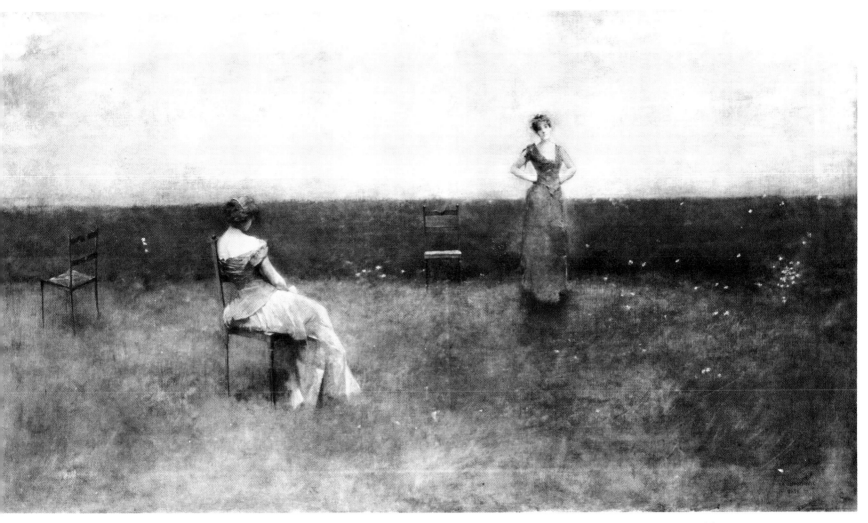

THOMAS DEWING
The Recitation (1891) 30 x 55 inches
The Detroit Institute of Arts

preferring the figure. His pictorial repertoire includes portraits and figure pieces of women, and in his precise draftsmanship, he was the Degas of The Ten American Painters. *The Recitation,* painted in 1891, is classic Dewing: the jewel-like color and surface, the precise drawing, the odd placement of the chairs, the elegant, somewhat attenuated, and enigmatic ladies. There is a concern with a mysterious light and atmosphere in a setting which is spatially ambiguous. Where, exactly, are these women? In a room? In a field of flowers? And what is the relationship of the women to each other? Dewing's work always seems to raise questions of this sort. It is as though he has deliberately tried to puzzle the viewer by the air of mystery derived perhaps from his idol Jan Vermeer of Delft, but in Dewing it is somewhat self-conscious, a little contrived. The draftsmanship might well be akin to Degas, but the mood, the atmosphere, and the space is also very much Whistler.

In his early models and inspiration, Dewing was selective, discriminating. As a boy he was very much taken by a Chardin in the Museum of Fine Arts, Boston, and he always retained his admiration for the French master. For a while he studied Botticelli and the Italian primitives; his painting became decorative, somewhat pre-Raphaelite. Dewing painted *Hymen,* also called *The Wood Nymph,* together with his wife, Maria Oakey Dewing, the flower

173

painter, and presented it to his friend, architect Stanford White, as a wedding present. *The Wood Nymph* is representative of Dewing's decorative style, as is—perhaps even more so—his painting called *The Days*. *The Days* is positively pre-Raphaelite in sentiment, and quite unlike his later work, it is crammed with detail. Stanford White designed a room around it, and Maria Oakey Dewing probably painted the foliage and flowers. But the female figures here, as well as the wood nymph, are closer to the wholesome American vestal virgins of Abbott Thayer at this point than to those elegant and lonely women who populate Dewing's later work. The painting of an idealized female figure or the production of whole canvases full of them was not unique to Thomas Dewing. Abbott Thayer was a specialist, and so was George de Forest Brush. It was a pervasive part of the American nineteenth-century aesthetic. The Gibson Girl was Charles Dana Gibson's ultimate popularization of the "ideal" type, and from then on she appears in everybody's painting; and even the women in Robert Blum's Japanese scenes look like Gibson Girls.

After 1887, Dewing became bored with decorative painting and began to pursue his own invention, to develop his own personal style. And like practically every advanced modern painter of his time, he was influenced by oriental art. But more important, by 1891, when he painted *The Recitation* and *The Piano,* he had discovered the seventeenth-century Dutch artists. Unlike his colleagues at Munich, who admired Frans Hals, Dewing preferred the "Little Masters," Metsu, Terborch, and particularly Vermeer. In his portraits and single figures of women, he strives for the perfection of technique and the enigmatic quality of the brilliant painter from Delft; and Vermeer is recalled also in his theme of women playing old-fashioned musical instru-

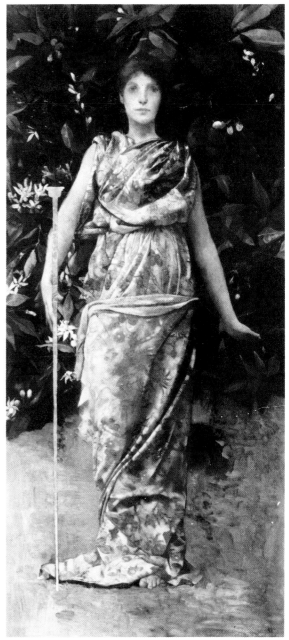

THOMAS and MARIA DEWING
Hymen (Wood Nymph) (1886) 31½ x 17⅛ inches
Cincinnati Art Museum
The Edwin and Virginia Irwin Memorial

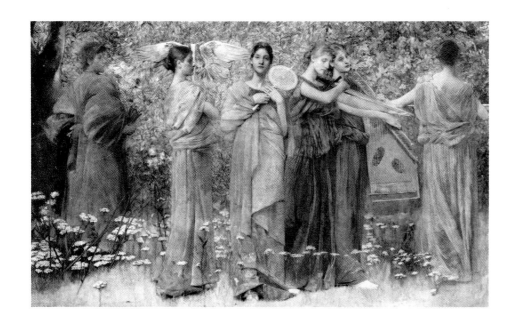

THOMAS DEWING
The Days (1887) 43¾ x 72 inches
Wadsworth Atheneum, Hartford

174

ments, as in *Girl with Lute*. His themes, his occasional use of still life and furniture, casually placed, and his use of large areas of empty space, oriental in feeling, all combine to form a style, or rather a private world, wholly his own. Although the pose of *Lady in White No. 1* is suggestive of Whistler, as is the color, it is painted in the light of Vermeer. A more direct reference to the great Dutch painter can be found in *The Necklace*. The very close resemblance between Dewing's picture and Jan Vermeer's *Young Lady Adorning Herself with a Pearl Necklace* suggests that Dewing might have seen this particular Vermeer. The gesture of the woman holding the pearls is the same in both pictures, except in Dewing's painting she is about to put them on. Both figures face the light source which comes from the same direction, but Vermeer's figure stands and is separated from the viewer by a table; whereas Dewing's figure is sitting and, as in *Girl with Lute*, is separated from the viewer by space. The diagonal of the curtain in the Vermeer is transposed into the diagonal of the portable mirror in the Dew-

JAN VERMEER
Young Lady Adorning Herself with a Pearl Necklace
(circa 1665) 21½ x 17¾ inches
Staatliche Museen, Berlin-Dahlem

THOMAS DEWING
The Necklace (circa 1907) 19¾ x 15¾ inches
*The National Collection of Fine Arts,
Smithsonian Institution, Washington, D.C.
Collection of Mr. and Mrs. Jack Kartee*

ing. In *The Necklace,* Dewing seems to pay yet further tribute by the use of the picture within a picture, characteristic of Vermeer's painting; and the picture on the wall in the upper left might even be a Vermeer. It is an altogether beautifully crafted, wonderfully elegant picture. The lady contemplating her pearls and the subject of *The Lady in White,* waiting, listening to music, or just thinking, belong entirely to a special world, to Dewing's world. It is rarified, refined, but there is also, however, something very strange about this world of Thomas Dewing. As in *Girl Seated in a Chair,* his women are detached and unapproachable, alone, isolated from each other and from the viewer, in much the same way as are the figures in the work of contemporary sculptor Alberto Giacometti. The subject of *Girl with Lute* sits far in the background, and the oriental carpet is as important to the picture as she is. The extreme perspective used here and in *A Reading,* combined with the uncluttered empty space, give this world an indefinable

THOMAS DEWING
Girl Seated in Chair. 24 x 20 inches
*Freer Gallery of Art, Smithsonian Institution,
Washington, D.C.*

THOMAS DEWING
Girl with Lute. 36 x 48⅛ inches
*Freer Gallery of Art, Smithsonian Institution,
Washington, D.C.*

176

modern quality, an implication of the surreal which is entirely at odds with Dewing's personality.

Apparently Dewing was a big bristling man; he was described as sarcastic, bitter, quarrelsome, always ready to pick a fight. Yet like Twachtman, who was also bitter, and Whistler, who was also sarcastic, Dewing painted some of the most sensitive, sophisticated, and poetic pictures in nineteenth-century American painting.

Hassam, Weir, Twachtman, Metcalf, and Dewing were primarily New York-oriented, whereas Frank Benson, Edmund Tarbell, and Joseph De Camp were considered "The Boston Men." All three held teaching positions at the Boston Museum School for years. Benson and Tarbell were born in Massachusetts, and De Camp was originally from Cincinnati. And if Twachtman and Dewing were the poetic members of the Ten, the three Boston painters, like Metcalf, were more conventional, genteel even—as befitted artists who worked in Boston. More susceptible to "amiable concessions" than any of the others, they shifted easily from a painterly and cheerful impressionist palette to the more sober portrait style of the National Academy when the occasion demanded it.

Frank Benson (1862–1951) was the best-selling Boston artist, and it is said that his annual income often reached six figures. Benson was probably

THOMAS DEWING
A Reading (1897) 20⅜ x 30¼ inches
National Collection of Fine Arts,
Smithsonian Institution, Washington, D.C.,
Henry Ward Ranger Fund

also the most painterly of the three. *Still Life* is a wonderful painting. Big, spirited, handsome, it is painted with lots of dash and vigor, and with a real love for the feel of paint. He is best-known for his etchings and drypoints of birds in flight, which he depicted with great skill. At the same time he painted richly textured pictures, in a "frank and cheerful" palette, of figures, mostly women and girls, and mostly his family. In many ways—the gaiety, the holiday atmosphere—his work resembles that of Potthast; and paintings such as *Eleanor* and *Portrait of My Daughters* exploit to the full the twin qualities of color and sentiment which were increasingly becoming strong characteristics of American impressionist painting after 1900. These qualities in Benson's work caused the critic William H. Downes to remark of it in 1911, "It is a holiday world, in which nothing ugly or harsh enters, but all the elements combine to produce an impression of natural joy of living."

Edmund Tarbell (1862–1938), more consciously stylish than Benson, became famous for his genre scenes, intimate family groups and figures in interiors. He became an instructor at the Boston Museum School in 1889, after returning from Paris, and held a position there until 1912. Then from 1918 to 1926, he headed the Corcoran School of Art, Washington, D.C. Tarbell was a friend of Duveneck and was briefly influenced by him. *Interior* (Cincinnati Art Museum), inscribed "To Duveneck, Tarbell," is painted in the dark tonality of Munich; but *Woman in Pink and Green* of 1897, which was included in the first exhibition of the Ten, shows the

(*see page* 194)

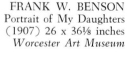

FRANK W. BENSON
Portrait of My Daughters
(1907) 26 x 36⅛ inches
Worcester Art Museum

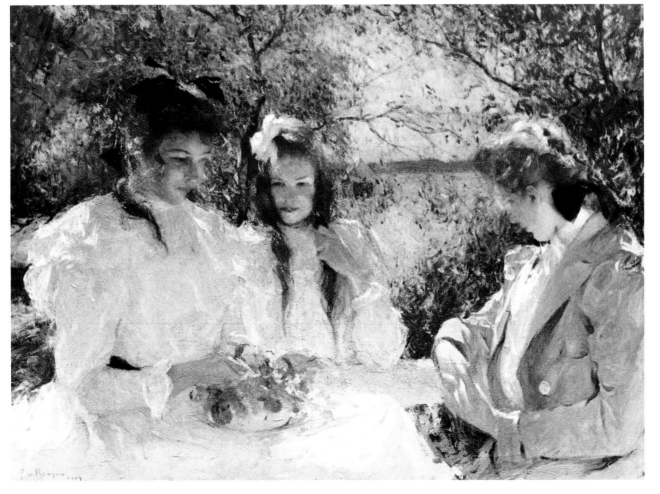

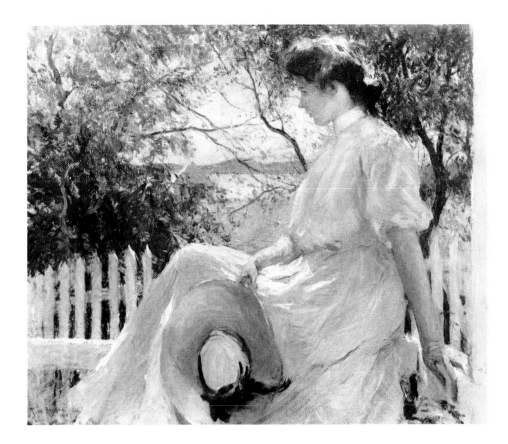

FRANK W. BENSON
Eleanor (1907) 25 x 30 inches
*Museum of Fine Arts, Boston,
Charles Henry Hayden Fund*

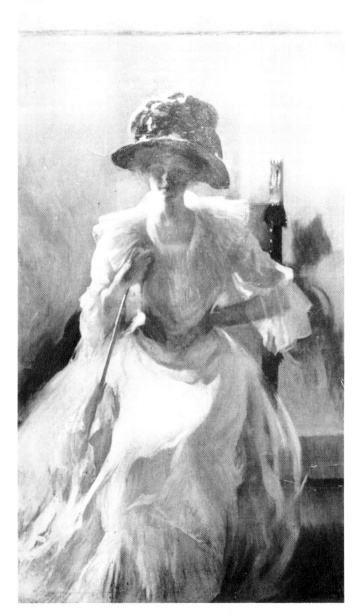

EDMUND C. TARBELL
The Golden Screen (circa 1898) 77 x 44 inches
*The Pennsylvania Academy
of the Fine Arts, Philadelphia
Temple Fund Purchase, 1899*

influence of impressionist practice; and the pose of his daughter Josephine holding the parasol also strongly suggests Whistler or Chase. *The Golden Screen,* painted *con brio* and with elegance, is even more suggestive of Chase. The girl, possibly his daughter Josephine, is posed in front of an exotic oriental screen, a common background of the time and a device used frequently by both artists.

A more mature Tarbell painted *The Rehearsal in the Studio.* The superb spatial disposition of the elements, the controlled light, and the sure handling of paint in this study of genteel Boston "art life" combine to make this a striking picture a little reminiscent of Degas. Like Benson, Tarbell painted his family, and his picture is both a family portrait and a record of life just before "the great war," again "in which nothing ugly or harsh enters." *My Family* is more tightly controlled and architecturally composed than *The Rehearsal;* it has intelligence and charm, and despite its brilliant hues, which have the lightness of watercolor, and the white light, it is gentle and serene. The light has the brightness of a summer's day, but without the summer's heat. The compote of fruit in the foreground, the Chinese porcelain on an eighteenth-century table, tend to gently emphasize the mood of harmony and tranquillity, the mood of the "good life" evoked by the figures. It was a way of life in a special world for the successful artist of the late nineteenth century; art and life were one, and the pursuit of harmony and tranquillity were goals of living as well as painting. *My Family* was painted in 1914, an ominous date. It was a date which signaled the end of those twin goals, and

(*see page* 191)

179

of the genteel tradition in American painting of which they were a part. And with it went American impressionism which had itself become absorbed into that tradition.

Joseph De Camp (1852–1923) was part of that world too. His work was not as spontaneous as Benson's, nor as lively or interesting as Tarbell's. It was sober, solid, and based on craftsmanship in the academic tradition, but enlivened by brushwork in the Munich manner. De Camp was one of "the Duveneck boys," studying under Duveneck in Cincinnati and later in Munich. Afterwards, De Camp established a studio in Boston, where he became a successful portrait painter. As such, his impressionism, somewhat like Sargent's, was limited to his days off; and when he did employ an impressionist palette, as he did in *The Little Hotel* of 1903, it was fairly muted in color and not unlike Duveneck's later, but less successful, attempts to cope with an impressionist palette.

Like Joseph De Camp, Edward Simmons (1852–1931) and Robert Reid

EDMUND C. TARBELL
Woman in Pink and Green
(1897) 48 x 36 inches
Collection of Mr. and Mrs. Raymond J. Horowitz

181

(1862-1929), the two remaining members of the original Ten, were rather minor figures in the movement. Simmons was essentially a muralist, and in fact, not many of his easel pictures still exist. The remaining canvases reveal his work to be sentimental in the manner of Robert Reid. Reid was a muralist, but he also painted genre pictures, figure pieces, and landscapes, and he painted these subjects in an impressionist manner. Reid studied at the Boston Museum School, the Art Students' League of New York, and at the Académie Julian in Paris. He exhibited regularly in the Salon and his work was included in the Paris Exposition of 1889, the year he returned to New York. Robert Reid's easel painting tends to be decorative, and even "pretty," as in the *Violet Kimono* and *The Mirror*, both of which are in the National Collection of Fine Arts, Washington, D.C. In this respect, he resembles Frederick Frieseke and Richard Miller. *The Mirror* is the stronger of the two pictures, and in its artiness and mood, it has something of a *fin de siècle* feeling about it. The pose is reminiscent of Whistler's *The Little White Girl* of 1864, and the use of the Japanese screen in the background also recalls Whistler's painting *The Golden Screen,* painted in the same year.

Thus, it can be seen that the Ten was not a radical organization. The members were more conservative than their French counterparts, and if some of them had difficulty selling their work, it was not because they were producing something new or wildly original, but because, with few exceptions, most collectors were not interested in acquiring American art. They did not believe that an American painter was capable of anything really good; Monet was always more saleable than Twachtman. Yet despite this attitude, the Ten were successful in some respects. In the course of their twenty-year history, they managed to show conspicuously, if not always profitably, and their exhibitions were usually regarded as the "hit" of the New York season. Further, some of their members—Hassam, Benson, Metcalf, and, to a certain extent, Weir—managed to sell their work and become recognized, even popular, artists. The Ten American Painters was considered by contemporary critics to be one of the most important art organizations of the day, and even though toward the end the critics did complain that its exhibitions were becoming indistinguishable from those at the National Academy, they did bring into sharp focus the fact that American painters were capable of making a contribution; of producing not only good, but in many cases, inspired and inspiring works. And the Ten did this more successfully than the National Academy or the Society of American Artists.

The Ten American Painters actually was one of the most significant art organizations of its time. And one of its late, but most important, members was William Merritt Chase (1849–1916), who was invited to take Twachtman's place after the latter's death in 1902. Indeed, Chase was not only a vital member of The Ten, but he was also one of the most important artistic personalities in American art in the last quarter of the nineteenth century.

From the era of the Philadelphia Centennial of 1876 to the World's Columbian Exposition at Chicago in 1893, where six of his canvases were exhibited, Chase was the embodiment of nearly every artistic influence exerted upon American painters in his time: still lifes and portraits in the manner of the National Academy; the silvery tonalities of Whistler; the bituminous bluster of Munich; the seventeenth-century Spanish and the Dutch artists; the suavity of Manet and Sargent; the bright color and broken brushwork of impressionism; all of these he utilized at one time or another and sometimes, it seems, simultaneously as well.

As a painter, Chase was quite obviously an eclectic but also a brilliant virtuoso who, like Duveneck and Sargent, painted in a broad spirited manner with a sense of elegance and élan. His paintings radiate a love of the métier. As a personality he was flamboyant, a star; he wore a pointed beard and a dashing waxed mustache. He would appear on Fifth Avenue wearing a Munich student's cap on his head and walking a huge white wolfhound on a leash. He kept a black servant in a Turkish costume, complete with red fez, standing outside his celebrated Tenth Street studio; and inside, amid the Bohemian bric-a-brac, a white cockatoo and two macaws greeted his artist friends and his fashionable visitors. Chase was a popular *bon vivant*, and he had power. Literally hundreds of students passed through his class at the Art Students' League, and through his private classes, which he held

ROBERT REID
Violet Kimono. 29 x 26¾ inches
*National Collection of Fine Arts,
Smithsonian Institution, Washington, D.C.
Gift of John Gellatly*

ROBERT REID
The Mirror. 37 x 30 inches
*National Collection of Fine Arts,
Smithsonian Institution, Washington, D.C.
Gift of William T. Evans*

until he died. He was president of the Society of American Artists for ten years, and only *he* could have put together that exhibition of modern French painting in 1883 which included so many impressionists.

Also in 1883, Chase painted the *Portrait of Miss Dora Wheeler*. This picture was shown for the first time in the Paris Salon of 1883, along with Whistler's *Arrangement in Grey and Black, No. 1* (portrait of the artist's mother) to which it bears some resemblance. The Whistler was first shown at the Royal Academy in 1872, and later at the Philadelphia Centennial of 1876. However, the strongest influence on Chase at that time was the modified impressionism of the Belgian painter Alfred Stevens (1828–1906)— according to his biographer Katherine Metcalf Roof, Chase admired Stevens extravagantly. Stevens was one of the most popular and prolific painters of the Second Empire, and he was awarded the highest honors by the governments of France and of Belgium. Both Chase and Whistler admired his work; in the 1880s Stevens and Whistler were particularly intimate, and the Belgian artist defended Whistler in his book *Impressions sur la Peinture*, published in 1886. If, in Chase's *Portrait of Miss Dora Wheeler*, the arrangement of the sitter is reminiscent of Whistler (and what arrangement like that would not be reminiscent of Whistler?), the palette is Alfred Stevens—the Alfred Stevens, for example, of *Resting*. Gay and chic, *Resting* is painted swiftly, with éclat, the kind of painting Chase loved.

ALFRED W. STEVENS
Resting. 16 x 18 inches
*Cincinnati Art Museum,
John J. Emery Fund*

facing page:

WILLIAM MERRITT CHASE
Portrait of Miss Dora Wheeler
(1883) 62½ x 65¼ inches
*The Cleveland Museum of Art,
Gift of Mrs. Boudinot Keith*

184

186

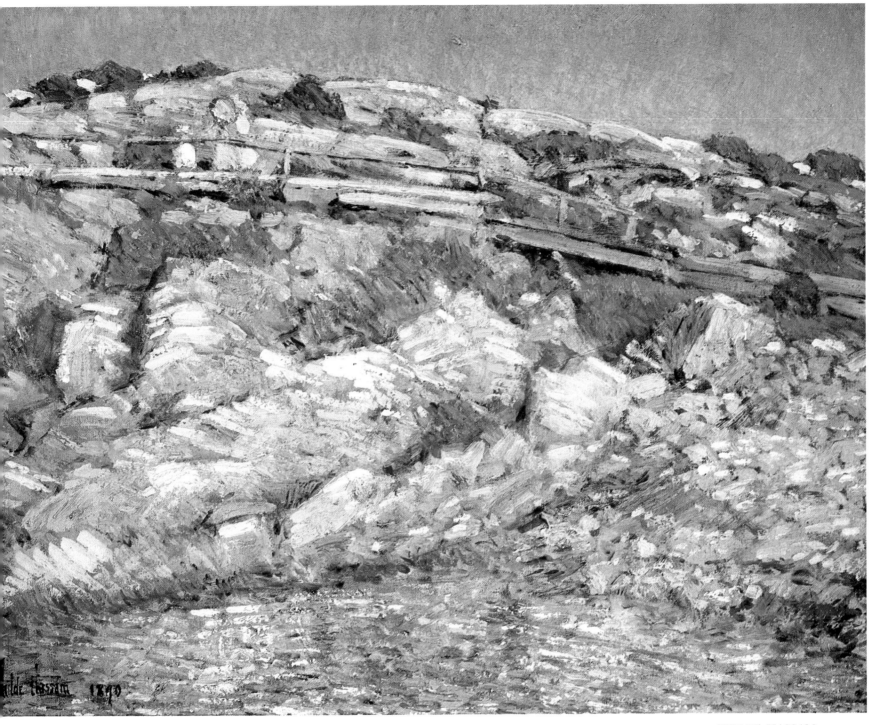

EDWARD WILLIS REDFIELD
New Hope (circa 1927) 50 x 56½ inches
The Pennsylvania Academy
of the Fine Arts, Philadelphia

CHILDE HASSAM
Walk Around the Island
(1890) 11 x 14 inches
Collection of Mr. and Mrs. Meyer Potamkin

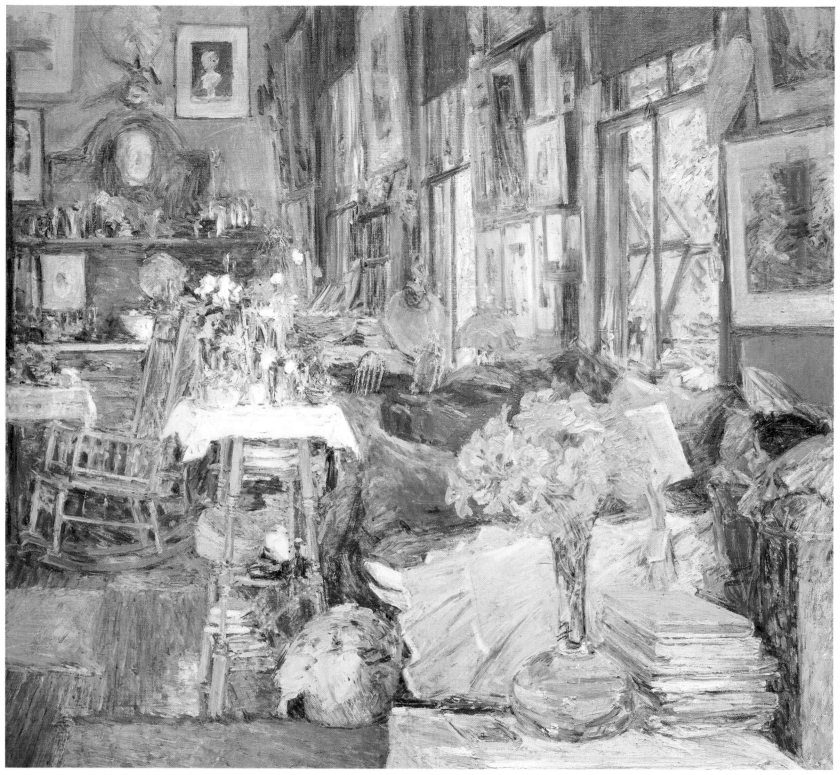

CHILDE HASSAM
The Room Full of Flowers (1894) 35 x 24 inches
Collection of Mr. Arthur G. Altschul, New York

facing page:

THOMAS DEWING
Lady in White (No. 1)
(circa 1913) 26¼ x 20¼ inches
National Collection of Fine Arts,
Smithsonian Institution, Washington, D.C.

188

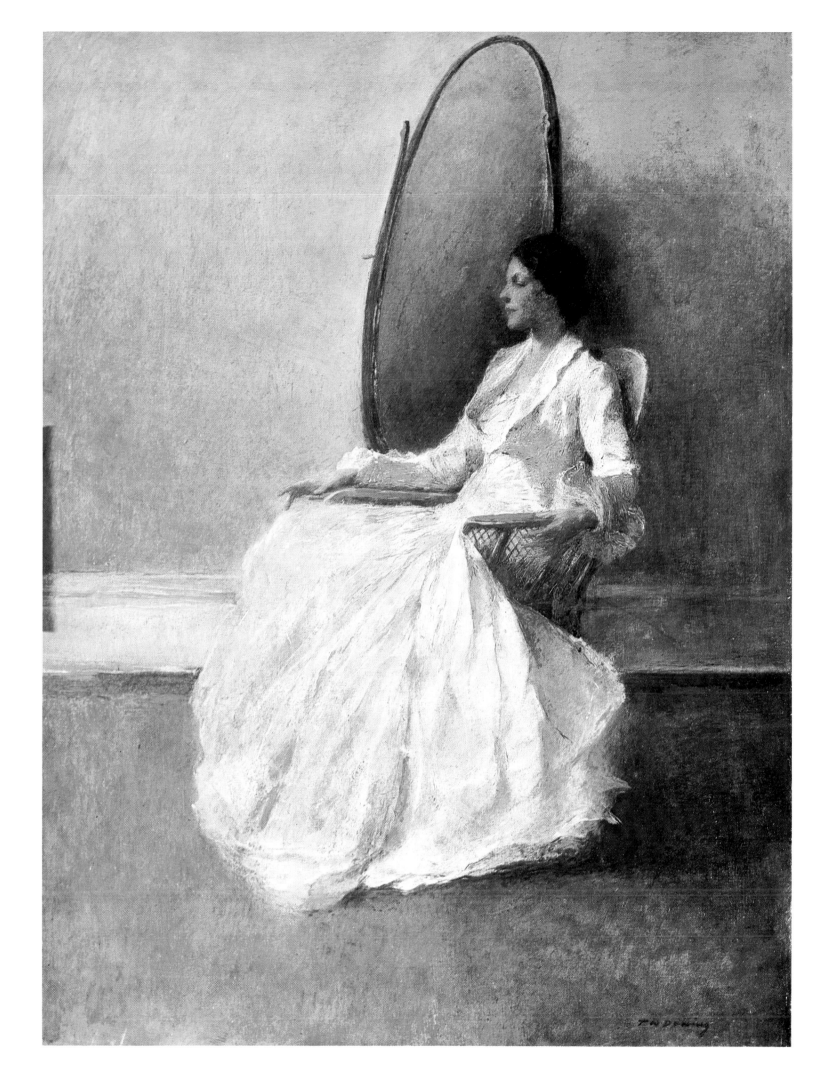

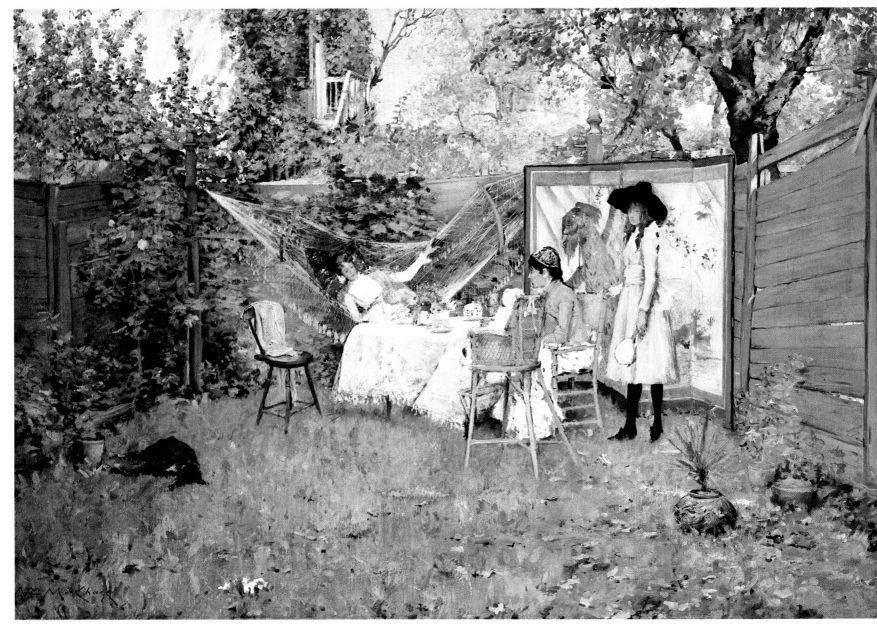

WILLIAM MERRITT CHASE
The Open Air Breakfast
(circa 1888) 37½ x 56¾ inches
*The Toledo Museum of Art,
Gift of Florence Scott Libbey*

EDMUND TARBELL
My Family (1914) 30 x 38 inches
*Private Collection (Photograph courtesy
Hirschl and Adler Galleries, New York)*

191

JOSEPH RAPHAEL
Rhododendron Field (1915) 30 x 40 inches
The Oakland Museum

facing page:

JOHN SINGER SARGENT
Carnation, Lily, Lily, Rose
67½ x 59 inches
Tate Gallery, London

193

FRANK W. BENSON
Still Life. 45 x 59 inches
National Collection of Fine Arts,
Smithsonian Institution, Washington, D.C.
Henry Ward Ranger Fund

facing page:

FREDERICK FRIESEKE
Lady Trying on a Hat
(1909) 63¾ x 51 inches
The Art Institute of Chicago

194

ERNEST LAWSON
Fort George Hill, Morning
(circa 1911) 25 x 30 inches
The Pennsylvania Academy
of the Fine Arts, Philadelphia

196

DANIEL GARBER
Battersea Bridge (1909) 9½ x 13 inches
*The Pennsylvania Academy
of the Fine Arts, Philadelphia*

197

MAURICE PRENDERGAST
The Promenade. 28 x 40⅛ inches
The Columbus Gallery of Fine Arts, Howald Collection

facing page:

RICHARD EDWARD MILLER
The Boudoir. 34 x 36 inches
*The Pennsylvania Academy
of the Fine Arts, Philadelphia*

198

Whatever the influences of Whistler and Stevens, the portrait of Dora Wheeler is magnificent. The sitter was one of his first pupils at the Art Students' League, and she went on to become a distinguished portrait painter in her own right. Her mother, Candace Wheeler, was an artist and writer who was a friend of Chase, and who was associated with Louis Comfort Tiffany in his early years. Chase's *Portrait of Miss Dora Wheeler* could be called a study in blue and gold, and with its sympathetic treatment of the sitter, its complex organization yet clarity of conception, it remains one of the masterpieces of his career. And had Chase seriously and consistently pursued the impressionist style, as both Mary Cassatt and Robinson did, he would have been one of the earliest Americans to take that step.

When he was seventeen in his home town of Franklin, Indiana, he began to paint portraits on his own and under the tutelage of a local portrait painter, Benjamin Hays. In 1870, he went to New York, enrolled in the classes at the National Academy of Design, and established a studio, where he spent most of the time painting still lifes. When he was twenty-two he went to St. Louis where his work so impressed a group of local business men that they raised the money to send him to Europe in 1872. In 1874, the year Frank Duveneck brought the Munich style to Cincinnati, and the year of the first impressionist exhibition, Chase entered the studio of Karl von Piloty. Chase was an adept, skillful painter, and he employed the Munich style with gusto and verve; in 1875, together with Frank Duveneck, he opened a studio in Munich. In 1876, he painted *The Turkish Page* which has all the bluster and bravado of the Munich manner. In 1877, he went to Venice with Duveneck and Twachtman; and in the same year he was offered a teaching post at the Royal Academy in Munich, but he declined. Instead he returned to America in 1878, settled in his famous Tenth Street studio and started teaching, both privately in his own studio and publicly at the Art Students' League. But Chase was not content, like Twachtman, to be isolated; he was too outgoing, too ebullient and restless. He was a cosmopolitan man, an international figure, who, from 1878 to his death in 1916, traveled back and forth to Europe as much as he could. In 1881, he prowled Paris with Weir, won an honorable mention in the Salon, and studied Velasquez in Spain. In the summer of 1882, he was back in Spain, with stops in France and Holland; he was again in Europe in 1883, and in 1884, he stayed for a while at Zandvoort, Holland, where he experimented with *plein-air* painting in the company of Robert Blum. And in 1885, he developed, for a time, a friendship with Whistler; the two of them toured Europe together, and painted portraits of each other. (Chase's portrait is in the Metropolitan Museum of Art, but regrettably Whistler's has been lost.) In the *Century Magazine* of June 1910, Chase recalled that first meeting in 1885. "I . . . determined not to beard the lion in his den, but at least to salute him. I rapped and waited. . . . the door opened guardedly, and a dapper little man

WILLIAM MERRITT CHASE
Turkish Page (1876) 48½ x 37⅛ inches
*Cincinnati Art Museum,
Gift of the J. Levy Galleries*

facing page:

WILLIAM GLACKENS
Chez Mouquin (1905) 48³⁄₁₆ x 36¼ inches
The Art Institute of Chicago

appeared and eyed me guardedly." They later had a falling out, as Whistler did with many of his friends. "Few men," Chase said, "were as fascinating to know—for a brief time." Chase had been fascinated by Whistler's style for some time, and he used it on and off during his whole career. *Harbor Scene,* probably painted in Venice, is, in its simplicity, akin to Whistler's Trouville painting; and *The Mirror,* a portrait of his daughter Alice done about 1901, is very Whistlerian in its thin, fluid execution and closely modulated color harmonies.

(*see page* 72)

(*see page* 69)

In 1886, Chase was given a one-man show at the Boston Art Club; and like Duveneck's exhibition eleven years before, it was a success and Boston was impressed. Duveneck, however, went back to Munich. Chase stayed in this country, got married, and in 1887, moved to Brooklyn. In Brooklyn he began a series of paintings of Prospect Park, done in a fully developed impressionist manner. *The Park Bench,* lively in color and crisp in execution, is one of these. The bold thrust of the bench into the foreground gives it immediacy; there is a hint of the camera's influence as well.

His most brilliant impressionist landscape paintings were done when he moved to Shinnecock, Long Island, where he built a house in 1892. *The Hall at Shinnecock* is unusually gentle and restrained for Chase. It is close in feeling to Tarbell's *My Family,* but more active. In Chase's painting, even the summer sun fairly shimmers on the polished wood floor. But it was in his painting out-of-doors that he did his finest impressionist work. *Shinnecock Hill* is a glorious picture. His McKim, Mead and White house is in the background, and in the foreground, the three little girls in white recall Mary Cassatt's *Picking Flowers in a Field.* Painted with Chase's inimitable and ebullient brush, it has all the verve and all of the zest of his "Long Island impressionism." His zest is evident in another picture of the same area, the magnificent *Shinnecock Hills.* Large, bright, and broadly executed, *Shinnecock Hills* is painted in the perceptual manner of a Sisley rather than with the chic style of an Alfred Stevens. It is pure joy, this picture—one of his best impressionist landscapes, and it is certainly equal to anything Sisley ever did.

(*see page* 204)

(*see page* 2)

(*see page* 39)

(*see page* 206)

In 1895, he bought a house on Stuyvesant Square, and in 1896, he went to Spain again. When he returned, he opened the Chase School on Fifty-seventh Street. In 1902, the year Twachtman died, he went to London to pose for his portrait by Sargent which was to be presented to the Metropolitan Museum of Art by Chase's students, and in 1903, he was in London when Whistler died. He also held his first summer class in Europe, which he was to do until 1913. In 1907, he bought a villa in Florence, and in 1908, he received a request from the Italian government for a self-portrait to be included in the Uffizi Gallery. In the year he died, Chase was given an honorary degree by New York University, one of an extraordinary number of honors and awards he accrued during his lifetime, both at home and

abroad. And with his death the American art world lost one of its most dedicated artists, an artist whose professionalism was sometimes overshadowed by his theatrical lifestyle. Next to Whistler, William Merritt Chase was the most flamboyant American artist of his time; and although he was an international figure, it is significant that New York rather than London was his stage. Chase brought to New York what was then called an "art atmosphere"; he started a cult of fashionable Bohemianism, and Manhattan had never seen anything like it. He had the biggest of the celebrated Tenth Street studios, and he moved in with his wolfhound, his birds, and jammed

WILLIAM MERRITT CHASE
Park Bench (1890) 12 x 16 inches
Museum of Fine Arts, Boston,
Gift of Arthur Weisenberger

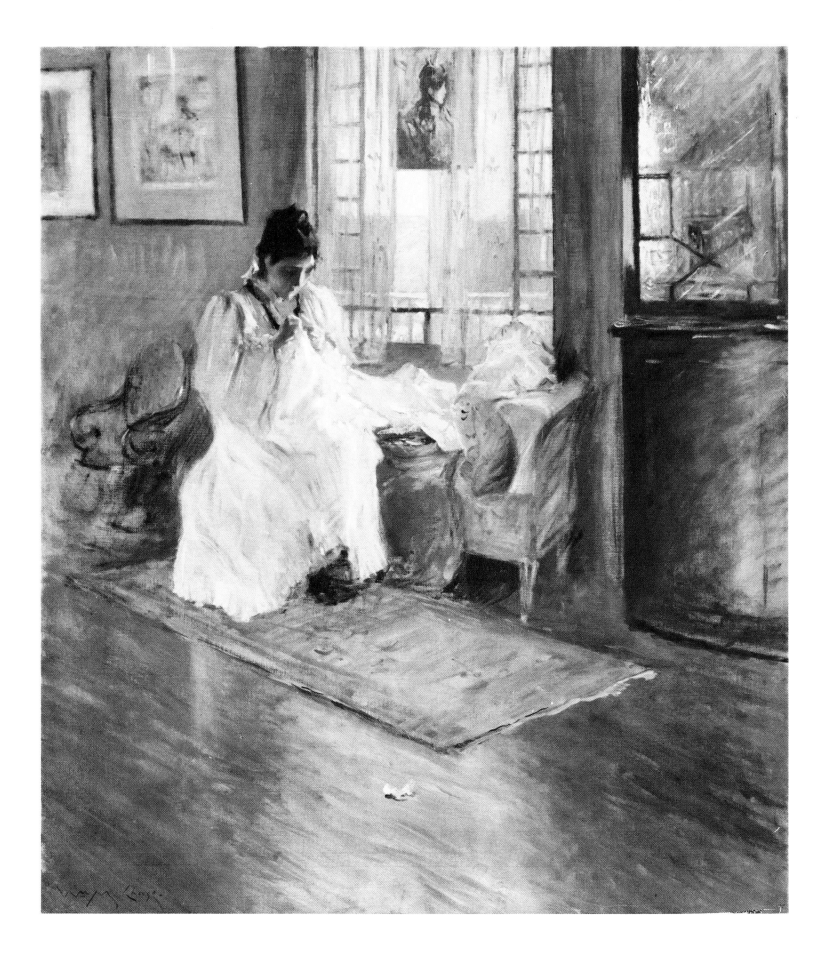

it full of exotic bric-a-brac collected on his travels. He had colorful textiles, art pottery, brass pots, musical instruments, and oriental screens—everything from carpets to costumes, much of which he used in his painting. Dapper and energetic, he was an enormously successful painter, teacher, tastemaker, and family man. He had houses in New York City, Shinnecock, and Florence, Italy; and his work reflects his eclectic and varied way of life. It is, at times and depending upon the occasion, close to that of Frank Duveneck, Alfred Stevens, Whistler, Sisley, Manet, and Sargent. Chase was not an innovator like Whistler, or a philosopher like Twachtman, or a poet like Dewing. He was pragmatic, and in many ways, he typifies the problem of the American artist of his era—the problem of a national artistic identity, although the question never comes up in his work, or perhaps it is side-stepped by his keen observation and mastery of technique. For all its eclecticism, Chase's work is stamped by his strong personality. Take *The Open Air Breakfast* for example. Probably painted in Brooklyn in 1888, it combines the brilliance of his *plein-air* painting and his love of the exotic, and it includes references—such as the costumes, the use of black—to his favorite old Dutch and Spanish masters. Like the portrait of Dora Wheeler, *The Open Air Breakfast* is a *tour de force* and exhibits all the characteristics of his best work, as well as his zest for life.

(*see page* 190)

In his "Brief Estimates of the Painters," from his book *A Collection in the Making,* Duncan Phillips called Chase a master of what the French call *"la bonne peinture."* Duncan Phillips, that most perceptive and personable of American collectors, a man who cared little for what was in fashion, added prophetically, "He deserves to be long remembered for his influence upon the development of taste in the United States during the period when we were slowly acquiring some of the artistic sagacity of Europe. . . . This painter's painter will have an enviable niche in the hall of fame." Duncan Phillips wrote those words in 1926; now, half a century later, Chase's work is once more back in favor with museums and collectors.

William Merritt Chase died in 1916. It was already near the end for The Ten and for American impressionism. In the words of Edward Simmons, "The 'pep' and enthusiasm of youth started The Ten American Painters and age has finished it. Peace to its ashes!" The Eight, who, for the most part, reacted against impressionism, had held their first exhibition in 1908; Cubism and Fauvism had come to America and caused a sensation in the Armory Show of 1913; and the First World War had begun. Two members of The Eight, William Glackens and Ernest Lawson, tried for a "revival of vigor" in the impressionist style, and a third, Maurice Prendergast, became the first American post-impressionist. However, the style lingered on. It flared briefly in California as a result of the Panama-Pacific Exposition of 1915, and in Paris its decorative and sentimental qualities were exploited by two expatriate American painters, Richard Miller and Frederick Frieseke.

facing page:

WILLIAM MERRITT CHASE
The Hall at Shinnecock
(circa 1895) 40⅛ x 35 inches
*The Metropolitan Museum of Art
Lazarus Fund, 1913*

WILLIAM MERRITT CHASE
Shinnecock Hills
(circa 1895) 40 x 50 inches
The Cleveland Museum of Art,
Gift of Mrs. Henry White Cannon

facing page:

JOHN SINGER SARGENT
Two Girls Fishing (1912) 22 x 28¼ inches
Cincinnati Art Museum

The American Impressionists

WILLIAM GLACKENS
Italo-American Celebration, Washington Square
(circa 1912) 26 x 32 inches
Museum of Fine Arts, Boston,
Emily L. Ainsely Fund

"Tea cakes. And when they showed me a room
full of my own confections I felt quite sick."
From *The Horse's Mouth,* by JOYCE CARY

BY the time of Twachtman's death in 1902, *everybody* was an impressionist, and even those who did not carry its *carte d'identité* were influenced by the impact of the style. There was hardly an American painter who was wholly untouched by it—even painters like George Inness, who called it "the original pancake of visual imbecility," and Kenyon Cox, who railed against its "pernicious" influence, were affected by impressionist practice. At the other extreme were artists such as John Singer Sargent, who understood impressionist principles from the start, Richard Miller and Frederick Frieseke, who popularized impressionism, made it sentimental and decorative, and William Glackens and Ernest Lawson, who tried to renew its sparkle and vitality.

John Singer Sargent (1856–1925) was in Paris in the early 1870s when the French impressionists were considered revolutionary. Even though he was influenced by the new painting to the extent of going through a brief impressionist period, and in fact, continued to utilize certain aspects of the impressionist technique on and off during his career, he was not dedicated to its philosophical premises. He did not pursue it to the full extent, as Twachtman, Weir, or Robinson did. He was not, in Monet's view, "a true impressionist." Yet impressionism broadened Sargent's style and enriched his palette, so when he did use it, he most effectively captured the brightness of sunlight on beach or piazza, the atmosphere of out-of-doors or inside a room, the brilliance of hue in a white gown or tablecloth, and, like William Merritt Chase, the glint and glitter of polished surfaces—the kind of thing Sargent's patrons loved.

Sargent was raised in a world of expatriate Americans living a life of "taste" and leisure in Florence. His parents originally came from Philadelphia, but they preferred to live in Italy, where Sargent received his first artistic training. In this he was encouraged by his mother, who was herself an enthusiastic amateur. He worked by himself at first, attended the Academy in Florence, and in 1874, he was accepted in Carolus-Duran's *atelier* in Paris. Carolus-Duran, who like his friend Manet was seriously impressed with the work of Velasquez, was considered to be very modern in the early 1870s. He based his teaching on accuracy of vision, a control of tonal relationships, and a direct and painterly attack on the canvas—all of which suited Sargent who already had an exact and clear vision and quickly absorbed everything else Carolus-Duran could teach him. In the summers he painted in the country, in Brittany and at Barbizon. He was among the first to discover Grez, the little town so delightfully described by Will Low. But the pictures he painted there were not Barbizon landscapes; he used a high-

keyed palette. In 1874 he made a painting (*Two Wine Glasses*) of the patio of a house, possibly in Grez, which is charged with impressionist brilliance. He was nineteen at the time.

In 1884, ten years after entering Carolus-Duran's studio, he showed at the Salon his now famous full-length portrait of Madame Gautreau, the celebrated Parisian beauty. Sargent probably met Madame Gautreau in 1881, and at once lusted to paint her portrait, writing immediately to a friend to intercede for him, "You might tell her that I am a man of *prodigious talent.*" She finally acquiesced, although she did not actually commission the portrait; and he began work on it in 1883. In the Isabella Stewart Gardner Museum in Boston, there is a brilliant little sketch, *Madame Gautreau Drinking a Toast,* which might be a result of one of his first encounters with the lady who wore lavender make-up. The sure but casual execution and the slice-of-life feeling are components of the impressionist style, but the large finished version (Metropolitan Museum, New York) is more controlled in technique and more formal, even stylized, in composition. It is one of his most striking and important paintings—but, at the time, no one liked it. In fact it caused a great outcry. Madame Gautreau disliked it; her friends and family positively hated it; and the critics and public found the mauve color of her skin, and her décolletage, thoroughly shocking and immoral. Madame Gautreau's mother asked the artist to have it removed from the salon but he curtly refused. Instead he moved to London in 1885.

Thereafter, London became his headquarters, and Sargent eventually became the first painter to Edwardian society. In this position he acquired American patronage as well, and he became a frequent transatlantic traveler, painting the establishment of the day in both England and America. His first trip to America was in 1887 upon the invitation of businessman and collector Henry G. Marquand, who requested Sargent to paint Mrs. Marquand in Newport. Sargent's first one-man show, at the St. Botolph Club in Boston, followed in 1888. It was an immediate success, and his combination of European chic with straightforward honesty in the delineation of character made him the John Singleton Copley of his generation.

Claude Monet was a direct influence on Sargent's impressionist work. Sargent visited Monet in Giverny in 1887, and he painted Monet at work several times; also in the same year, he acquired one of Monet's pictures. However, he was probably well aware of Monet's painting before 1887, since Sargent's arrival in Paris in 1874 coincided with the first impressionist exhibition. Many years later, he wrote to a friend about how awed he had been when he first met Monet; in fact, he remained a loyal admirer of the Frenchman throughout his life.

However, Sargent's impressionist pictures were produced not in France, but in England; not in Giverny, but in Worcestershire, in the pastoral villages of Broadway, Calcot on the Thames, and Fladbury on the Avon. Here

(*see page* 213)

JOHN SINGER SARGENT
Two Wine Glasses (1874) 18 x 14½ inches
Collection of the Marchioness of Cholmondeley

he painted his most fully developed impressionist pictures: landscapes, figure studies, boating scenes; he studied light and atmosphere and painted everything in a very high-keyed palette. Edwin Abbey introduced Sargent to the artistic community at Broadway in the Cotswolds, and it was there that he painted a large subject picture of two girls in a garden at twilight, with additional light coming from a series of Japanese lanterns. Called *Carnation, Lily, Lily, Rose,* the finished painting is in the Tate Gallery, London; there is a lovely study for it in a Cincinnati private collection. It was, as Sargent said, a "fearful difficult subject." For one thing, he could paint on it only for the ten minutes at a time, during the fleeting evening light; for another, he felt that his paints were not bright enough. But despite the long period over which it was painted, it has immediacy; and despite the fact that it owes a little to the pre-Raphaelites and a little to Whistler, the light is acutely observed and it was *not* painted in the studio. And when it was exhibited at the Royal Academy, it was probably the first time anything resembling an impressionist picture had been hung in England.

Paul Helleu, Sketching, and His Wife was painted in 1889 at Fladbury when Helleu and his bride came to visit. Sargent knew Helleu from his Paris days when they both were in the circle of Carolus-Duran. Later Helleu would become a successful portrait-painter of chic and beautiful women. For Donelson Hoopes (who wrote of it in *The Brooklyn Museum Annual, 1965-66*) *Paul Helleu, Sketching* was "one of Sargent's most completely realized impressionist pictures." That is probably true, but the painting does point out a major problem that Sargent had with the impressionist style—a problem evident in the work of a number of other American painters as well. The landscape and the light in the Brooklyn picture are painted in accordance with impressionist practice, but the figures are not. They are the result of the tradition of "the quiet observation of fact" and are not integrated in the pictorial structure as a whole. Unlike the surrounding landscape, they are not seen in strictly aesthetic terms. Most American impressionists were unsuccessful in integrating the figure with their landscapes. It was a problem for Twachtman, for Weir, and especially for Childe Hassam and Sargent, they were all more at ease painting pure landscape. Sargent's art, unlike Twachtman's, for example, was founded on the literal transcription of the object in front of him; for, as he once remarked, "I don't dig beneath the surface for things that don't appear before my own eyes."

Sargent painted a number of serious impressionist studies for a brief period between 1885 and 1889, and under the impact of impressionism his style became more expansive, more fluid, and his color became more luminous. *Robert Louis Stevenson* is a good example; it is much like Manet in its freshness, simplicity, and vigor of attack. Then the demands of portraiture caught up with him—1890 marks the beginning of his busiest and most successful phase of portrait painting. Thereafter any attempts at "pure"

(see page 192*)*

(see page 212*)*

JOHN SINGER SARGENT
Carnation, Lily, Lily, Rose
19½ x 23½ inches
Private Collection, Cincinnati

(see page 212*)*

JOHN SINGER SARGENT
Portrait of Robert Louis Stevenson
(1887) 20¹⁄₁₆ x 24⁵⁄₁₆
The Taft Museum, Cincinnati

JOHN SINGER SARGENT
Paul Helleu, Sketching, and His Wife
(1889) 25⅝ x 31¹³⁄₁₆ inches
The Brooklyn Museum

212

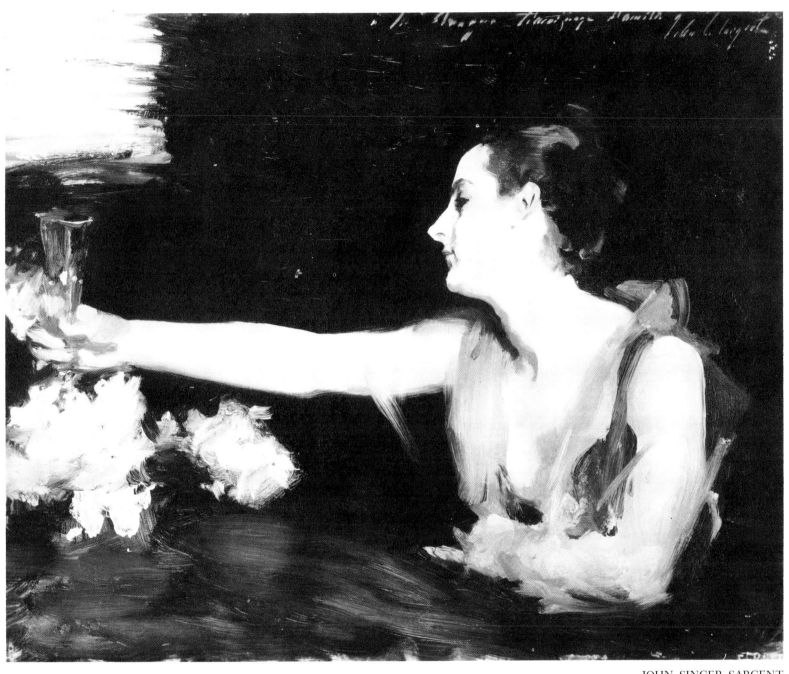

JOHN SINGER SARGENT
Madame Gautreau Drinking a Toast
(circa 1884) 12½ x 16 inches
Isabella Stewart Gardner Museum, Boston

painting were restricted to those moments when he was "off-duty." The pictures he produced in those moments, the oils like *Home Fields,* and the watercolors, were as full of bravura as they were somewhat cold in feeling and empty in form. His need to experiment, to search, was gone. *The Sketchers* is a lovely picture, full of charm and sunlight, yet it is an echo of the past—it was painted around 1913, the year of the famous Armory Show in New York; not only was impressionism as a style "giving way to the new," but Sargent's art and the world upon which it was based were about to crumble under the juggernaut of "The Great War."

American impressionism was always less robust than its French counterpart. It was more delicate and, in some cases, more poetic; but in many cases delicacy turned into sentimentality, poetry into decoration, or combinations of both. Robert Henri and most of "The Eight" rebelled against the softening of the style and the idealization that went with it. Maurice Prendergast, however, and some of the California painters used the style as a starting

JOHN SINGER SARGENT
Home Fields (circa 1885) 28¾ x 38 inches
Detroit Institute of Arts

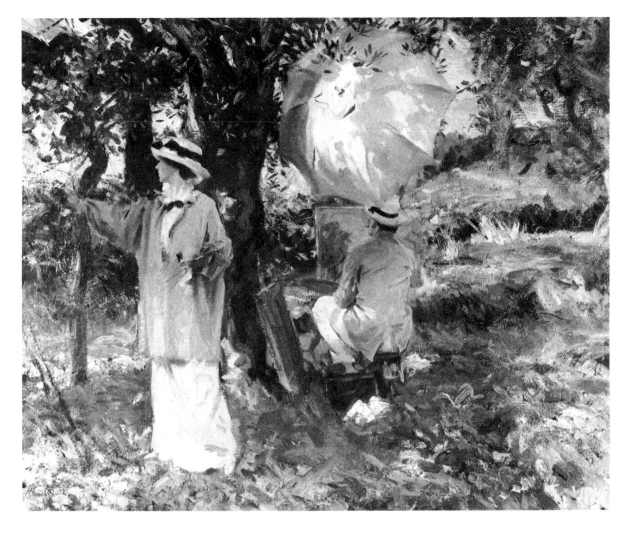

JOHN SINGER SARGENT
The Sketchers (1914) 22 x 28 inches
*The Virginia Museum of Fine Arts,
Richmond. Glasgow Fund,* 1958

point for their excursions into a modest post-impressionism. Out in San Francisco, the Panama-Pacific International Exposition of 1915, which was something of a repetition of the Chicago World's Fair, was perhaps the last important large showing of American impressionist painting. It also symbolized the end of the easy-going "art-atmosphere" of the late nineteenth-century American art world represented by Whistler, Chase, and Duveneck, each of whom had an individual gallery devoted to his work. The Panama-Pacific International Exposition was presented as though the Armory Show of 1913—with its excitement and controversy, its inclusion of the new European Cubism and Fauvism—had not happened. The Exposition brought together a number of California impressionists for the first time, including Joseph Raphael (1872-1950) and E. Charlton Fortune (1885-1969), who had an impact on younger artists in the next decade because of their presence in it. Fortune and Raphael were two of the best artists in that show, and they both had very idiosyncratic sytles in which they used the bright palette and broken brushwork more for expressive than for impressionist

purposes. The loose, casual construction of Fortune's *Summer Landscape* and the dense formal structure and color saturation of Joseph Raphael's *Rhododendron Field* both seem to prefigure the work of Richard Diebenkorn and the modern California painters. Xavier Martinez, a disciple of Whistler, and Jules Pages, whose painting *Sonoma County Landscape* is similar in its study of light to the work of Eastman Johnson or Winslow Homer, were also influential as a result of the Exposition.

Joseph Raphael and E. Charlton Fortune were not very well known outside of California in their time and their work is little known today. They were the most important exponents of a "California impressionism," but for the most part impressionism was less current there than in the East. California painters seem to have jumped from the tonalism of William Keith to a Nabis-type flat-patterned style derived from the Japanese (via the French Nabis group) through the strong influence of the San Francisco mural painter Arthur Mathews. This may have happened partly because of the distance from the East Coast, where an Anglo-European cultural influence predominated, and largely because of the influence of Mathews himself. San Francisco was the art world of California and Mathews was the center of it.

(*see page* 193)

E. CHARLTON FORTUNE
Summer Landscape (1914) 22 x 26 inches
Oakland Art Museum,
Loaned by M. H. deYoung Memorial Museum,
Gift of the Skae Fund Legacy

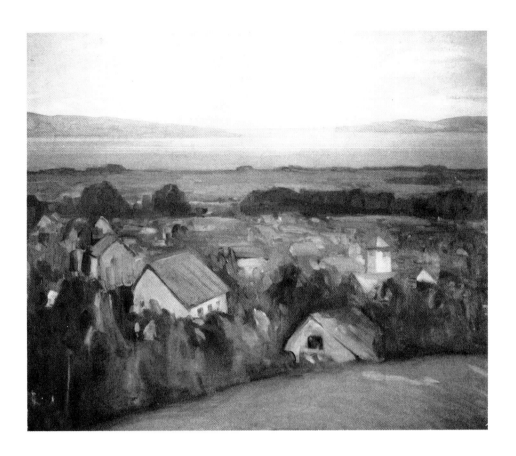

XAVIER MARTINEZ
The Bay (1918) 38¼ x 44½ inches
The Oakland Museum
Gift of Dr. William S. Porter

JULES PAGES
Sonoma County Landscape 12 x 18 inches
The Oakland Museum
Loaned by Mr. and Mrs. Victor Reiter

The work of Daniel Garber (1880-1958) has a strongly decorative, *designed* quality. Garber studied with Frank Duveneck at the Art Academy in Cincinnati in 1897, and with Thomas Anshutz and J. Alden Weir at the Pennsylvania Academy from 1899 to 1905. His work is uneven, but in his best paintings, such as the landscapes of Bucks County, Pennsylvania, there is poetry and an understated lyricism of color which make him one of the more interesting of the late American impressionists.

(*see page* 197)

The sentimental turn taken by American impressionism is represented by Frederick Frieseke (1874-1939) and Richard Miller (1875-1943). Both were famous in their time, and both carried the style into the late 1930s. In 1932, *Art Digest* claimed that "Frieseke, internationally, is perhaps America's best known contemporary painter." He lived most of his life in France, where he studied briefly with Whistler, and adopted the impressionist palette after about 1901. His fame soon spread across Europe, and eventually to America, but after his death he was soon forgotten. It is not surprising, really. Frieseke painted "pretty" pictures of women posed out-of-doors or in equally "pretty" interiors. Although his craftsmanship was sound, as in *Lady Trying on a Hat,* his color is sugary and sweet; and his paintings are sentimental or, at best, decorative. Decoration, sentiment, sound and sometimes slick, craftsmanship are characteristic of the work of Richard Miller as well. Miller went to Paris in 1898 and stayed there for twenty years, teaching and painting. Like Frieseke, he painted "pretty" pictures, mostly of women; he painted portraits in an academic manner and landscapes in an easy manner. *Woman and Teapot* is typical of Miller's pleasant, lush, easy, and sentimental decorative style. The work of Frieseke and Miller is the kind described by Gully Jimson, Joyce Cary's marvelous character in *The Horse's Mouth,* when he saw a gallery full of impressionist painting: "Tea cakes." And a room full of "confections" would have been an apt description for much of American impressionism after the turn of the century. It was the kind of painting Robert Henri and his friends rejected.

(*see page* 195)

(*see page* 198)

Henri received some impressionist training, but he reacted against it, eschewing the bright palette of Monet or Hassam and, instead, returning to the dark tones of Frank Duveneck and the Munich School. Henri and his group, "the Eight," rejected impressionism, not only because of its confectionary look, its prettiness, but because of its celebration of "the smiling aspects of life" and its "holiday atmosphere," because of its views of genteel middle-class life and its "ideal" landscape motifs. The American city in all its forms was rarely painted until the advent of the Eight. The members of the group believed that ordinary people and their environment should be more honestly depicted, without disguising the more mundane aspects of life. At least Henri did, and John Sloan; but two members of the Eight, William Glackens (1870-1938) and Ernest Lawson (1873-1939), used the impressionist format and, like Schofield and Redfield, tried to instill a new vigor

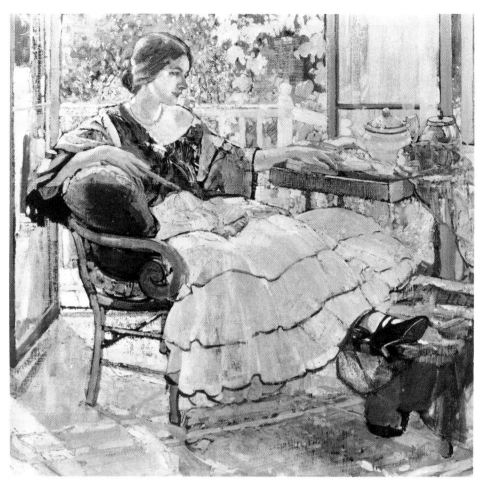

RICHARD MILLER
Woman and Teapot. 34 x 36 inches
Ira Spanierman Galleries, Inc., New York

DANIEL GARBER
The Hawks' Nest. 52 x 56 inches
Cincinnati Art Museum

219

in to the style; a third member, Maurice Prendergast (1859-1924), went beyond impressionism and the "social" realism of most of the Eight to produce very personal, stylized paintings which have more in common with Cézanne or Gauguin than they do with Monet, Twachtman, or Glackens.

William Glackens was an artist-reporter for the *Philadelphia Record,* and afterwards the *Press,* where John Sloan, George Luks, and Everett Shinn were on the staff. In the evenings he studied with Thomas Anshutz at the Pennsylvania Academy, and he shared a studio with Robert Henri. In 1895, he worked his way to Europe on a cattleboat, visited Holland and France with Henri and Elmer Schofield. When he returned to America, he settled in New York where he worked for the *New York Herald,* the *New York World,* and various illustrated periodicals; and he continued to support himself as an illustrator until 1914, when he gave it up entirely in order to devote himself to his painting. Glackens was always active, though, in any cause for the promotion of a modern American art. In 1908, he exhibited with the Eight at the Macbeth Galleries; in 1910, he was one of the organizers of *The Independents,* an exhibition which attracted two thousand people on opening day; and he was one of the organizers of the Armory Show in 1913, and chairman of the committee for the selection of the American entries. In that same year, he illustrated Theodore Dreiser's *A Traveler at Forty.* The two had much in common; for just as the impressionist style had a parallel in the writing of Hamlin Garland, who was also its foremost American champion in his art criticism, the Eight had its parallel in literature in the writing of Dreiser, Frank Norris, and subsequently, Sinclair Lewis. These writers also rebelled against "aestheticism," and asserted the importance of a broad American experience as subject matter for their art.

In his own work, Glackens first painted in the dark tonalities of Henri and the early work of John Sloan, but later, under the influence of Renoir and perhaps Manet, he adopted a palette of brighter, sharper color. Glackens stands accused of imitating Renoir, and in a picture like *Promenade,* his style is certainly extremely close to that of the French artist, but Glackens's work was never as "soft," nor was his color as subtle as the early work of Renoir; and Glackens's draftsmanship was never as fine as that of the Frenchman's later period. Glackens's earlier painting is similar in style to Henri, Luks, or Bellows, and it is probably his best. His handling is cursive, free, sloppy even, as in *The Drive: Central Park.* Like Bellows, Shinn, and Luks and, to a certain extent, the German Expressionists, his color has a sharp, almost acid quality about it. It recalls a comment once made by Thomas Dewing about another artist: he used color just *sour* enough to save the work. *Chez Mouquin* is one of his masterpieces, one of his best known and most often reproduced paintings. Painted in 1905, it owes more to Manet than to Renoir; in fact it is strongly reminiscent of Manet's *The Bar at the Folies-Bergère.* Mouquin's, of *Chez Mouquin,* was a Sixth Avenue restaurant, where many

(*see page* 200)

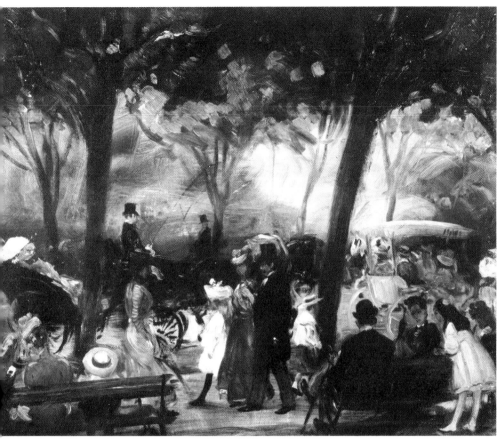

WILLIAM J. GLACKENS
The Drive: Central Park
(circa 1905) 25¾ x 32 inches
The Cleveland Museum of Art, J. H. Wade Fund

WILLIAM J. GLACKENS
The Promenade. 32 x 25 inches
The Detroit Institute of Arts

of the Eight used to go; it was "a real Paris place." *Chez Mouquin* is indeed a vigorous work, and as most of Glackens's paintings, it has something of Henri, a little of Manet, and a lot of Renoir.

Glackens's friend Ernest Lawson also used the impressionist format. Lawson arrived in New York via Halifax, Nova Scotia, where he was born, and Kansas City and Mexico City, where his father was employed. The pictures he first admired in New York, or at least the ones he wrote home about, were a Bouguereau which he saw hanging in a saloon, and Bastien-Lepage's *Joan of Arc* and Rosa Bonheur's *Horse Fair*, both in the Metropolitan Museum. However, he soon came under the influence of John Twachtman and J. Alden Weir, particularly Twachtman, with whom he studied at the League in 1891–92, and at Cos Cob, Connecticut, in the summer. And it was Twachtman's muted impressionism that Lawson brought with him when he went to Paris in 1893. He studied at the Académie Julian, but soon dropped that in favor of painting out-of-doors. Two of his pictures were accepted at the Salon of 1894, but he did not want to stay in France. He wanted, as he said, to help his individuality, "and at the same time get as much French

influence as will be consistent with it." That statement seems odd in light of the fact that he arrived in France already influenced by the French through the style of John Twachtman. But he stated further that the "French influence kills if taken in too large a dose—witness most of our best artists who have become to all intents and purposes Frenchmen in work and thought. Now I will go back to Connecticut, and see what I can do." It is not clear whether Lawson meant an expatriate artist such as Mary Cassatt, or whether he meant French-trained painters such as Twachtman or Weir; in any event he went back to America in 1894. He did go back to France, however, returning to America in 1896; he settled in Toronto for a while, and in 1898, he moved to New York. He became involved in the activities of the painters who would organize the Eight in 1908. Gertrude Whitney, who was later to found the Whitney Museum of American Art, bought one of Lawson's paintings from the group show of the Eight that year; and Lawson soon attracted the interest of a number of other collectors, notably, John Quinn, Albert Barnes, Frank Crowninshield, Duncan Phillips. He also attracted the attention of Ferdinand Howald, an obscure Swiss engineer living in Columbus, Ohio. Howald, whose pictures are the backbone of the Columbus Gallery of Fine Arts, quietly amassed one of the truly great collections of early modern art in this country. He loved Lawson's work, and Columbus owns seven superb paintings. *Hudson River at Inwood* is one of them, and

ERNEST LAWSON
Hudson River at Inwood. 30 x 40 inches
The Columbus Gallery of Fine Arts,
Howald Collection

the fresh sparkling color amid the white of a snowy day and the rich fragmented paint surface indicate the influence of Twachtman.

Lawson, like Henri, learned his impressionist technique in art school, and at first he painted in the delicate airy style of John Twachtman. In France he was somewhat influenced by Sisley, but when he returned to America to "see what I can do," he found subject matter which suited him. He painted in and around New York City, in Washington Heights for example, and along the Hudson and Harlem rivers. Like Twachtman, Lawson painted a great many winter scenes, again tackling the problem of white as a color, but unlike Twachtman's, Lawson's style is fairly "rugged." *Harlem River* and *Melting Snow, Early Spring* are painted in the style for which he is best known: the paint is applied in a thick impasto of jewel-like color, referred to by critic F. K. Price as a "palette of crushed jewels." Lawson's work is both sensitive and strong, and he was the only member of the Eight to paint pure landscape; but it is, like the painting of Glackens, an extension of impressionist principles. He always did think of himself as a traditionalist, yet his textural and chromatic variations were more personal and post-impressionist. Unlike Twachtman he was not interested in the evocation of moods of nature so much as in using the landscape format for capturing an inner mood.

(*see page* 224)

ERNEST LAWSON
Harlem River (circa 1910–1915) 20 x 24 inches
Allen Memorial Art Museum
Oberlin College, Oberlin, Ohio

Lawson was an emotional man; he once wrote to Price that color should be used to depict "the three major emotions in a man's life—anticipation, realization and retrospection." His friend Somerset Maugham understood that side of him, and used Lawson as the model for Frederick Lawson, the emotional artist in *Of Human Bondage*.

Ernest Lawson was included in the Armory Show of 1913 and so was Maurice Prendergast. The painting of Maurice Prendergast, however, goes beyond that of Lawson in making a break with the French impressionist tradition upon which their work is based. Born in 1859, the same year as Georges Seurat, Prendergast also laid on brush strokes of unmixed color. However, he was not interested in subtle theories of optical fusion, but in the glitter and sparkle of light and movement expressed in a kind of prismatic placement of hue against hue.

Maurice Brazil Prendergast was born in St. John's, Newfoundland, and his first job consisted of selling fabrics and designing posters for a Boston dry-goods firm. In 1886, he made his first trip to England and possibly Paris. In 1891, he made his second trip abroad, this time for formal study. In Paris he studied at the Académie Julian, and at Colarossi's in the mornings; in the afternoons he went to the cafés and parks, sketching from life, trying to capture the movement of people. Movement was a theme that was to intrigue him throughout his career. While he was in Paris, Prendergast formed a

ERNEST LAWSON
Melting Snow—Early Spring
20 x 25 inches.
Vose Galleries, Boston

friendship with the Canadian painter Charles Wilson Morrice, who influenced him profoundly. The two artists not only had similar aims, but the Canadian had been in Paris longer and introduced Prendergast to his acquaintances, including the painters Charles Conder, Walter Sickert, and Aubrey Beardsley, all of whom, like Morrice, were dedicated admirers of Whistler. He was introduced to the writers Arnold Bennett, Somerset Maugham, and an Irish *amateur* named Roderick O'Connor, who knew more about Gauguin and especially Cézanne than anyone else there.

Prendergast's association with this group was important. Vital and exciting, it gave direction to his career; and as his familiarity with the work of the post-impressionists grew, it proved to be the key element in the development of his highly personal style. *Evening Shower, Paris,* painted in 1892, dates from the beginning of his stay in Paris. As in much of his early work, the flattening of the forms and their rhythmic treatment in *Evening Showers* indicates the influence of Whistler. There are also traces of Bonnard and Vuillard, but these influences were gradually replaced by that of Cézanne.

In 1894, Prendergast returned to the United States to live with his brother Charles in Winchester, Massachusetts. In 1898, through the good offices of Mr. and Mrs. Montgomery Sears, who were also among the early collectors of French impressionism, Prendergast went abroad again—this time to Paris, St. Malo, and especially Venice. In Venice, he discovered Carpaccio, and in the work of that charming painter of the Venetian Renaissance, he found a kindred spirit. Prendergast was painting primarily in watercolor at this time, and his Venetian watercolors reflect his interest in Carpaccio and point toward his mature oils. In 1900, he returned to the United States, and in 1901, he painted a charming series of watercolors in New York, mostly in Central Park, in which the theme of festival and procession echoes his watercolors from Venice. *May Day, Central Park* has more of the fantasy of Carpaccio than of the aestheticism of Whistler. The spontaneity required by watercolor helped him to pursue his vision of the swiftness of movement and luminosity of color. He intensified his palette and, inspired by Carpaccio, Prendergast transferred the brilliant pageantry of sixteenth-century Venice to his own paintings.

Prendergast's work in watercolor predominated over his work in oil until about 1904, when he began to develop a more serious interest in the oil medium, moving, by 1907, toward a more abstract style. The critics, referring to his pictures shown with the Eight, spoke of "an explosion in a color factory." In 1909-10, he was back in France, and in 1911-12, he was once again in Venice. In 1913, he exhibited seven watercolors in the International Exhibition of Modern Art which has come to be known as the Armory Show, and his work was among the most avant-garde of that of any of the American artists included in that exhibition. In 1914, he left Boston, and for the next decade he lived in New York, where he died in 1924.

MAURICE PRENDERGAST
Evening Shower, Paris (1892) 12½ x 8½ inches
Museum of Fine Arts, Boston
Collection of Mr. and Mrs. Perry T. Rathbone

(*see page 1*)

225

In 1908, Prendergast painted *Woman in Brown,* a picture reminiscent of Cézanne's portrait of Madame Cézanne; and between 1910 and 1912, he painted a few portraits, probably including the strong *Portrait of H. R. Burdick.* It was said that Prendergast was one of the first to appreciate Cézanne, that he understood his work better than any other American artist of his time; the portrait of the Boston photographer and painter Horace Burdick certainly indicates his debt to the great French artist. The build-up of color planes in the head, the patches of bare canvas, the placement of the figure as it fills the picture space and the general feeling of the painting recall some of Cézanne's self-portraits. Portraits are rare in Prendergast's work, whereas the *Still Life* of 1915, although somewhat Cézannesque, is more typically Prendergast; and the tapestry effect, the flattening of the

MAURICE PRENDERGAST
Portrait of H. R. Burdick
(circa 1908–1912) 20 x 18 inches
Collection of R. P. Pach, North Carolina

MAURICE PRENDERGAST
Portrait of Woman in Brown Coat
(1908) 23¼ x 26 inches
*Museum of Fine Arts, Boston
Gift of Mrs. Charles Prendergast*

226

MAURICE PRENDERGAST
Still Life (1915) 18½ x 21
*Museum of Fine Arts, Boston,
Gift of Mrs. Charles Prendergast*

space, the surface treatment of *The Promenade* is more typical still. Important influences on Prendergast—including Cézanne, the Nabis, Charles Morrice, and the pageantry of Carpaccio—are all strongly welded and happily fused here into the artist's unique and personal statement. He remains best known for the tightly packed forms, mosaic pattern, and jewel-like color found in this marvelous picture, one of fourteen Prendergasts in the Ferdinand Howald Collection.

Prendergast was never concerned with a political or social message in his art; and his work was never brought before the public by way of illustration or print. He was essentially a loner, and he was original. The theory suggested by Gauguin, that art is a synthesis of imagination and memory, was also an important part of Prendergast's aesthetic; and at the beginning of the twentieth century in America he alone stood for the new direction art was to

(*see page* 198)

227

take in subsequent decades. Stylistically he represents the end of American impressionism and the advent of a truly modern painting in the United States.

This book has attempted to chart the course of American impressionism from its beginnings and development in the work of major artists, such as Mary Cassatt and Theodore Robinson, and of minor figures, such as Mark Fisher, to its culmination with The Ten American Painters, and finally to its stylistic end in Maurice Prendergast. And it did end. Until about ten years ago, many of the paintings discussed here were relegated to basement storage and the artists who painted them were forgotten or virtually unknown. Since then there has been a tremendous revival of interest in the style on the part of scholars, dealers, collectors, museums, and gradually, the general public. The painters of that "holiday world," a simpler life, cheerfully painted, have come back into their own.

The reasons for this reassessment vary. Economics has, of course, played its role; however, it is too simplistic to say that because the work of the French impressionists has been thoroughly eliminated from the market by incredible prices, collectors have been forced to look elsewhere. For some twenty years there has been a tremendous growth of interest in American art in general—a serious concern for our art historical and artistic continuity, our heritage. With the advent of abstract expressionism in the late 1940s and early '50s, American painting was looked at as never before, and New York, rather than Paris, became the center of the art world. Contemporary American art created an awareness of past American art, and American impressionism became recognized as an important part of the past. Scholars are indeed interested in the colleagues and contemporaries of the French impressionists, and they are turning up some fresh and sometimes surprising material in their studies of impressionism as an international movement.

In the light of today's pace of life, its complexities and tensions, representations of what J. Alden Weir called "a beautiful world" appeal to many people. The work of the American impressionists provides a refreshing change from the complications of today's world—as well as a respite from the complexities of contemporary art with its bombardment of varying approaches and styles which appear to change with ever-increasing and dizzying speed. Then, too, part of the appeal of American impressionism is undoubtedly the excitement of discovery, or even rediscovery, the heady experience of finding an artist overlooked by everybody else.

The American impressionists have been overlooked and their rediscovery has not only added to the knowledge of a particularly interesting era in American life, but the sheer good painting, "the intrinsic quality" of much of their work, has expanded the experience and enriched the lives of those who acknowledge the merit of a superb painting regardless of the artist or his nationality. "La bonne peinture" does count for something after all.

Epilogue

"Paint what you see and look with your own eyes." GILBERT STUART

I MPRESSIONISM originated in France and became international in scope. It revolutionized the art of painting by its concern with the very act of painting, which in turn came about as the impressionists found new formal solutions for the expression of new ideas. Like the Barbizon painters before them, the impressionists rejected the artificial subject-picture, in favor of painting out-of-doors; but unlike the Barbizon artists, or the American Hudson River School, the impressionists went further. They broke with the older conception of a picture as a classically ordered unit in time and space, and substituted the casual passage of time, a "fleeting moment," and a fragment from the continuous space, signifying movement, change. Hence, the changing elements, the representation and expression of an overall light and atmosphere became their common concern. "The watchword of impressionism," according to Fritz Novotny in *Painting and Sculpture in Europe, 1780–1880,* "is that light in something higher than matter, that light is freedom, matter captivity." The impressionists achieved this representation of light through seemingly casual and spontaneous execution, through the offhand, "unfinished" appearance of their canvases—derived from both photography and Japanese prints—and above all through the use of color. The impressionists painted with color that was bright, variegated, and to a large extent, newly discovered; and they used it in a new way. Because of impressionist painting, representing light and the subtle variations of atmosphere through color eventually became common practice for all artists.

As the impressionist style was adopted by American artists in the 1880s, and as it gained momentum and general acceptance, there were few painters who were immune to it, even those who were in vehement opposition. Inness, for one, was furious when the art critic of a Florida newspaper classified him as an impressionist. George Inness, Jr., in a book about his father, *Life, Art and Letters of George Inness,* quotes the painter's answer to the editor in which Inness states that impressionism is "the original pancake of visual imbecility," and that Monet practiced a form of "humbug." Yet the glorious color in Inness's late work is surely indebted to the brighter palette of impressionist practice. In the same letter, Inness makes a statement in his own defense that has significance here. He talked of "generalizing without losing that logical connection of parts to the whole which satisfies the mind"; and, "the elements of this, therefore, are *solidity of objects* [my italics] and transparency of shadows in a breathable atmosphere through which we are conscious of spaces and distances." Inness was speaking for himself, of course, but his statement is implicit in the attitude and work of most of the American impressionists. Their concern for the "logical connection of parts to the whole" and for the "solidity of objects" is one of the major differences between French and American impressionism. There

229

seems to have been a need for "the quiet observation of fact" (an attitude that goes back to Copley and appeared even in the most painterly, the "brushiest" of American painters), for the "palpable reality" of a Duveneck, a William Merritt Chase, or a John Singer Sargent, who once said, "I don't dig beneath the surface for things that don't appear before my eyes." This attitude is expressed in the strong linear tradition in American art, and expressed also in the emphasis placed on learning to draw well by American artists when they went to Paris to study. It accounts for the popularity of Bastien-Lepage, whose combination of *plein-air* painting and precise draftsmanship appealed to a group of painters insistent on the integrity of the object. And it accounts also for the general lack of integration of the figure with the impressionist setting in American impressionist painting, and the conservatism of the American version itself. No American went as far toward abstraction as Monet did in, for example, his water-lily series, or in a wonderful picture such as *Wisteria*. John Twachtman came close. Of all the American impressionists he understood abstraction, and he was not very interested in the representation of objects. But even he, in some of his last pictures painted at Gloucester, experimented with a more realistic, almost Munich, style, although he used impressionist color.

It would appear that what American painters adopted from impressionism was, for the most part, its technique. They brought back from Paris a set of tools with which to work on what they considered to be the faulty machinery of American art. But it was an external cleaning that they achieved; in the broken brushwork, the brighter color, they brought back a lively surface to paint the "surface qualities." The underlying assumptions, the motor of evolution and change inherent in French impressionism, were either disregarded or not considered applicable to the American environment. Perhaps there was quite enough visible change, enough "movement" and commotion, in nineteenth-century American life, to cause American artists, consciously or unconsciously, to keep on seeking in nature those qualities of stability, permanence, and poetry so beautifully expressed in earlier American landscape painting, particularly in the luminist style. Despite the lively impressionist technique, a mood of quietness persists as a characteristic of American impressionism; the quality of silence was held over, but its modern aspects, its new forms, were influenced by Whistler.

The somewhat abstract and austere silence, the delicacy and nuance, the mood of isolation, of quiet musing, the loneliness even, found in Whistler's work, also permeate the work of many of those American painters influenced by Monet. The best of them, like Twachtman and Dewing, achieved a subdued poetry, or, like Weir, good prose. This quiet mood differs from that of the "quietist" painters like J. Francis Murphy, Frank Currier, or William Keith in that the latter were *tonal* painters and modeled their forms in light and shade; whereas the impressionists, even Whistler, did not model their

forms in that way. They used *hue,* no matter how subdued. And along with this subdued mood in much of American impressionism, there exists a romantic and pastoral quality, part of the genteel tradition in American art. With few exceptions, this consists of an avoidance of industrial subject matter and, in particular, of the city itself. Instead, there is a concentration on the "smiling aspects of life," which William Dean Howells considered the only elements worthy of good art and literature. This attitude led to the competent pleasantries of a Potthast and the superficiality of a Frieseke or a Miller—and eventually, to the demise of the style itself.

All this was accompanied by another attitude, an attitude of ambivalence toward Europe; and once again, as it had been earlier, the question of a national artistic style was raised. There were endless discussions among American artists about an American style. Mary Cassatt thought perhaps that J. Alden Weir might found an American school. The strong style and big canvases of Elmer Schofield were an indication of an attempt to equate masculinity and virility with Americanism in art. It was an age of uncertainty in artistic direction, which might account for the restlessness of John La Farge; it was also, as Jarves pointed out, an age of borrowing from other styles, which led to the eclecticism of William Merritt Chase. The question of a national style has always been a difficult one to answer. There were, and are, American experiences, attitudes, and manner of living—but an American style? It may be that the answer lies in the work of William Merritt Chase—eclecticism may, in fact, constitute the American style in the last quarter of the nineteenth century.

Impressionism in America was developed by study abroad, of course, but also through the early acquiring of French impressionist paintings by American collectors and their advisers. Also contributing was the influence of such painters as Bastien-Lepage, Whistler, and Monet, as well as individual borrowing from a variety of other artists, including Degas, Renoir, Stevens, Sisley, Hals, and Velasquez, and, in the case of Dewing, Vermeer.

Photography played an important role, as, of course, did Japanese prints. It was the beginning of the modern concept of a "museum without walls," which John La Farge, like Paul Gauguin, foreshadowed. Although, with the exception of Whistler, and perhaps Maurice Prendergast, who really belongs to the twentieth century, the American impressionists were not innovators, and although they did not wholly follow the pattern of Gilbert Stuart's advice, perhaps because of the insecure American cultural climate of the time, there were still brilliant *individual* achievements. The best of the impressionists created intensely personal, and even original, styles. In the work of Twachtman, Dewing, Cassatt, the early work of La Farge, the city views of Hassam, and the varied scope of Chase, they created many memorable images and made a lasting contribution to American art. And the the lesser lights were skilled professionals who deserve to be better known.

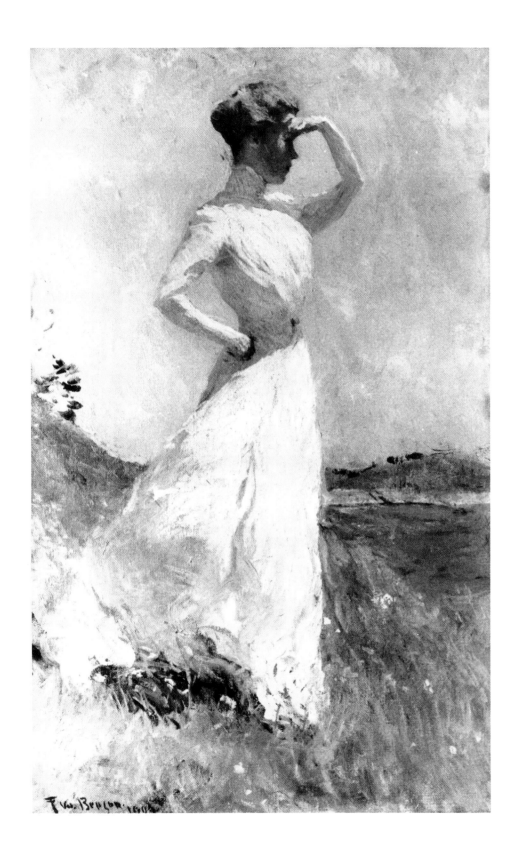

FRANK BENSON
Sunlight (1908) 25¼ x 30½ inches
Cincinnati Art Museum

232

Selected Bibliography

EUROPEAN BACKGROUND—General

Richard Muther, *The History of Modern Painting*, vol. 3, J. M. Dent and Co., London; E. P. Dutton and Co., New York, 1907.

Charles L. Borgmeyer, "The Master Impressionists," *Fine Arts Journal*, 1912.

Edgar P. Richardson, *The Way of Western Art*, Cooper Square Publishers, New York, 1939, reissued 1969.

Ernst Schreyer, "Far Eastern Art and French Impressionism," *The Art Quarterly*, vol. 6, 1943.

John Rewald, *The History of Impressionism*, The Museum of Modern Art, New York, 1946, 1955, 1961; revised and enlarged edition, 1973.

Arnold Hauser, *The Social History of Art*, vol. 4, Vintage Books, New York, 1958.

Fritz Novotny, *Painting and Sculpture of Europe: 1780-1880*, Pelican History of Art, 1960.

Raymond Cogniat, *Monet and His World*, Thames and Hudson, London, 1966.

EUROPEAN BACKGROUND—Technical

J. R. D. Riffault des Hêtres, A. D. Vergnand, and G. A. Toussaint, *A Practical Treatise on the Manufacture of Colors for Painting*, translated from the French by A. A. Fesquet, H. C. Baird, Philadelphia, 1874.

Frederick W. Weber, *Artists' Pigments: Their Chemical and Physical Properties*, Van Nostrand, New York, 1923.

J. Carson Webster, "The Technique of Impressionism: A Reappraisal," *College Art Journal*, November 1944.

Maurice Grosser, *The Painter's Eye*, Rinehart & Company, Inc., New York and Toronto, 1951.

Ralph Mayer, *The Artist's Handbook of Materials and Techniques*, The Viking Press, revised edition, 1958. (Also letter from Ralph Mayer to the author, May 6, 1970.)

William Innes Homer, *Seurat and the Science of Painting*, The M.I.T. Press, Cambridge, 1964.

F. Van Deren Coke, *The Painter and the Photograph*, Exhibition Catalogue, University of New Mexico Press, 1964.

Rosamond D. Harley, *Artists' Pigments 1600-1835*, The International Institute for Conservation of Historic and Artistic Works, Butterworth and Co., Ltd., 1970.

Rosamond D. Harley, "Oil Color Containers: Development Work by Artists and Colourmen in the Nineteenth Century," *Annals of Science*, March 1971.

Aaron Sheon, "French Art and Science in the Mid-Nineteenth Century, Sans Points of Contact," *The Art Quarterly*, Winter, 1971.

AMERICAN BACKGROUND—General

James Jackson Jarves, *The Art Idea*, 1864.

Charles Downing Lay, "The Hearn Fund," *The Arts*, March 1927.

Frank Jewett Mather, Jr., *Modern Painting*, Henry Holt and Company, New York, 1927.

Agnes E. Meyer, "The Charles L. Freer Collection," *The Arts*, August 1927.

Lilla Cabot Perry, "Reminiscences of Claude Monet," *The American Magazine of Art*, March 1927.

Ralph Seymour and Arthur Stanley Riggs, "The Gellatly Collection," *Art and Archaeology*, May-June 1934.

Samuel Isham, *The History of American Painting* (with supplemental chapters by Royal Cortissoz), The Macmillan Company, New York, 1936.

Hans Huth, "Impressionism Comes to America," *Gazette des Beaux-Arts*, April 1946.

Wolfgang Born, *American Landscape Painting: An Interpretation*, Yale University Press, New Haven, 1948.

Oliver Larkin, *Art and Life in America*, Rinehart and Company, Inc., New York, 1949.

John I. H. Baur, "American Luminism," *Perspectives U.S.A.*, Autumn, 1954.

Edgar P. Richardson, *Painting in America*, Crowell Co., New York, 1956, revised edition, 1965.

Aline Saarinen, *The Proud Possessors*, Random House, New York, 1958.

Yvon Bizardel, *American Painters in Paris*, The Macmillan Company, New York, 1960.

Louisine W. Havemeyer, *Sixteen to Sixty, Memoirs of a Collector*, The Metropolitan Museum of Art, New York, 1961.

Leo Marx, *The Machine in the Garden*, Oxford University Press, New York, 1964.

John W. McCoubrey, *American Art 1700-1960*, Sources and Documents in the History of Art Series, H. W. Jansen, editor, Prentice-Hall, Inc., New Jersey, 1965.

Barbara Novak, *American Painting of the Nineteenth Century*, Praeger Publishers, New York, 1969.

Denys Sutton, "The Museum of Fine Arts and the Boston Ethos," *Apollo*, January 1970.

One Hundred Years of Impressionism: A Tribute to Durand-Ruel, Exhibition Catalogue, Wildenstein and Co., New York, 1970.

John K. Howat and John Wilmerding, *19th Century America, Painting and Sculpture*, Exhibition Catalogue, The Metropolitan Museum of Art, New York, 1970.

William Truettner, "William T. Evans, Collector of American Paintings," *The American Art Journal*, Fall, 1971.

French Impressionists Influence American Impressionists, Exhibition Catalogue, with essays by Richard J. Boyle, F. Van Deren Coke, Ira Glackens, William I. Homer, and Robert C. Vose, Lowe Art Museum, University of Miami, Florida, 1971.

AMERICAN IMPRESSIONISM

World's Columbian Exposition, 1893. Official catalogue edited by the Department of Publicity and Promotion, M. P. Handy, Chief Editor, W. B. Conkey, Co., Chicago, 1893.

Hamlin Garland, *Crumbling Idols* (1894), edited and with an introduction by Jane Johnson, Belknap Press of Harvard University Press, Cambridge, 1960.

John I. H. Baur, *Leaders of American Impressionism*, Exhibition Catalogue, The Brooklyn Museum, New York, 1937.

Allen S. Weller, "Sources of Style: The Impressionists," *Art in America,* June 1963.

F. Van Deren Coke, *Impressionism in America,* Exhibition Catalogue, University of New Mexico, 1965.

F. Van Deren Coke, *The American Impressionists,* Exhibition Catalogue, Hirschl & Adler Galleries, Inc., New York, 1968.

Marcia Tucker, *American Paintings in the Ferdinand Howald Collection,* Exhibition Catalogue, introduction by E. P. Richardson, The Columbus Gallery of Fine Arts, 1969.

Donelson F. Hoopes, *The American Impressionists,* Watson-Guptill Publications, New York, 1972.

Moussa M. Domit, *American Impressionist Painting,* Exhibition Catalogue, National Gallery of Art, Washington, D.C., 1973.

SOURCES FOR INDIVIDUAL ARTISTS

The sources listed below are arranged by chapter. Where more than one artist is mentioned, they are arranged alphabetically.

CHAPTER V

James McNeill Whistler:

E. R. and J. Pennell, *The Life of James McNeill Whistler,* 2 vols., London, 1908.

Otto H. Bacher, *With Whistler in Venice,* The Century Company, New York, 1908.

Charles L. Borgmeyer, "A Few Hours with Duret," *Fine Arts Journal,* March 1914.

Frank Morley Fletcher, *Colour Control,* Faber and Faber, London, 1936.

Denys Sutton, *Nocturne: The Art of James McNeill Whistler,* Country Life, Ltd., London, 1963.

From Realism to Symbolism: Whistler and His World, Catalogue for the exhibition organized by the Department of Art History and Archaeology, Columbia University, New York, with the Philadelphia Museum of Art, 1971; with essays by Allen Staley and Theodore Reff.

Alastair Grieve, "Whistler and the Pre-Raphaelites," *The Art Quarterly,* vol. 34, no. 2, 1971.

CHAPTER VI

Charles Louis Borgmeyer, "Alexander Harrison, 1853-1930," *Fine Arts Journal,* September 1913.

Charles Louis Borgmeyer, "Birge Harrison, Poet Painter," *Fine Arts Journal,* October 1913.

Winslow Homer:

G. W. Shelden, *Hours with Art and Artists,* 1882.

Lloyd Goodrich, *Winslow Homer,* Whitney Museum of Art, The Macmillan Co., New York, 1944.

Henry James, *The Painter's Eye,* edited and with an introduction by John L. Sweeney, Rupert Hart-Davis, London, 1956.

Albert Ten Eyck Gardner, *Winslow Homer, American Artist: His World and His Work,* Clarkson N. Potter, Inc., New York, 1961.

Lloyd Goodrich, *Winslow Homer,* Whitney Museum of Art, New York Graphic Society, Greenwich, 1973.

John La Farge:

Cecilia Waern, *John La Farge, Artist and Writer,* Seeley and Co., Ltd., London, and Macmillan Co., New York, 1896.

Royal Cortissoz, *John La Farge: A Memoir and a Study,* Houghton Mifflin, Boston and New York, 1911.

Henry James, *Notes of a Son and Brother,* Charles Scribner's Sons, New York, 1914.

John La Farge, Exhibition Catalogue, Graham Gallery, New York, 1966.

Henry A. La Farge, *John La Farge,* Exhibition Catalogue, Kennedy Galleries, Inc., New York, 1968.

Homer Martin:

Elizabeth Gilbert Davis Martin, *Homer Martin, A Reminiscence,* William Macbeth, New York, 1904.

Frank Jewett Mather, Jr., *Homer Martin, A Poet in Landscape,* New York, 1912.

Nelson C. White, *Dwight W. Tryon: A Retrospective Exhibition,* Museum of Art, University of Connecticut, Storrs, 1971.

Joseph R. Woodwell:

Homer Saint-Gaudens, *Joseph R. Woodwell,* Exhibition Catalogue, Carnegie Institute, Pittsburgh, 1933.

Joseph R. Woodwell, Exhibition Catalogue, The Henry Clay Frick Fine Arts Department, University of Pittsburgh, November 1953 to January 1954.

CHAPTER VII

Mary Cassatt:

Achille Segard, *Un Peintre des Enfants et des Mères—Cassatt,* Librarie Ollendorf, 1913.

Adelyn D. Breeskin, *The Graphic Work of Mary Cassatt: A Catalogue Raisonné,* H. Bittner, New York, 1948.

Frederick A. Sweet, *Sargent, Whistler and Mary Cassatt,* Exhibition Catalogue, The Art Institute of Chicago, 1954.

Adelyn D. Breeskin, *Mary Cassatt: A Catalogue Raisonné of the Oils, Pastels, Watercolors and Drawings,* Smithsonian Institution Press, Washington, D.C., 1970.

John Singer Sargent:

Hon. Evan Charteris, *John Sargent,* London and New York, 1927.

Philip Hardy, *Catalogue of the Exhibited Paintings and Drawings,* The Isabella Stewart Gardner Museum, Boston, 1931.

Frederick A. Sweet, *Sargent, Whistler and Mary Cassatt,* Exhibition Catalogue, The Art Institute of Chicago, 1954.

CHAPTER VIII

Theodore Butler:

Claude Monet and the Giverny Artists, Exhibition Catalogue, Charles E. Slatkin Galleries, New York, 1960.

M. L. D'Otrange Mastai, *Mark Fisher,* Exhibition Catalogue, Vose Galleries, Boston, John Nicholson, Ltd., 1962.

Stuart P. Feld, *Lilla Cabot Perry, A Retrospective Exhibition,* Hirschl and Adler Galleries, Inc., New York, 1969.

William Lamb Picknell:

Marquis de Chennevières, "Le Salon de 1880," *Gazette des Beaux-Arts,* July 1880.

William Howe Downes, "William Lamb Picknell," *Dictionary of American Biography,* edited by Allen Johnson and Dumas Malone, New York, 1928-1964.

CHAPTER IX

Theodore Robinson:

Will H. Low, *A Chronicle of Friendships,* New York, 1908.

John I. H. Baur, *Theodore Robinson,* The Brooklyn Museum, New York, 1946.

John I. H. Baur, "Photographic Studies by an Impressionist," *Gazette des Beaux-Arts,* October-December 1946.

Theodore Robinson, American Impressionist, exhibition of paintings, pastels, and drawings, Kennedy Galleries, Inc., New York, 1966.

CHAPTER X

Hein Frantz, "Frank Meyers Boggs," *International Studio Magazine,* March 1913.

Still-Lifes by Emil Carlsen, Exhibition Catalogue, The Macbeth Gallery, New York, 1935.

Kent L. Seavey, *A Century of California Painting, 1870-1970,* Exhibition Catalogue, sponsored by Crocker Citizens National Bank, 1970.

John J. Enneking, Exhibition Catalogue, Vose Galleries, Boston, 1962.

Maude I. G. Oliver, "A Painter of the Middle West, L. H. Meakin," *The International Studio,* November 1907.

Arlene Jacobowitz, *Edward Henry Potthast,* Exhibition Catalogue, Chapellier Galleries, New York, 1969.

J. Nilsen Laurvik, "Edward W. Redfield—Landscape Painter," *The International Studio,* August 1910.

C. Lewis Hind, "An American Landscape Painter: W. Elmer Schofield," *The International Studio,* February 1913.

Harold Donaldson Eberlin, "Robert W. Vonnoh: Painter of Men," *Arts and Decoration,* September 1912.

"Vonnoh's Half Century," *International Studio,* June 1923.

Eliot Clark, "The Art of Robert Vonnoh," *Art in America,* August 1928.

CHAPTER XI

THE TEN AMERICAN PAINTERS—General

James Britton, "The Ten and the Academy," *American Art News,* April 1915.

Edward Simmons, *From Seven to Seventy,* Harper and Brothers, New York and London, 1922.

Childe Hassam, "Twenty-Five Years of American Painting," *The Art News,* April 14, 1928.

John Douglas Hale, *The Life and Creative Development of John H. Twachtman,* unpublished Ph.D. thesis, Ohio State University, 1957.

Dorothy Weir Young, *The Life and Letters of J. Alden Weir,* Yale University Press, New Haven, 1960.

THE TEN AMERICAN PAINTERS—
Sources for individual artists

Frank Benson:

William H. Downes, "The Spontaneous Gaity of Frank Benson's Work," *Arts and Decoration,* March 1911.

M. C. Salamon, *Frank W. Benson,* London, 1925.

William Merritt Chase:

Katherine Metcalf Roof, *The Life and Art of William Merritt Chase,* Charles Scribner's Sons, New York, 1917.

M. L. D'Otrange-Mastai, *William Merritt Chase: A Retrospective Exhibition,* The Parrish Art Museum, Southampton, New York, 1957.

The First West Coast Retrospective Exhibition of Paintings by William Merritt Chase, The Art Gallery, University of California, Santa Barbara, 1964.

Henry S. Francis, "Portraits by Whistler and Chase," *The Bulletin of the Cleveland Museum of Art,* January 1965.

Joseph DeCamp:

William Howe Downes, "Joseph DeCamp and His Work," *Art and Progress,* April 1913.

Thomas W. Dewing:

Ezra Tharp, "T. W. Dewing," *Art and Progress,* March 1914.

Royal Cortissoz, *American Artists,* Charles Scribner's Sons, New York and London, 1923.

Nelson C. White, "The Art of Thomas W. Dewing," *Art and Archaeology,* June 1929.

235

Childe Hassam:

Frank T. Robinson, *Living New England Artists,* Boston, 1888.

Adeline Adams, *Childe Hassam,* American Academy of Arts and Letters, New York, 1938.

Willard Metcalf:

Royal Cortissoz, *American Artists,* Charles Scribner's Sons, New York and London, 1923.

Bernard Telvan, "A Painter's Renaissance," *International Studio,* October 1925.

Edmund Tarbell:

J. E. D. Trask, "About Tarbell," *American Magazine of Art,* April 1918.

John Henry Twachtman:

John Douglas Hale, *The Life and Creative Development of John H. Twachtman,* unpublished Ph.D. thesis, Ohio State University, 1957.

Richard J. Boyle, *A Retrospective Exhibition: John Henry Twachtman,* with an introduction to prints by Mary Welsh Baskett, Cincinnati Art Museum, 1966.

Richard J. Boyle, John Douglas Hale, *John Henry Twachtman, An Exhibition of Paintings and Pastels,* Ira Spanierman Gallery, New York, 1968.

J. Alden Weir:

Duncan Phillips, *Julian Alden Weir: An Appreciation of His Life and Works,* with essays by Emil Carlsen, Royal Cortissoz, Childe Hassam, and J. B. Millet, Phillips Publications Number One, E. P. Dutton and Company, New York, 1922.

Paintings by J. Alden Weir, Exhibition Catalogue, The Phillips Collection, Washington, D.C., 1972.

John I. H. Baur, *Leaders of American Impressionism: Mary Cassatt, Childe Hassam, John H. Twachtman, J. Alden Weir,* The Brooklyn Museum, New York, 1937.

Dorothy Weir Young, *The Life and Letters of J. Alden Weir,* Yale University Press, New Haven, 1960.

CHAPTER XII

Frederick Frieseke:

Allen S. Weller, *Frederick Frieseke,* Exhibition Catalogue, Hirschl and Adler Galleries, Inc., New York, 1966.

E. Charlton Fortune:

Paintings by E. Charlton Fortune, Los Angeles County Museum, California, 1928.

Kent L. Seavey, *A Century of California Painting,* Exhibition Catalogue, Crocker Citizens National Bank, California, 1970.

William Glackens:

Ira Glackens, *William Glackens and the Ash Can Group: The Emergence of Realism in American Art,* Crown Publishers, New York, 1957.

Leslie Katz, *William Glackens in Retrospect,* Exhibition Catalogue, City Art Museum of St. Louis, 1966.

Ernest Lawson:

Duncan Phillips, "Ernest Lawson," *Magazine of Art,* vol. 3, no. 7, May 1917.

F. N. Price, "Lawson of the Crushed Jewels," *International Studio,* vol. 78, February 1924.

Barbara O'Neal, *Ernest Lawson,* Exhibition Catalogue, The National Gallery of Canada, Montreal, 1967.

Richard E. Miller:

Richard E. Miller, N. A.: An Impression and Appreciation, The Longmire Fund, St. Louis, Missouri, 1968.

Maurice Prendergast:

Duncan Phillips, "Prendergast," *Arts,* vol. 5, 1924.

Van Wyck Brooks, "Anecdotes of Maurice Prendergast," *The Prendergasts: A Retrospective Exhibition,* Addison Gallery of American Art, Andover, Massachusetts, 1938.

Hedley Howell Rhys, *Maurice Prendergast,* Exhibition Catalogue, with catalogue entries by Peter A. Wick, Museum of Fine Arts, Boston, Harvard University Press, 1960.

Charles H. Sawyer, *Maurice Prendergast,* Exhibition Catalogue, The Knoedler Galleries, New York, 1966.

Joseph Raphael:

Kent L. Seavey, *A Century of California Painting,* Crocker Citizens National Bank, California, 1970.

John Singer Sargent:

Charles Merrill Mount, *John Singer Sargent: A Biography,* New York, 1955, London, 1957.

Donelson F. Hoopes, "John Sargent: The Worcestershire Interlude 1885-89," *Brooklyn Museum Annual,* vol. 7, 1965-66.

Richard Ormond, *John Singer Sargent: Paintings, Drawings, Watercolors,* Harper and Row, New York, 1970.